NIGHT & LOW-LIGHT PHOTOGRAPHY

Jill Waterman

Foreword by MICHAEL KENNA

AMPHOTO BOOKS An Imprint of Watson-Guptill Publications. New York

© JILL WATERMAN

Camera	Nikon F3HP
Lens	Nikkor 24mm
Aperture	f/8
Exposure	30–45 minutes
Film	Fujichrome Sensia 100

Senior Acquisitions Editor: Abigail Wilentz
Senior Development Editor: Alisa Palazzo
Designer: JooYoung Lee / Verde Design
Art Director: Timothy Hsu
Production Director: Alyn Evans

First published in 2008 by Amphoto Books
an imprint of Watson-Guptill Publications
Nielsen Business Media
a division of The Nielsen Company
770 Broadway
New York, NY 10003
www.watsonguptill.com
www.amphotobooks.com

ISBN-13: 978-0-8174-3241-6
ISBN-10: 0-8174-3241-8

Library of Congress Control Number: 2008926467

Text copyright © 2008 Jill Waterman
Individual copyright information for the photographs indicated with each image.

Watson-Guptill Publications books are available at special discounts when purchased in bulk for premiums and sales promotions, as well as for fund-raising or educational use. Special editions or book excerpts can be created to specification. For details, please contact the Special Sales Director at the address above.

About *PDN*

Photo District News is the award-winning leading publication for professional photographers and creatives. As it has every month for over two decades, *PDN* delivers unbiased news and analysis, interviews, photographer portfolios, exhibitions listings, marketing and business advice, product reviews, technology updates, and all the information photographers need to survive in a competitive business. It is the definitive resource for those who take pictures and those who use pictures.

Printed in Singapore

1 2 3 4 5 6 7 8 9 / 16 15 14 13 12 11 10 09 08

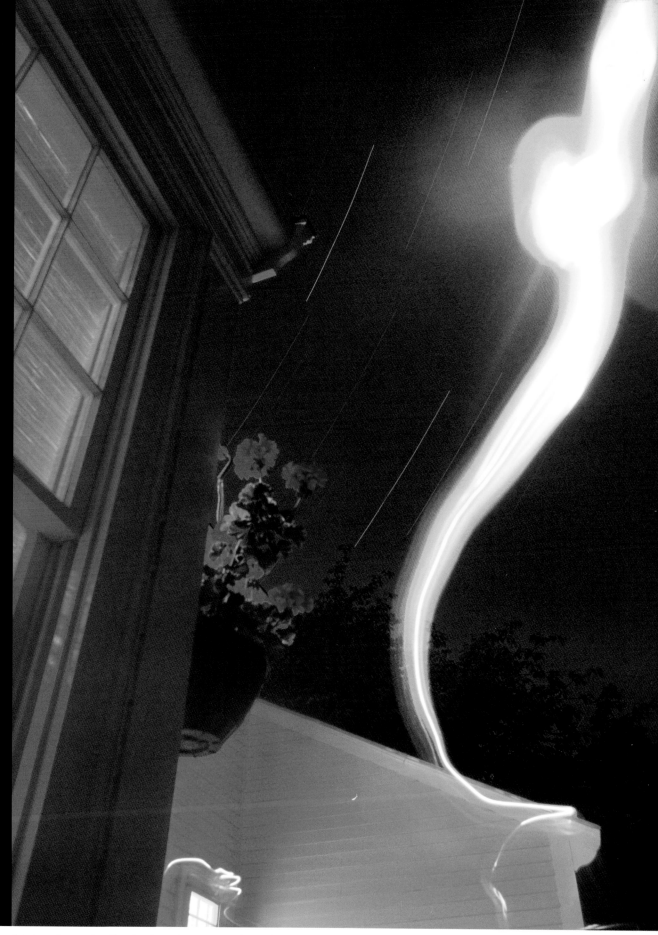

A summertime party offered a chance to contrast red party lighting with distant star trails. A planned one-hour exposure began as party guests moved inside. After about half an hour, a guest in search of missing keys grabbed a flashlight and went out the back door. The beam of the flashlight struck the open camera lens as he moved through the scene. Surprisingly, instead of ruining the image, the passing light made a perfect addition to the shot. Unexpected events often turn into fortuitous elements when shooting at night and should never be discarded before taking a close look.

TABLE OF

CONTENTS

© **STEVE HARPER**

Camera Leicaflex

Lens Nikkor 50mm

Aperture f/2.8

Exposure 7 minutes

Film Kodak 160 Tungsten

Fierce wind and heavy fog are challenging conditions for successful picture-making. Steve Harper—always ready for a unique experiment—grabbed a blanket and held it overhead for the duration of the exposure. His legs and torso register clearly on the film but his upper body is hidden beneath a veil of the light-colored fabric in constant motion. The cool color temperature of tungsten film makes the overall scene shift blue.

Foreword

The night is an integral part of the twenty-four-hour cycle. Yet, most photographs are the result of instant exposures made during daylight hours. Why is that? Photographing outside, alone in the dark, is not something most of us choose to do on a regular basis. The night is often associated with shadows, secrets, mysteries, and danger. It is a time when we usually put away our cameras and seek shelter indoors. This book may persuade us to do otherwise.

There is something magically seductive about a creative process that is not fully in our control. Much of what happens during night photography is like that. Long exposures, from seconds to hours, make images unpredictable. While the shutter stays open, objects and elements may move at any time, and the earth is moving all the time relative to the planets and stars. Color and contrast may shift due to reciprocity failure and the idiosyncrasies of particular films and digital systems. Weather conditions may vary or change dramatically. Light can appear in many forms and from unforeseen and multiple directions. Deep shadows invite our curiosity. These assorted creative possibilities are all part of this fascinating experience.

Patience is the core requirement for successful photography in very low light and during the night. A curious eye and a willingness to wait and watch will go far. Technical know-how can be learned quite easily. Camera equipment does not need to be sophisticated. Inclement weather can be withstood. However, the night does demand time, a most precious commodity. Point-and-shoot cameras and the digital revolution have ensured that instant visual gratification is now available for all, and there is certainly a place for this. But what a luxury and privilege it is to quietly observe and to allow light to accumulate and record phenomena that our human eyes are incapable of perceiving. I can think of few better antidotes to take for this fast-paced, multicolored, highly stimulated, and constantly accelerating world of ours than a regular dose of night photography!

In workshops and lectures over the years I have consistently maintained that photographing at night is a highly subjective process that could never be translated into an exact science. I have informed unsuspecting students that this peculiar activity of making photographs when one should sensibly be asleep, is highly capricious. I have also concluded that there would never be a good book published on this subject. I now plead guilty to disseminating misinformation.

Night photography might remain subjective, unpredictable, and at times even uncomfortable, but this volume effectively unlocks the vocabulary, grammar, and syntax necessary for would-be night practitioners to produce their own expressive poetry. This is a good book, and I trust that it will coax and guide a new wave of photographers to explore the night. It is an activity that, from personal experience, I heartily recommend.

Michael Kenna January 2008

A radar tower in the Marin Headlands takes on an eerie glow due to a pair of bright red lights that overwhelm the cool-toned tungsten film with a contrasting color-cast. Moving antennae on the tower cause the light to spread along the course of their trajectory. The sharpness of the camera optics and the contrast of the red light both contribute to the crispness of the starlight effects that surround the spotlights.

CONTRIBUTING PHOTOGRAPHERS

Tim Baskerville www.thenocturnes.com

Tim Baskerville received a BFA in photography from the University of San Francisco, and has been photographing at night for over twenty-five years. He curated the original Nocturnes exhibition in 1991 and founded the subsequent critically acclaimed Web site in 1996. Baskerville has written articles about night photography for *Photo Metro* magazine, and his work has received many awards and has appeared in numerous publications and exhibitions in the United States and abroad. He currently teaches night photography at UC Berkeley Extension, UC Santa Cruz, and the College of Marin. Additionally, he conducts an annual photographic workshop in Western Ireland.

Dave Black www.daveblackphotography.com

As a freelance photographer for over twenty-seven years, Dave Black has primarily focused on the sports industry, including such publications as *Sports Illustrated* and *Newsweek*. Known for his creative use of lighting and, in particular, the artistic technique of light painting, he continues to broaden his portfolio with work for *National Geographic* and its book *Where Valor Rests, Arlington National Cemetery*. He has been a teacher and guest lecturer on photography since 1986. His monthly Web site tutorial pages, "Workshop at the Ranch" and "On the Road," attract more than 85,000 visitors monthly.

Stewart Cohen www.stewartcohen.com

Director/photographer Stewart Cohen is known for the enthusiasm he brings to assignments. His expertise spans print, film, and publishing. He is the winner of numerous industry awards and has been widely profiled in publications and exhibited nationwide. Addicted to making pictures, he's always out there watching for the giveaway emotions like love, lust, ambition, and greed. Who knows what he'll find after dark?

Beau Comeaux www.beaucomeaux.com

Beau Comeaux received his BFA in studio art from Louisiana

Chris Crisman www.crismanphoto.com

Chris Crisman grew up watching the fall of the steel industry in Titusville, Pennsylvania, an event that has had a significant influence on his life. A 2003 graduate of the University of Pennsylvania, Crisman works as a commercial photographer in Philadelphia. His clients include magazines such as *Rolling Stone, Field & Stream, Fast Company,* and many others. His extensive portrait project on the retired steelworkers of his hometown has garnered him many accolades, including publication in the *Communication Arts 2006 Photo Annual* and selection by the Magenta Foundation for the Arts as one of twenty emerging photographers in the United States.

John E. Dowell, Jr. www.johndowell.com

An exhibiting artist for over forty years, John Dowell is a printmaking professor at Temple University's Tyler School of Art. His art has been featured in forty-five solo exhibitions, shown at the Venice Biennale, the Corcoran Gallery of Art, and the Whitney Biennial, among others. He has received many awards, including a James Van Der Zee Lifetime Achievement Award from Philadelphia's Brandywine Workshop, and numerous grants and commissions. His art is in the permanent collections of sixty-five museums, and his photographs are in the collections of the Houston Museum of Fine Arts, Harvard University's Fogg Museum, RISD Museum, Lehigh University Museum, Clark University Art Galleries in Atlanta, and the Davison Art Center Collection of Wesleyan University.

Chip Forelli www.chipforelli.com

Chip Forelli's award-winning photographic career encompasses twenty-five years with publication credits that include *Communication Arts, Photo District News, Graphis, Archive, Black & White Magazine, Lenswork,* and *Sierra Magazine*. He has worked on advertising campaigns for BMW, Land Rover, AT&T, and Eastman Kodak, and has done pro bono work for Médecins Sans Frontières. *The New York Times* has praised his "otherworldly

Andy Frazer www.gorillasites.com/nightphotos

A night photography junkie since 1999, Andy Frazer began filming interviews in 2003 with accomplished night photographers to let them explain, in their own words, why they are attracted to this specialty and how they capture the magic of the night in photographs. His documentary, *Night of the Living Photographers,* is available as a free download from the Web. In January 2006, Frazer began a night photography blog as an additional means to spread the gospel of the night. His own night photographs focus on abandoned buildings, the urban landscape, and the ocean.

Susanne Friedrich www.sanneART.com

Susanne Friedrich studied graphic design and photojournalism in Boston where she initially worked as a commercial photographer of weddings, portraits, and performances. Always interested in experimenting with alternative techniques, she began to photograph at night in 2001, and started using a modified Holga to make night images in 2002. She has exhibited her images in various galleries and venues in the San Francisco Bay Area, and her work is held in many private and corporate collections in the United States and Europe. She makes a living as a Web producer and graphic designer in San Francisco.

Helen K. Garber www.helenkgarber.com

Helen K. Garber is known for her night urban landscapes from international cities, and her latest project—*A Night View of Los Angeles,* commissioned for the 2006 Biennale of Architecture in Venice, Italy—is a 40-foot, 360-degree panorama of Los Angeles seen from the U.S. Bank Tower helipad. Urban Noir/LA-NY, her multimedia installation and photographic exhibition, was featured in 2007 at the Samuel Dorsky Museum of Art in New Paltz, New York. Her photographs have appeared in books and are in perma-nent collections of museums and private and corporate collec-tions nationwide. She is represented in Los Angeles by Stephen Cohen Gallery and in Boston by Tepper/Takayama Fine Arts.

Steve Harper www.steveharperphotography.com

A self-taught photographer, Steve Harper started his career standing in front of the cameras of Arbus, Penn, Horst, Avedon, and other greats as a Ford agency model in the 1960s. In 1969, he moved to Mendocino, California, where he opened a photography gallery. In 1979, Harper embarked on a teaching career that led him to research, develop, and teach the first college-level night photography course. Night photography quickly became his own photographic expression, and his classes were always full. Michael Kenna has aptly referred to Harper as "a guiding light for a whole generation of night photographers."

Mark Jaremko www.markjaremko.com

Mark Jaremko's interest in photography began during his childhood in Toronto when he received a Kodak Brownie Hawkeye from his father. In recent years, his focus has been on night photography in urban and industrial settings. He is fascinated by the interplay of static and moving objects, and how meaning is conveyed by color as well as composition. He photographs at all times of the day but is most drawn to night scenes evoking tranquility, loneliness, and isolation. He is attracted by the peaceful and secluded nature of the night, and his goal is to capture this mood in his photographs.

Lance Keimig www.thenightskye.com

Lance Keimig's interest in night photography dates back to 1984, when he was first introduced to the camera. In 1997, he cofounded the Nocturnes Night Photography Workshops with Tim Baskerville. Keimig currently leads night photography workshops across the United States, in Ireland, and in Scotland. In 2003, he cofounded the Mono Lake Photo Workshops with Christian Waeber. Keimig's work is held in the collections of the Duxbury Art Complex Museum, the Boston Public Library, the Boston Athenaeum, and numerous corporate collections including Fidelity, Hitachi, and Rayovac.

Bill Kouwenhoven

Originally from Baltimore, Bill Kouwenhoven studied comparative literature, culture, and foreign relations at Johns Hopkins University. He is fascinated by the city at night and how it appears like a stage set with simple props, lights, backdrops, and empty dark spaces that wait for protagonists to appear. The darkness inherent in his images allows him to seamlessly combine photographs from diverse cities while suppressing site-specific details to assemble a sort of universal theater. He presently lives in New York and Berlin, where he works as a freelance photography critic and curator.

Tom Paiva www.tompaiva.com

As a professional freelance photographer based in California, Tom Paiva specializes in large-format photography of industrial

and maritime settings, as well as architecture and interiors. His long-term passion is night photography, and he loves to create images of urban settings and moonlit landscapes on film. He was involved in the formation of the group The Nocturnes and was included in its landmark San Francisco exhibit in 1991. Paiva has led night-photography and view-camera workshops, and his work has been the subject of numerous articles in the photographic press. A book of his photographs, *Industrial Night*, containing forty-six color images was published in 2002.

Troy Paiva www.lostamerica.com

Troy Paiva captures the disappearing man-made world with his evocative and exotic night-photography technique. The time-exposures capture the surreal night sky of circling stars and blurred, fast-moving clouds while his light-painting techniques bring these abandoned places back to life with washes of vibrant color. In 2003, Paiva's first book, *Lost America*, was published by Motorbooks International to critical acclaim. A second book of his night photography will be released by Chronicle Books in 2008. His work has also appeared in numerous publications, including *Automobile, Hot Rod, and Popular Photography* and on many CD and book covers.

Jim Reed www.jimreedphoto.com

A veteran full-time storm chaser, Jim Reed is recognized as one of the world's most accomplished weather photographers and has a unique and interpretive approach to America's changing climate. Over two decades, he has documented almost every type of meteorological phenomenon, including fifteen hurricanes, tornadoes, blizzards, electrical storms, and floods. His credits include live television appearances on every major network and projects for America Online, Microsoft, *National Geographic*, the National Oceanic & Atmospheric Administration, Nikon, *The New York Times, Reader's Digest, Time*, and the World Meteorological Organization. He is also the author of several books, including *Storm Chaser: A Photographer's Journey* (Abrams, 2007, www.stormchaserbook.com).

Orville Robertson www.newyorkstreetphotography.com

Orville Robertson has been photographing urban landscapes and people for nearly twenty-five years. He is the publisher and editor of *Fotophile*, the photography journal he founded in 1993. His work is included in many museum, private, and corporate collections and has appeared in numerous exhibitions, including at Schomburg Center for Research in Black Culture, the Brooklyn Museum, the Museum of the City of New York, Anacostia Museum/Smithsonian Institution, Amon Carter Museum, and many other facilities. In 2001, Robertson cocurated Committed to the Image: Contemporary Black Photographers at the Brooklyn Museum. He was awarded a 2002 Fellowship in Photography by the New York Foundation for the Arts.

Daryl-Ann Saunders www.dasfineart.com

A commercial and fine-art photographer in New York, Saunders has been commissioned by a wide range of clients, including *Forbes*, NY Life Insurance Company, Showtime Networks, and many music publications. Her fine-art work is widely exhibited and held in both private and corporate collections, including Pfizer and GE. "On the Platform" is her ongoing project of color photographs created on subway platforms at night in cities throughout the world. Her photographs clarify the colorful, complex relationship between man-made structures, community, and nature. Her fine-art work is represented by Safe-T Gallery in Brooklyn.

Lynn Saville www.lynnsaville.com

Lynn Saville is an urban landscape photographer working primarily at twilight, night, and dawn. Her book, *Acquainted with the Night,* was published by Rizzoli in 1997. Saville's photographs are represented by Yancey Richardson Gallery in New York. Her work is exhibited internationally and collected in museums in Europe and the United States. Awards include a fellowship from the New York Foundation for the Arts and a grant from the New York State Council of the Arts. She is a member of the teaching faculty of the International Center of Photography and New York University.

Claire Seidl www.claireseidl.com

Claire Seidl is both a photographer and a painter. She has exhibited her work widely in both solo and group exhibitions with reviews in publications such as *Art in America, ARTnews, The New York Times, The New York Observer,* and *the Portland Herald Press*. Her work is held in the collections of museums, universities, and numerous corporate collections. Seidl received a BFA from Syracuse University and an MFA from Hunter College and has taught art throughout her career. She lives and works in New York City and in Rangeley, Maine. Most of her photographs are taken in Maine, where she shoots extensively at night.

M. J. Sharp www.mjsharp.com

A Tennessee native, M. J. Sharp was based at the award-winning alternative newsweekly *The Independent* in Durham, North Carolina, for most of the 1990s. She has also freelanced extensively, both locally and nationally. For the past few years, she has concentrated on large-format night photography and, in 2007, earned her MFA from the University of North Carolina at Chapel Hill.

Ragnar Th. Sigurdsson www.arctic-images.com

A professional photographer educated in Sweden and Iceland, Ragnar Sigurdsson started as a news photographer and then opened his own studio in 1985. A pioneer in the use of digital equipment in Iceland, Sigurdsson's archive of 200,000 photos specializes in Arctic nature and travel and features volcanoes, geothermal activity, geological formations, glaciers, waterfalls, wildlife, and the flora of the Arctic among other locations and subjects. In addition to receiving three CLIO awards, Sigurdsson is widely exhibited, and in 1997, Icelandic TV made a documentary about his work. In 1996, Sigurdsson and a partner founded the publishing firm Arctic Books.

Kenny Trice www.kennytrice.com

Kenny Trice is an artist best known for stunning landscape and architectural images. A primary interest in his image-making is to capture the ethereal quality of ordinary scenes. He received a BA in Latin American studies from the University of Texas, Austin, and attended the Academy of Art University in San Francisco. His work has been included in two *Photo District News* photo annuals and in *American Photography*. Clients

...nge from GSD&M and Publicis to *Flaunt, Surface,* and *Forbes* magazines. Trice and his family currently live in Brooklyn.

Robert Vizzini www.robertvizzini.com

Robert Vizzini was born in Brooklyn in 1952. Largely self-taught, he has been photographing seriously since 1991. A workshop with Michael Kenna in 1997 solidified his passion for low-light shooting. His work has been featured in many of the major art-photography publications, including *Aperture, Blind Spot, DoubleTake,* and *Black & White Magazine.* Known for his "spare and elegant eye," Vizzini was the first recipient of the New Discovery Award of the International Photography Awards. His work is in many public collections, including Bibliotèque Nationale de France, Southeast Museum of Photography, and Swiss Re Capital Partners.

Christian Waeber www.cwaeber.com

Christian Waeber was born in Switzerland and moved to Boston in 1993. He wears two hats: As a medical researcher, he uses techniques that rely heavily on photography and imaging, which led him early on to explore the potential of the photographic medium for fine-art purposes, and as a photographer, he specializes in night, architecture, and figure photography. He is best known for his large-format night photographs of Boston's Big Dig. His work has been shown in numerous solo and group shows and has recently been featured in *View Camera, Preservation Magazine,* and *Art-Photo-Akt.*

Jill Waterman www.newyearphotos.com

A photographer, writer, and media professional based in New York since 1985, Jill Waterman has specialized in night photography since the early 1980s. Her photographic projects include Nightscapes, a series of long-exposure color photographs, and The New Year's Eve Project, an ongoing and international documentation of this annual celebration. Waterman's photographs have been exhibited and collected internationally and have received extensive media coverage including a January 2003 interview with Katie Couric on NBC's *The Today Show.*

Deborah Whitehouse

www.deborahwhitehouse.com, www.artshow.com/whitehouse

Photographer and photomuralist Deborah Whitehouse works in both fine-art photography and large-scale public art. Her edgy fine-art photography series Saturday Night is in museum and private collections internationally. Her best-known public work, *Spirit of Atlanta,* greets thousands of people daily at the Atlanta International Airport. Selected photographs and installations have appeared in *Art in America and Public Art Review.* Currently she is coauthoring a photo book for Mexican and American children focused on a Mexican father's homecoming after working in the United States for many months.

Marc Yankus www.marcyankus.com

Mark Yankus digitally layers textures scanned from tintypes, books, and other objects with his original images in a superimposition of old and new, resulting in a metaphor for his wider conceptual interests. His fine art and publishing experience spans more than twenty-five years, with his work exhibited at The Brooklyn Museum, Exit Art, The Library of Congress, and the New York

...gallery ClampArt. Yankus's images have been used as book covers and theatrical posters and have appeared in publications ranging from *The Atlantic Monthly to Photo District News.*

Barbara Yoshida www.barbarayoshida.com

After receiving an MA in art from Hunter College, New York–based Barbara Yoshida spent twenty years as a painter and began photographing in 1989. A member of the International Dark-Sky Association, Yoshida appreciates the innate qualities of moonlight and travels far away from artificial light to work. She exhibits both nationally and internationally and has worked in residence at MacDowell Colony, Light Work, and Atlantic Center for the Arts. In 2006, she was selected for the international survey Photography Now: One Hundred Portfolios. Public collections include Museet for Fotokunst Brandts Klaedefabrik, Frederick R. Weisman Art Museum, Huntington Gardens Art Collection, and Polaroid Corporation.

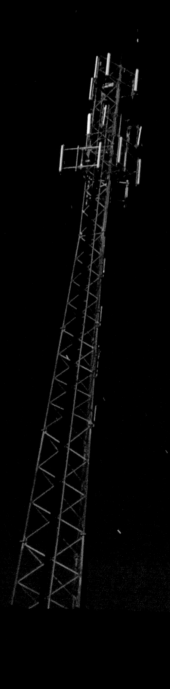

EQUIPMENT

Photographers who work with nighttime and low-light subjects embrace a rich assortment of cameras and gear. The uniqueness of this specialty dictates a wide gamut of equipment—from the classic to the arcane to the latest in high tech. Night shooters are as discriminating about their selections as they are passionate about their favorites, but most make use of multiple camera models or formats and pack a broad range of accessories to meet the needs of different conditions and desired effects.

A night photographer who for many years shot film images featuring elaborate lighting, Troy Paiva switched to digital after the release of the 8-megapixel Canon EOS 20D. The immediate feedback of digital allows him to adjust exposure and lighting on the fly. At low ISO settings, his images are generally noise-free when he keeps the exposure time under four minutes. He shoots in raw file format (see page 5) and adjusts his white balance in postproduction to suit the mood of the scene. In this image, light painting (see page 110) with red-and-green-gelled flashlights was added to a scene lit by sodium-vapor lamps.

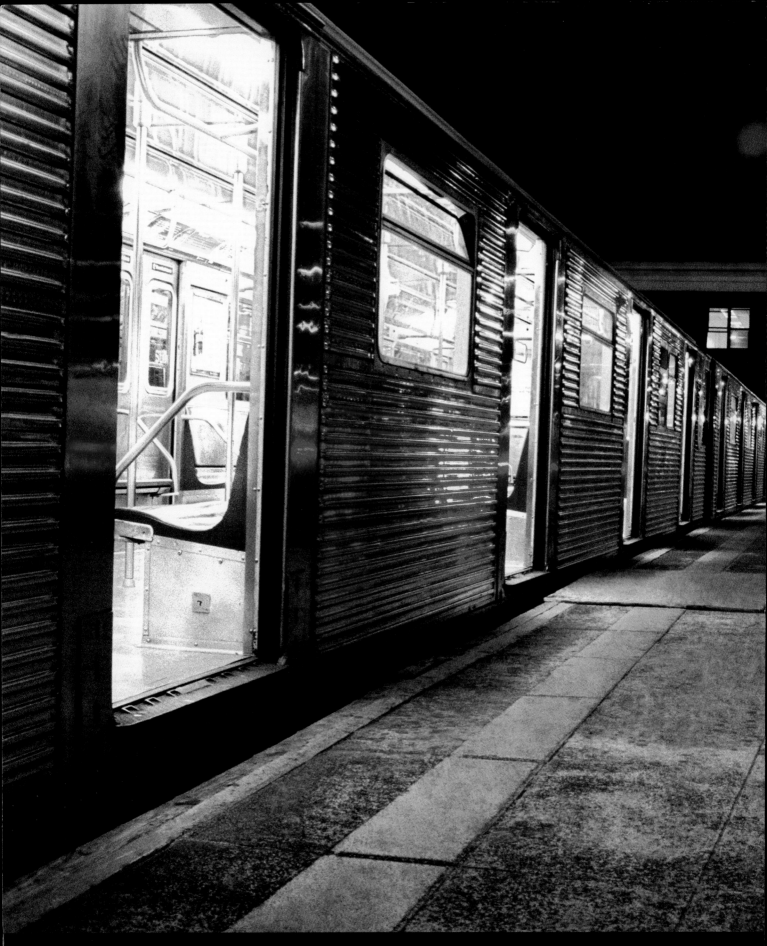

© DARYL-ANN SAUNDERS

		Aperture	f/22
Camera	Olympus IS-3 SLR	Exposure	Between 4 seconds and 1 minute
Lens	Integrated 35–180mm, 1:5.6 zoom	Film	Fujicolor NPZ 800

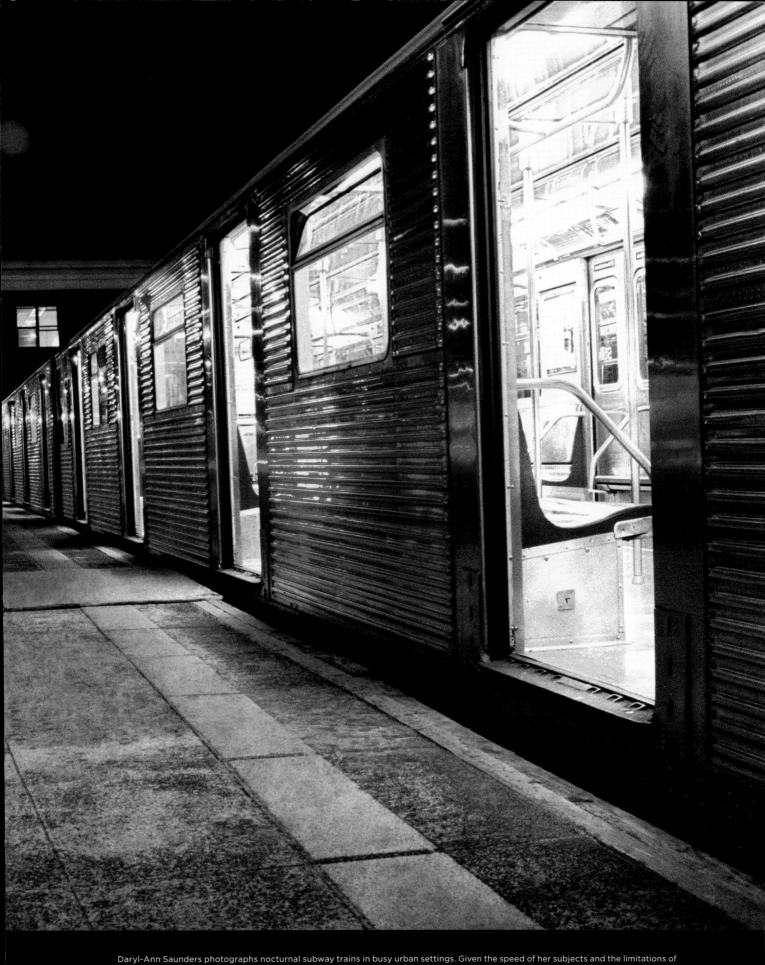

Daryl-Ann Saunders photographs nocturnal subway trains in busy urban settings. Given the speed of her subjects and the limitations of her environments, she has to plan a lot in advance. She shoots digitally for commercial work, but she selected a modest analog SLR with an integrated lens for her subway project to avoid the hazards of working with interchangeable parts and carrying expensive equipment in locations that are potentially unsafe.

Digital or Film?

The choice of camera is as important as any other factor in determining the kind of pictures one makes. When deciding on the best camera to work with at night, several factors need to be taken into account. Preferred subject matter and shooting conditions are at the top of this list. Is the primary work likely to be journalistic action shots taken with a handheld camera or moody landscapes taken with the camera mounted on a tripod? Other important considerations about gear include one's familiarity and comfort level with the equipment.

Doing proper homework before making an equipment purchase can go a long way to assuring satisfaction in the field. Research gear by fully reading the specifications, go online to check performance with other users, or consider renting equipment to try it out firsthand.

For a photographer just beginning to explore the night, digital capture has gained a clear advantage because of the practicality of the exposure preview and histogram readily available on screen and the possibility for making refinements based on these insights. Digital capture doesn't have reciprocity failure issues like film does, so exposure times tend to be shorter. Because exposures can be immediately verified by reviewing the camera's LCD screen, there is less need for bracketing. This can translate into a big advantage when the clock is ticking away minutes in the darkness instead of hundredths of a second in the midday sun.

Despite the conditions of a dark alley and an overcast night, Mark Jaremko was able to record the textured surface of a corrugated wall and backlit window in great detail with a 16.7 megapixel DSLR with a full-frame sensor. The question of whether a full-frame sensor and a high pixel count will improve image quality is very much a matter of personal judgment and shooting style. Jaremko finds the high resolution to be helpful in producing higher-quality prints in a large format.

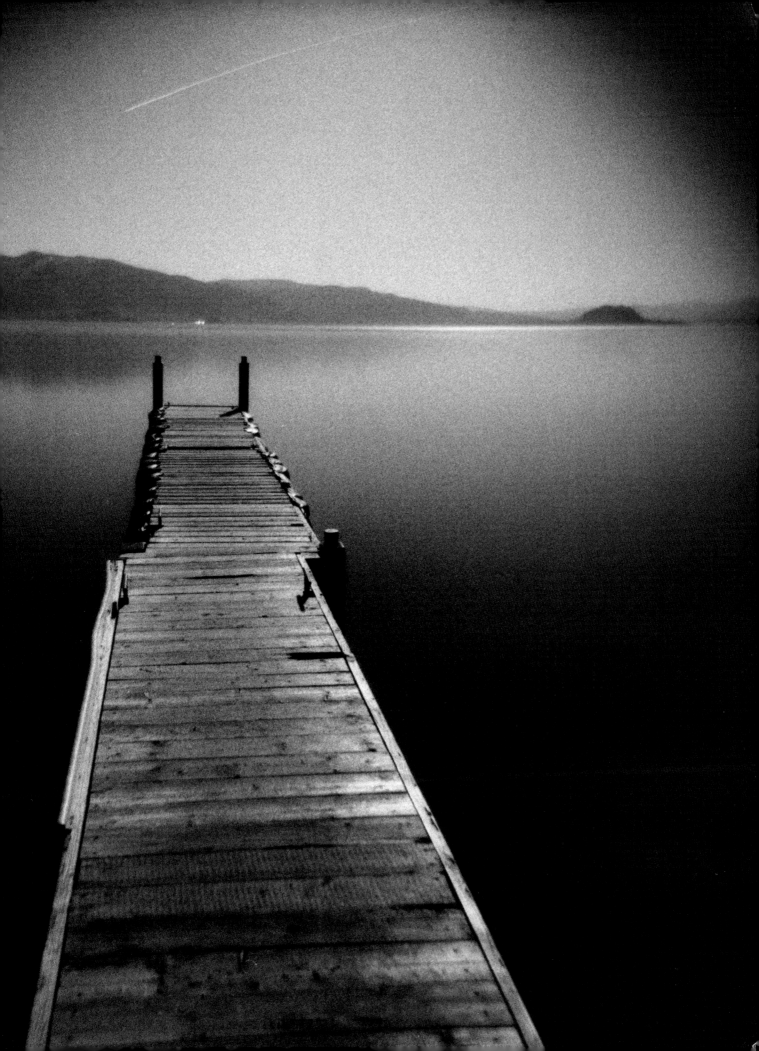

Personal Vision

When you work with larger formats, it forces you to slow down and compose very carefully. You have to slow down so much more that it becomes part of the reason for using it. — **Lance Keimig**

© **KENNY TRICE**

Camera	Hasselblad 500c
Lens	50mm
Aperture	f/16
Exposure	1 minute, 30 seconds
Film	Kodak Portra 160

A photographer who has always preferred medium format over 35mm, Kenny Trice shot his earliest suburban night scenes with a Hasselblad. He goes to great lengths to find locations and always thoroughly checks the sites he scouts and drives just a bit farther until he falls upon the right spot. After shooting for a few years with the square format, he realized that cameras with a landscape orientation were more suited to the scenes he wanted to capture, so he switched to 6x7 and 4x5 formats in his more recent work (see page 86).

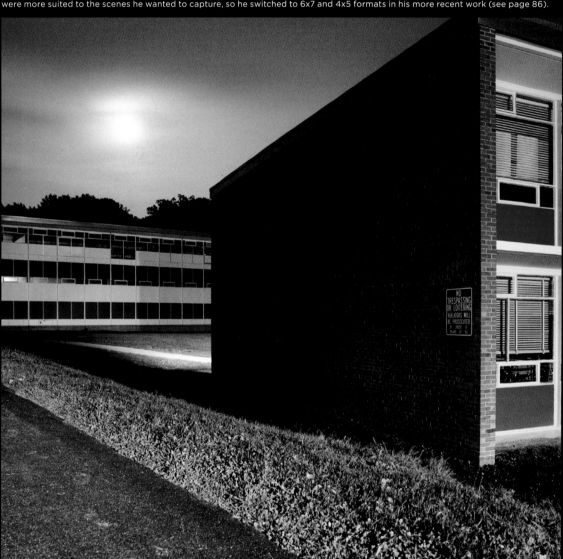

MEDIUM-FORMAT DIGITAL

Medium-format cameras come in both film and digital models. An important fact about medium-format digital systems is that these cameras utilize a CCD sensor, which is a different type of sensor that uses a different technology than the CMOS sensor now more commonly found in the newest 35mm DSLR cameras. CCD (charge-coupled device) sensors are also found in other high-end and scientific-imaging uses, such as astrophotography and astronomy. This sensor technology was developed first and was the primary type of sensor used in most digital cameras until fairly recently. CCD sensors convert light into an electric charge that leaves the sensor as an analog signal and is then digitized and stored as bits. With these sensors, all of the pixels can be devoted

to light capture. CCD sensors are known for producing high-quality, low-noise images, especially in medium-format cameras, which are larger in size. Yet, CCD chips tend to be more complicated to produce and their power consumption is greater than the more integrated and power-efficient CMOS (complementary metal-oxide-semiconductor) sensors. CMOS sensors represent an alternative technology, whereby light is converted from an electric charge to digital data within the sensor itself. Although initially used in lower-end cameras, recent improvements in the development of CMOS chips have made them gain acceptance as a technology behind the newest 35mm DSLRs.

Working at night with medium-format digital systems has been limited in the past because of both cost considerations and power issues. Early medium-format digital backs needed to be tethered to a power supply or a computer to function; however with current models, this is no longer an issue. Although medium-format cameras with CCD sensors remain extremely costly, the latest medium-format digital cameras and backs offer greater capabilities for low-light and nighttime photography. The good news is that photographers with a need for large file sizes and extreme image sharpness can now work with these camera models at night, provided they have the resources to afford the technology or the ability to rent the equipment.

A SAMPLING OF MEDIUM-FORMAT FILM CAMERAS

With 6x6 (2 1/4) cameras, framing and composition are affected by the square aspect ratio. While 35mm and 6x9cm format shooting affords more opportunity to break up the framing of a shot and approach a composition from angles, a square-format camera is more conducive to composing for an object in a landscape.

Holga

A cheap plastic 120-rollfilm camera that many people view as a toy, the Holga is the most expedient way to enter the arena of medium-format photography. Holgas are made with a fixed shutter speed of 1/100 second that needs to be disabled in order to make them useful for night photography. Detailed instructions for modifying these cameras for use with long exposures are available online at www.argonauta. com. Since Holgas are prone to light leaks, it's advisable to tape the camera edges with gaffer's tape and to spray paint the camera interior matte black.

Hasselblad

Many of the photographers featured in this book work partially or exclusively with a medium-format Hasselblad at night. This square-format camera is particularly well suited to night shooting because it is totally mechanical, with no batteries to fail. It has a bright viewfinder, is easy to use in the dark, and has interchangeable backs. Working with multiple backs can be useful for switching between different types of film midroll to capture the same subject with multiple variations (either at different film speeds or in color and black and white). It's also helpful for making identical captures with two different backs as extra insurance in film processing or for the immediate feedback about exposure and focus provided by a Polaroid back.

Mamiya 7

A solidly made camera in the 6x7-landscape format, the Mamiya 7 has the advantages of light weight and the quiet operation of a rangefinder. This model is the only medium-format rangefinder to offer interchangeable lenses. The camera is built to resemble the 35mm format, yet it features the larger 120 or 220 rollfilm formats. Changing film is relatively easy, and this, combined with the camera's bright viewfinder and easy focusing, make it well suited to working at night.

Mamiya RZ67

This medium-format camera has a rectangular landscape format and a revolving back to allow for switching to portrait orientation without turning the camera on its side. A mirror lock-up function protects against camera shake when shooting at slow shutter speeds, and an accessory prism finder provides through-the-lens (TTL) spot metering capability that remains accurate in low light.

Ebony SW23 View Camera (with rollfilm backs)

The Ebony SW23 is a compact medium-format view camera that offers the convenience of rollfilm and the flexibility of 6x6, 6x7, or 6x9 formats. Constructed of titanium and ebony wood, it also offers the perspective control of larger formats, with full movements on the front and rise on the back. Perspective control is particularly helpful for low-light situations when a scene includes close-up detail. The Ebony's view-camera format allows the photographer to maintain focus using camera tilt instead of needing to stop down the lens and add extra time to take a shot. This camera has several accessories that are ideal for night photography, including a hot-shoe-mounted articulated lens shade that can be adjusted to almost any position and holds a card to prevent flare.

Camera	Windsor 4x5		Aperture	f/16 to f/22
Lens	150mm		Exposur	55 seconds
			Film	Fuji NPL

Large-Format and View Cameras

Large-format cameras are highly specialized systems that allow a photographer to make images with rich detail and vast control over perspective and depth of field. These cameras function using an adjustable bellows to create a light-tight enclosure between fixed elements, or standards, on two sides: the lens plane and the film plane. Movement of the front and back planes by means of swings, tilts, and rise makes it possible to change spatial relationships and correct distortions before the image is captured. Extreme precision, flexibility in setting camera angles, and adjusting perspective to a degree that's impossible with other camera types makes this format especially useful for architecture and industrial subjects.

Large-format photography is also favored by those for whom image clarity is important. Yet, while the sharp resolution and image quality afforded by larger-format cameras is substantial, with every increase in size, the need for precision on the part of the photographer goes up exponentially. Everything has to be perfectly adjusted or it will show in the final result.

Working at night with large-format equipment requires both technical skill and physical strength. Low-light situations can make camera adjustments a challenge, and the method for viewing and focusing an image on the ground glass with a loupe can be particularly difficult to manage at night. Large-format cameras can weigh fifteen pounds or more, and when this is combined with a sturdy tripod and the other accessories needed in the field, it is not a practice for the inexperienced or the faint of heart. Camera functions tend to be manual, so electronics, meters, and batteries are not a concern.

Large-format work always entails a long list of accessories, from a dark cloth to a focusing loupe to film holders to an external meter, just for starters. A Fresnel screen and a compendium bellows can be particularly helpful when shooting with large-format cameras at night. *A Fresnel screen* is a special lens that attaches to or replaces the ground glass at the back of a large-format focusing screen. It helps to "even out" the brightness of the image that appears on the camera's ground glass and will make the scene appear brighter in dark conditions. This effect is more noticeable when a wide-angle lens is used. The quality of Fresnel screens can vary widely, and the best quality items are custom made, specific to the camera and the length of the lens.

A *compendium bellows* attaches to the front of a large-format camera and surrounds the lens like a flexible lens hood. Primarily used to help to control lens flare for tabletop work in studio situations, this accessory can be very useful when shooting around artificial lighting at night as long as there's no wind to cause camera shake. The compendium bellows can also shield the lens from elements such as rain and moisture and can help prevent lens fog from a rising dewpoint. A compendium bellows is made specific to a camera model for a proper fit.

A sliver of midtown Manhattan is revealed in a bird's-eye view through the window of an office high-rise. In order to get the most from his restricted vantage points, John Dowell makes full use of large-format camera adjustments, while at the same time trying to keep parallax. He keeps his f-stop set to the middle of the aperture dial where the focus is sharpest.

TIPS FOR LONG EXPOSURES WITH LARGE-FORMAT FILM

Nighttime work with large-format cameras tends to be a traditional, film-based practice that employs sheet film, either with individually prepared film holders or prepackaged "quick-load" film. Working with sheet film is an expensive proposition, so it's important to make every shot count. Attention to the following tips can help avoid problems during long exposures at night.

• Prepackaged film stocks (Readyload and QuickLoad, for example) are more prone to pop in the holder during very long exposures. While prepackaged film is more convenient, working with sheet film in individually prepared holders may be a safer route.

• When exposing prepackaged film stocks, the envelope can be subject to movement caused by the breeze as it hangs out of the camera during the exposure time. Carefully securing the envelope so that it remains immobile during an exposure can help prevent this motion from affecting the film.

• Before pulling the dark slide to start the exposure, give the film a minute or two to acclimate to the ambient air inside the camera. This should greatly reduce the chances of the film popping during the exposure, especially in humid or damp conditions.

• In certain conditions, Fuji NPL large-format negative film has a greater tendency to pop than large-format chrome films. Adding a tiny piece of double-sided tape to the center of the sheet film in the holder can help prevent this.

• Excess heat or shifts in humidity during a photo session can cause large-format film to buckle in the film holder and result in blurry pictures. To minimize this risk, prepare some extra holders with the film secured in the center by a tiny piece of double-sided tape. Keep these holders in reserve until conditions dictate holding the film in place.

LARGE-FORMAT CAMERA TYPES

The most common large-format cameras produce an original that measures 4x5 and 8x10 inches although cameras are also made in a variety of other sizes, from the 5x7–inch quarter-plate to wide panoramics. Cameras come in several different types, with smaller models sacrificing camera movements for added portability.

Press Cameras

These models aren't truly considered large format, although they use sheet film. The most popular types of press cameras are the wide range of models manufactured by Speed Graphic. These cameras are lightweight and sturdy but have limited camera movements. They are no longer manufactured but are still widely available at low cost on the Internet.

Field Cameras

These are available from many different manufacturers at a wide range of price points. They generally fold up into a self-contained case when not in use. With these models, greater amounts of camera adjustments are generally cost dependent. The Canham DLC45 field camera is a compact, lightweight model that's unique in its ability to accept lenses from 58mm to 450mm without the need for a recessed lens board. A very flexible proprietary bellows results in good camera movements.

View Cameras

These cameras are the workhorses of large-format photography. View cameras are attached to a monorail, which adds to their bulk and makes them heavy to transport but sturdy in the field. Cameras by Arca-Swiss are at the top of the line both in quality and price. The Toyo G and Sinar P are other well-respected view-camera models.

8x10 View Cameras

The shift up in format from 4x5 to 8x10 yields a negative size that's four times larger and can result in a great enhancement in image tonality and shadow detail. This jump in format also requires an increase in focal length of the lenses used. To ensure focus in the foreground and to take full advantage of the high resolution this format can provide, it's advisable to shoot with the lens stopped down to at least f/22 or to compose so that the foreground is lacking in detail.

When a client assigned him to produce a 20-foot panoramic image for a press conference backdrop, Tom Paiva decided to work with his 8x10 view camera so that there was virtually no grain and maximum detail when the film was output at that large a size.

Personal Vision
When competing against digital, one needs to
go to the other extreme by using large format
— Tom Paiva

Lenses: It's All About Speed

The camera lens takes on added importance at night, particularly in conditions when lighting is limited or contrast is harsh. Fast lenses offer more versatility in low-light conditions. Many photographers who specialize in nighttime or low-light conditions will only consider purchasing lenses with maximum aperture settings of $f/2.8$ or less for normal 35mm optics. Ultrafast lenses, with maximum aperture settings of $f/1.0$–$f/2.0$, are particularly valuable in situations where depth of field is not an issue, such as when shooting distant landscapes.

Many night photographers gravitate to the wide-angle view because wider lenses generally have greater light-gathering abilities. Fixed-focal-length lenses may provide ease of use in dark conditions and are less prone to flare because of their simpler optical design, yet zoom lenses have greater versatility. When working with telephoto or zoom lenses at maximum range, it's important to consider the fact that the longer the lens used, the greater the risk of image-blurring vibration, especially at long exposure times.

Image Stabilization

Image-stabilizing lenses give photographers an added degree of flexibility when shooting at slow shutter speeds in a low-light setting. Image stabilizers counteract camera shake by using tiny gyros that react to camera movement by signaling lens elements or the sensor plane to move in the opposite direction. This is an invaluable feature for dampening vibration to minimize blur caused by camera motion, particularly in low-light, handheld situations. Image stabilization is not useful for night photography with tripod-mounted cameras and exposure times lasting several minutes to an hour or more.

Image stabilization has also become a very popular enhancement to the latest point-and-shoot digital cameras. Since the light weight of these models makes handholding a challenge at slow shutter speeds, the image-stabilization feature is an important consideration for anyone wishing to cover low-light situations with a digital point-and-shoot.

To get a starburst effect from a light source in an image, stop the lens down to f/11 or smaller. Conversely, as the aperture is opened to increasingly wider settings, the highlights of light sources will get increasingly blown out. When shooting lights with the lens out of focus, the illumination will be surrounded by a halo or a glow.

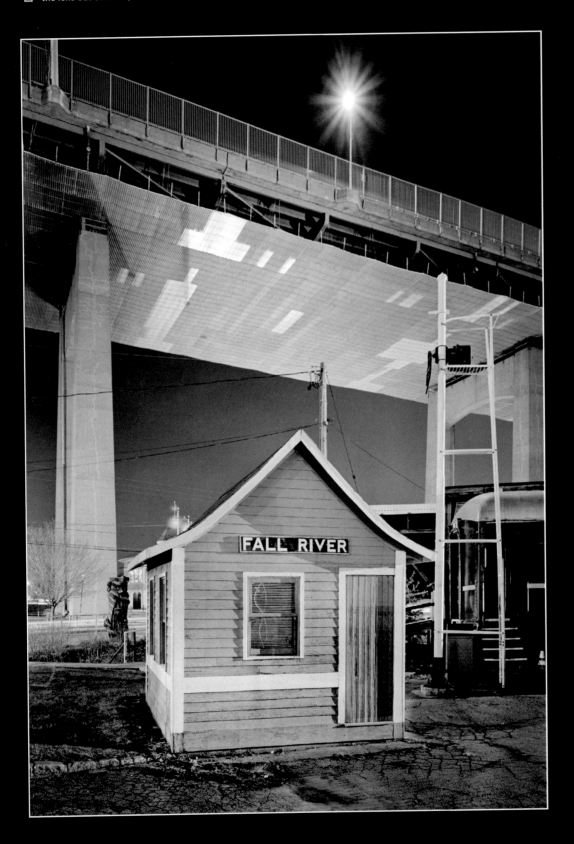

Lance Keimig used a wide-angle lens together with front rise to pack a lot of information into this shot and to prevent the vertical lines in the building from converging toward the top of the frame. The star effect in the streetlight is a result of stopping down the lens. The smaller the aperture, the greater the effect produced by the lights.

and set the zoom level, then point the camera at a distant light source such as the moon, stars, or a distant streetlight. Lock on this light with autofocus and the camera will be set on infinity. Image composition can then be readjusted to frame and expose the desired subject.

© LANCE KEIMIG

Camera	Ebony 23SW	Exposure	about 5 minutes
Lens	Nikkor SW 65mm, 1:45	Film	Fuji Neopan Acros
Aperture	f/11		

Focusing at Night

One of the primary issues that arises with images made in nighttime or low-light settings is a problem with focus. There are a number of potential reasons for this:

- Dark conditions make it difficult to get sufficient definition to focus through the camera's viewfinder. Either there is not enough light to see the focusing screen for manual focus or, with autofocus lenses, the electronic sensor doesn't have enough light to allow the focus to lock on to an object. To avoid this, illuminate the area targeted as the focus point with a flashlight and secure the focus with the help of this light.

- The focus of lenses can drift due to temperature change. When shooting one subject over an extended period, it is always important to check focus between captures.

- Digital autofocus lenses have a tendency to focus beyond infinity while appearing to match the infinity mark on the focusing ring, especially when used in manual mode. To remedy this issue, set up the shot under daylight conditions, prefocus the lens, and secure it with a small piece of gaffer's tape to avoid further movement.

- With a zoom lens, the infinity setting can shift depending on the focal length selected. With these lenses, it's strongly advised to verify the infinity focus through the range of focal points before trusting the settings in the field.

Besides autofocus or manual, through-the-lens focusing methods, two long-standing focusing techniques based on distance can help counter issues of inadequate or inaccurately applied depth of field that can plague images made at low-light settings. The first is zone focusing. Rather than focusing through the viewfinder, zone focusing allows the focus of a lens to be set by reading the depth-of-field scale related to a selected aperture. Manual lenses generally have a series of notches adjacent to the distance scale on the lens. The notches are often color coded to the range of f-stops on the aperture dial. Identify the notches matching a given aperture and see where they

BASIC EQUIPMENT LIST

The well-worn scouting motto "Be prepared" is never more apt than when venturing out after dark. An all-purpose list, based on the materials suggested by night-photography workshop leader Lance Keimig, is enhanced here by recommendations from other night photographers interviewed for this book.

- Camera(s) of your choice. Veteran night photographers often run two (or more) systems at a time to multitask with exposures and maximize their results. Operating multiple cameras simultaneously is recommended only once one is fairly confident working at night. The most logical time to try this is under moonlight conditions when exposures are longer. Working with multiple cameras is less advisable in urban situations, where it's important to keep a close eye on gear at all times.
- Sturdy tripod that will allow sufficient height and not be susceptible to wind. A professional-grade tripod is one of the best equipment investments one can make. Consider packing a second mini tripod or clamp for getting close to the subject or altering the vantage point.
- Locking mechanical or electronic cable release. A light-colored cable is easier to retrieve if dropped in the dark. Cable releases with built-in timing functions are very handy, albeit at a much greater cost.
- Digital watch, timer, or chronograph for monitoring exposure times. Timers that allow for multiple settings can be particularly useful when working with more than one camera at once.
- Penlight or other small flashlight for checking camera settings and rooting around in a camera bag.
- More powerful flashlight, such as a Surefire or Mag-Lite, and/or strobes for light painting.
- Small collapsible reflector to use with lights to fill in shadow areas.
- Small bubble level to ensure that camera angles are straight when the situation requires it.
- Compass to help maintain orientation in the dark and assist in identifying the position of the stars.
- Extra batteries—and then more extra batteries—for auxiliary lights and anything else that needs power to operate in the dark.
- Lens hood to prevent unwelcome flare.
- Plastic bags and rubber bands to cover camera and equipment in case of inclement weather. Hotel shower caps are perfect for this purpose.
- Umbrella, rain poncho, garbage bag, or other waterproof items to protect camera, body, and gear.
- Lens tissue, chamois, or super absorbent towel to wipe condensation caused by rising dewpoint.
- Rubber jar opener to aid in removing stuck parts, such as threaded lens filters.
- Small roll of masking or gaffer's tape and a ball of string for securing things in place.
- Set of mini screwdrivers and all-purpose army knife for sudden repairs.
- Small changing bag with double zippers or portable changing room tent if working with large format.
- Pad of paper and writing instrument for taking notes.
- Work samples and valid identification to show authorities or anyone encountered who is curious about your motives for loitering with intent in the dark.
- A good book, which can provide great company to read by flashlight during long exposure times.
- Additional items, within reason, to enhance comfort level, such as sweater, gloves, hand or foot warmers, food, and drink.

match the distance scale. These two distance markers represent the maximum and minimum distance points that will be reasonably in focus for that aperture. In nighttime conditions, it can be easier to read the distance markings on the lens rather than to use the viewfinder to focus on a distant point in a darkened landscape. This method is also helpful in situations when the camera is positioned so that full access to the rear viewfinder is obscured.

The second technique is hyperfocal focusing. This method for calculating depth of field identifies the closest distance at which a particular lens can be focused while keeping objects at infinity acceptably sharp. For any given lens, this is the focus distance with the maximum depth of field. When a lens is focused at this point, the depth of field extends from half of the hyperfocal distance out to infinity. Each focal length–aperture combination has its own hyperfocal distance. Normal to wide-angle

lenses (50mm and less for 35mm cameras) have a relatively short hyperfocal distance and are good lenses to use with this focusing technique. The hyperfocal distance for telephoto lenses is quite distant, so this method is less useful with this equipment. There are many online resources that provide further insights about the usefulness of this focusing method, and a quick Internet search turns up several hyperfocal distance calculators available for free download or inexpensive purchase.

Lens Hoods and Flags

A lens accessory that's indispensable at night to shield the lens from nearby lights is a lens hood. This serves to block flare and can prevent glowing effects or halos from leaking into the edges of the frame. For maximum protection, lens hoods are generally tailored to individual lens models. A proper fit will prevent image vignetting that can occur if the edge of the hood enters the field of view. French flags or compendium bellows are specialty items geared to studio and large-format photography and can also be used in nighttime situations to selectively block a lens from encroaching lights.

Specialty Lenses

There are many lenses available in this category. For example, a perspective control lens adds a touch of large-format adjustments to a 35mm format. With these special optics, a photographer is able to shift the lens up to 11mm horizontally, vertically, or diagonally depending on lens model.

In addition to shift movement, some lens makers offer the possibility to control the plane of focus by tilting the lens plane. Although its primary purpose is to eliminate unwanted converging lines from architectural shots, this type of lens can also be used in digital imaging to produce panoramic composites. Use this technique and type of lens to create a panoramic combining two or more images:

- Shift the lens all the way to one side and make an exposure.
- Without moving the camera or tripod, rotate the lens 180 degrees so that the shift is in the opposite direction. Make a second exposure with the lens in this setting.
- In postproduction, combine the two images in Photoshop CS3 using Photomerge.
- Since the camera remains in the original position and only the lens moves, the images combine easily, and there is no perspective distortion.

Camera Canon 5D **Lens** Canon Tilt Shift TS-E 24mm **ISO** 100 **Aperture** *f*/8 **Exposure** 4 minutes, 10 seconds

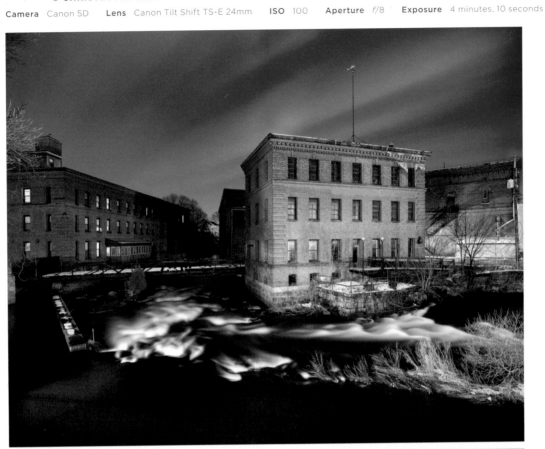

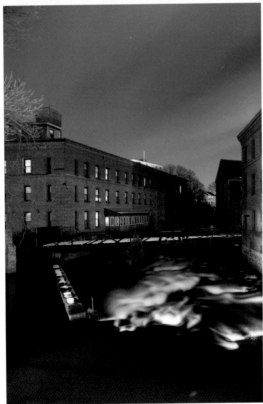

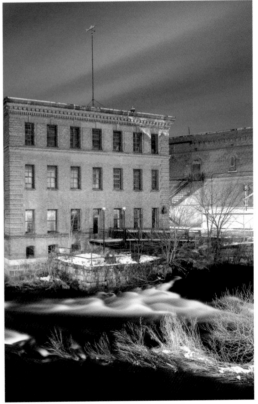

Two adjacent vertical images made with a 24mm architectural shift lens were stitched together in Photoshop to produce this wide panorama. One issue Waeber encountered with this image was the movement of clouds between the left- and the right-hand exposures. A lot of Photoshop blending, smudging, and healing-brush work was needed to make the stitching seamless.

CLEAR FILTERS AND WHEN NOT TO USE THEM

Keeping a clear or ultraviolet filter over the lens is generally considered beneficial to camera care. While this is generally advisable—particularly in situations when the lens may be subject to damage from dust, moisture, or foreign objects—for best results when photographing at night, it is often recommended to remove filters from a lens. Especially when you are photographing light-based activities (such as fireworks or situations in which point-light sources are included in the frame), reflections caught between the surface of the filter and the surface of the lens can result in the lights being multiplied in the image through a ghosting effect, especially with longer lenses. This can be hard to repair and can greatly compromise image quality or even ruin an image, particularly if the situation includes many lights.

Filters

For many years, filters were standard accessories for photographers who needed to balance color film under artificial light. The ability of digital capture to customize color balance both in camera and in postproduction now alleviates the need to carry an extensive set of filters. Yet the potential to neutralize high-contrast conditions and specific color casts caused by artificial lights still make certain filters important items for a night photographer's tool kit.

Color Compensating Filters

Color Compensating (CC) filters come in a wide range of colors and densities, in regular increments from CC05 to CC50. These filters enable precise adjustments to color casts caused by a given light source. Of the six colors of CC filters available, magenta filtration is most useful for night photography. This filter type counters the green spike in the color temperature of high-discharge sodium vapor, mercury vapor, and florescent lamps. The green color cast will show up with all films, but with color negative film it can be adjusted for in printing. With digital capture it can be adjusted in white balancing. The amount of magenta filtration required will vary with the film, lamp types, and age of the lamps. Large-format photographers such as Tom Paiva typically keeps CC20, CC30 and CC40 Magenta filters on hand to correct for color casts from artificial lighting present in nighttime industrial sites.

Neutral-Density Filters

Neutral density (ND) filters are gray-toned filters that block light equally across all wavelengths to reduce illumination in an image and, therefore, increase exposure time. They are available in a range of opacities and can be stacked over a lens, one on top of another. Nighttime effects can be created with a daytime exposure if enough filters are stacked over the lens. Neutral-density filters can also be used to minimize the high-contrast conditions that can be prevalent at night.

Solid filters will block light to the entire image, and split-field types are useful for selectively reducing the light in one portion of the image, either with a soft- or hard-edged effect. They are available in either glass or plastic, with plastic models more prone to the scratching that can subsequently cause flare when hit by direct light. When using ND filters with film, reciprocity issues must be factored into the exposure time through an arithmetic increase based on the quantity and the strength of the filters used.

Stack neutral-density filters in front of the lens to force long exposures during the daytime or to extend nighttime exposures in conditions where lighting is brighter than desired.

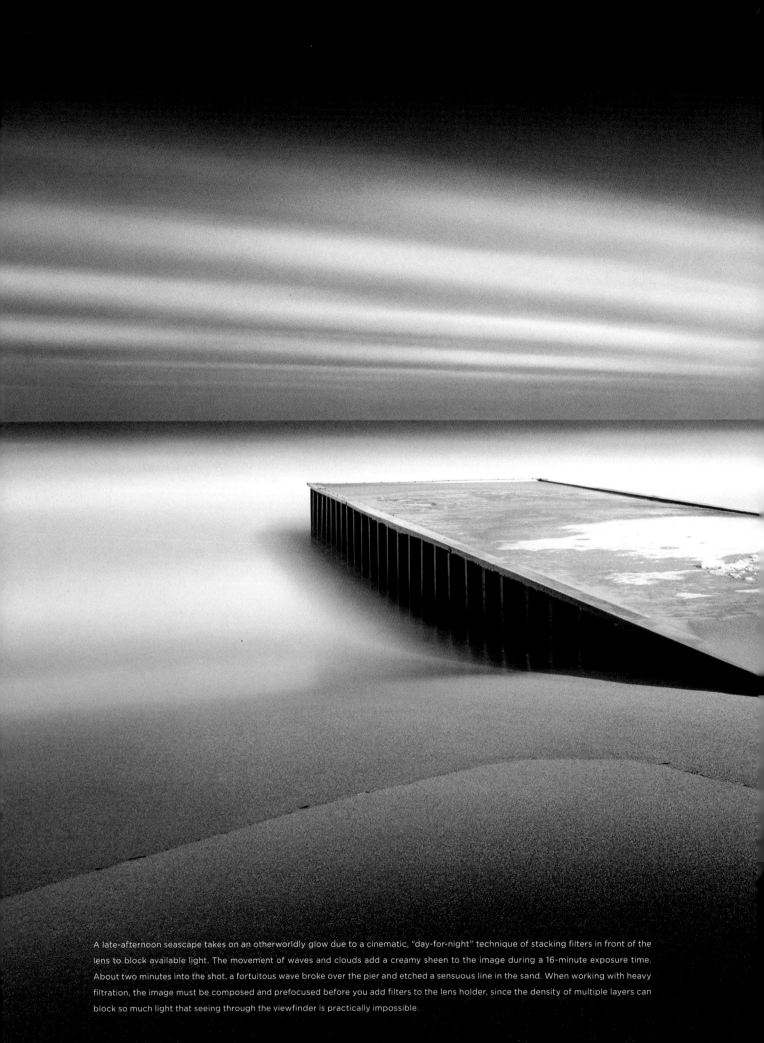

A late-afternoon seascape takes on an otherworldly glow due to a cinematic, "day-for-night" technique of stacking filters in front of the lens to block available light. The movement of waves and clouds add a creamy sheen to the image during a 16-minute exposure time. About two minutes into the shot, a fortuitous wave broke over the pier and etched a sensuous line in the sand. When working with heavy filtration, the image must be composed and prefocused before you add filters to the lens holder, since the density of multiple layers can block so much light that seeing through the viewfinder is practically impossible.

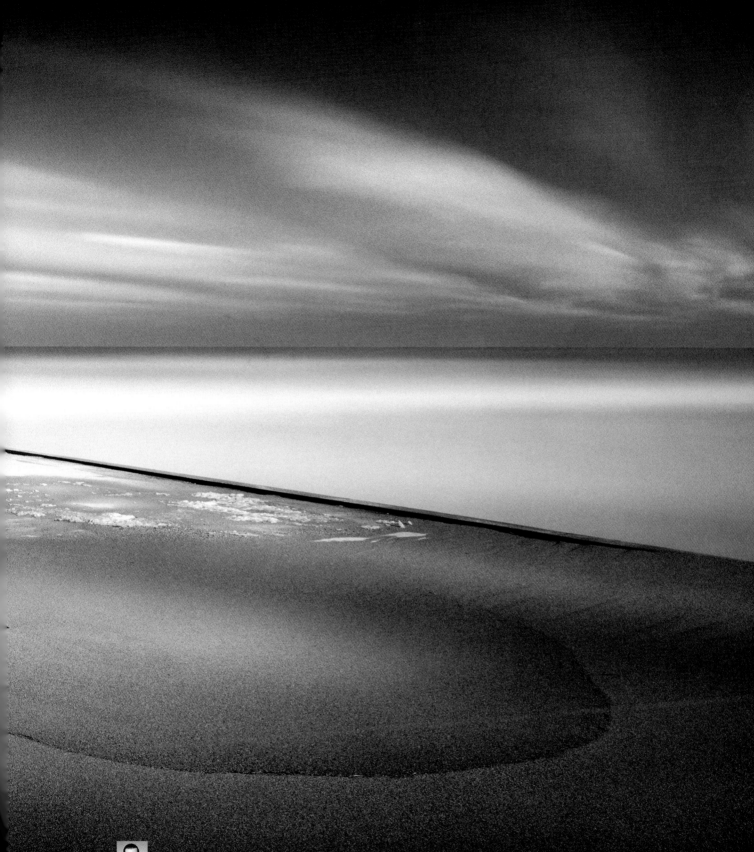

© CHIP FORELLI

Camera Linhof Technika 2000 4x5

Lens 75mm

Filters 6 to 8 stops of neutral-density filters, a polarizer, and an orange filter to boost contrast in the sky

Aperture f/32.5

Exposure 16 minutes

Film T-Max 100

Metering

Metering at night has always been somewhat of a slippery subject. The combination of high-contrast lighting and deep shadows in many nighttime scenes complicates exposures and can make accurate metering an effort of compromise. When taking a meter reading in these conditions, it is best not to include lights in the scene. Metering into point-light sources can trick the meter into thinking that the scene is brighter than it really is and lead to underexposure. Meter around the lights, and then adjust the composition afterward if desired.

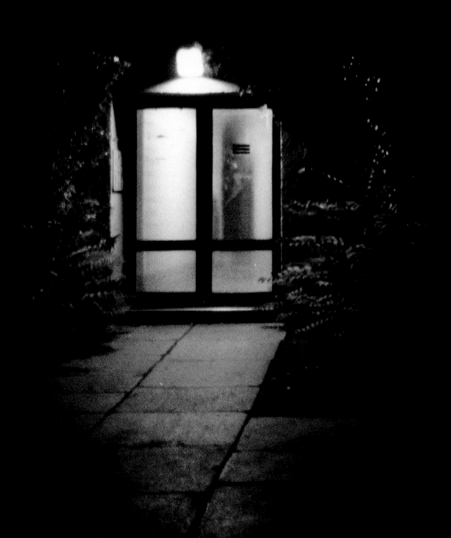

Bracketing

In low-light conditions and when long exposure times make handheld or in-camera meters ineffective, bracketing is an effective method for ensuring that all the exposure values will be captured. This is done by recording a sequence of identical images, extending the exposure time or adjusting the f-stop in regular increments on both sides of a baseline exposure setting. For an image that has a baseline exposure of $f/5.6$ at 15 seconds, one might record a sequence of images with the aperture opened to $f/11$, $f/8$, $f/5.6$, $f/4$, and $f/3.5$. Or, keeping the aperture the same, change the exposure time to record a sequence at 8 seconds, 15 seconds, 30 seconds, 1 minute, and so on.

The flexibility of digital imaging now makes it relatively simple to make exposure adjustments in postproduction, either by using Photoshop Levels and Curves to bring out the most from a single image or by taking the extended range of exposure values from a bracketed sequence and compressing them into a composite using a high-dynamic-range technique.

In-Camera and Handheld Meters

The internal metering capabilities of recent- model DSLRs have given photographers a needed boost in evaluating low-light and nighttime exposures. The sensitivity and accuracy of these internal meters has, to some degree, replaced the need for handheld light meters for digital work.

Still, there are times when a handheld meter is helpful. Of the several different types available, the most useful for working at night and in low light is the spot meter. This meter measures the light reflecting off a subject, which is generally localized to a focused point. In order to get an accurate reading, the tonality of the object must be taken into account. The ideal tone used for metering is 18% gray, which is represented in a Kodak gray card. An alternative to consider in dark situations when the meter has problems reading this low value is to take meter readings from a "white" card. There is typically a 2-stop differential between white and 18% gray, so for an accurate exposure, the settings that result from a white card reading will need to be reduced in the camera settings by 2 stops.

EXPOSURE TIME TESTS WITH HIGH ISO SETTINGS: FORCED CAMERA METERING

An in-camera metering technique that can be useful in low light involves setting the camera's ISO controls to a higher setting to assist in evaluating exposure times. For digital captures, this will allow a test exposure to be made within a much shorter time frame. The resulting image preview and its histogram will be an invaluable reference in the field for working out the optimum exposure and for fine-tuning the image at a longer exposure time. Keep in mind that this method for exposure calculation may result in a test image that suffers from image noise or visual artifacts.

With analog cameras, this technique can also be applied on a limited basis in conjunction with adjusting the aperture to its widest setting. With film capture, this method is effective only if ambient light levels are sufficiently bright to force a reading from the in-camera light meter at the higher settings. Film reciprocity issues will also need to be considered when extrapolating the resulting exposure time.

This is how it works. In a situation when an estimated exposure time of 4 minutes would be needed for an image shot at f/8 and ISO 100, open the lens to the largest aperture, and set the camera to a high ISO reading. In this example, use f/2.8 and ISO 400. For each successive jump on the ISO dial and full stop on the aperture notch, the exposure time will be cut in half.

These are the calculations:

- Shift from ISO 100 to 200: half of 4 minutes = 2 minutes
- Shift from ISO 200 to ISO 400: half of 2 minutes = 1 minute
- Shift from f/8 to f/5.6: half of 1 minute = 30 seconds
- Shift from f/5.6 to f/4: half of 30 seconds = 15 seconds
- Shift from f/4 to f/2.8: half of 15 seconds = 7.5 seconds

By adjusting the camera settings using this type of progression, the time factor can be cut down to a point that allows a digital test shot in a matter of seconds rather than minutes. In all cases, after the exposure test is completed, make sure to reset the aperture and lower the ISO settings or the final exposure will be drastically overexposed.

Tripods

The tripod is one of the most essential accessories for low-light and night photography, and there is a wide array of equipment choices available for every type of situation and at many different price points. Most veteran photographers have tripods on hand in a variety of sizes and models to serve different functions and shooting situations. The factors of stability, weight, range of motion, and ease of operation for releasing and locking the legs, center column, tripod head, and camera mount are primary attributes to be carefully assessed before purchase.

Professional-grade tripods often have detachable heads, and there are two types from which to choose. Individual preference is highly dependent on personal habits and tastes. *Pan/tilt heads* have separate adjustments for horizontal and vertical movements. They allow for adjustment to one axis independently of the other and can be particularly convenient in situations such as architectural shooting. Yet, they can be cumbersome to operate when working in the dark and more difficult to shift from landscape (horizontal) to portrait (vertical) framing. With less expensive pan tilt models, the range of motion can be limited and may not allow a full 360 degrees of traverse.

Ball heads enable the camera movement from one central point and allow faster camera adjustments with a greater range of motion. This type of tripod head is often

preferred by large-format photographers because the range of motion is more fluid and better synced to the swings and tilts of the camera controls. Ball heads are considerably more expensive than pan/tilt models for a comparable quality level.

The tripod head is often the weak point in a setup, especially during long exposures in windy conditions. For best operation, a tripod should suit the weight of the camera gear. This is most important when using a long focal length lens. With long lenses, a second tripod or a lens bracket can be very useful.

Many tripod heads offer a quick-release plate that allows the camera to be rapidly set up and detached. This is an extremely handy feature, and many photographers keep a quick-release plate permanently attached to their camera body. The Arca-Swiss format is a respected standard among quick releases. These are usually manufactured for a specific camera and body combination, which makes them very precise. Another useful accessory for the tripod is a small spirit level. These are sometimes built into the tripod head or center post, and they are used to ensure the camera is horizontal when desired.

Wooden tripods are another option, often favored by photo traditionalists. The heavy weight of wooden models makes them far less practical unless conditions will be corrosive to metal, such as when near the ocean or in a pool of water. One useful recommendation for working with a metal tripod in water or sand is to cover the legs with heavy-duty plastic bags to minimize damage from abrasive particles or corrosion. Careful cleaning and, if necessary, rinsing of the tripod legs in fresh water after such excursions, may also help keep the tripod in good working order.

While the importance of owning a professional-grade tripod cannot be underestimated, alternative support systems also exist to enable successful images when a full-blown tripod is not handy or practical. In recent years, a wide array of minitripods, grips, super clamps, camera pods, and other support systems have entered the photo accessory marketplace and present photographers with more choices and greater flexibility for image-making in the most challenging situations.

Tripod Alternatives

• If exposures are relatively short (1 to 2 seconds) and your camera has automatic programming capabilities, set the program to continuous-shooting mode and make a rapid-fire sequence of handheld exposures. In all likelihood, one of these exposures will be sharper than the rest. This technique is useful in conditions where a tripod will not be effective, like during a sunset cruise on a boat. Under these types of conditions, panning slightly with the camera in the same direction you are moving can sometimes help to maximize sharpness.

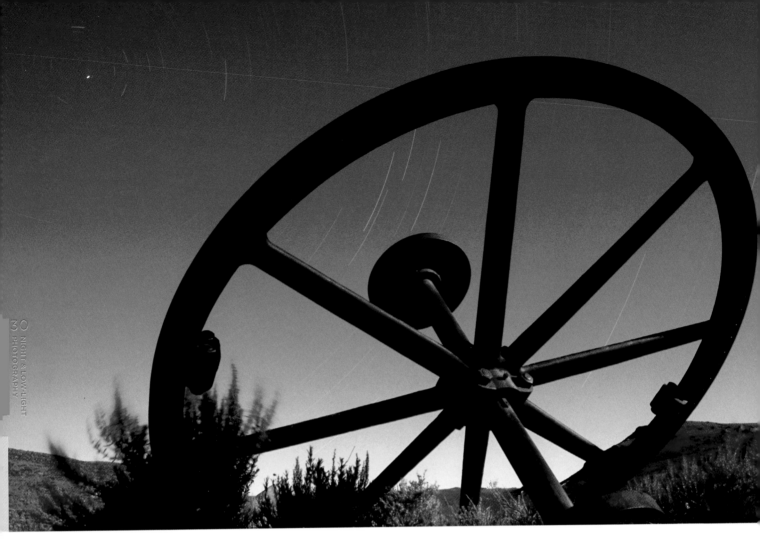

- For exposures that can be metered automatically, use your body as a tripod. Sit on a flat surface, adjust camera settings to automatic, and use the self-timer to trip the shutter.

- Seek out a hard surface to support the camera or lens. The edge of a table, the crook of a tree, fence slats or chain links, even the surface of a car or a camera bag can be put into service as an alternative to a tripod. A piece of clothing placed underneath the camera can be molded to suit the desired angle of view. Adding a small object, like a wallet or film canister under the lens, can also help to stabilize the setup.

- If there's a pane of glass between you and your subject, you can stabilize the camera by placing the lens flush against the surface of the glass. Cup your hand around the end of the lens barrel to provide extra support and to shield reflections that may occur if the lens isn't totally flush with the surface. A rubber lens shade or a dark cloth wrapped around the lens can provide a handy shield for light leaks as well as for cutting vibrations.

- Use the ground as a tripod and place your camera pointing upward to get dramatic views of the night sky. Place a towel or protective sheet under the camera to shield it from dirt and moisture.

CABLE RELEASES AND ALTERNATIVE MEASURES

A cable release provides a valuable intermediary between your body and the camera's mechanics. But, there are some alternate methods:

- Use the camera's self-timer system to automatically trigger the shutter. This is an option for exposures up to at least 30 seconds on most cameras. If the viewfinder is left exposed when using a self-timer and automatic metering, pay close attention to the possibility of light entering through the eyepiece. A bright light could fool the metering system and lead to underexposure. Some cameras have eyepiece shields to prevent this from occurring.

- Use the camera's mirror lock-up function in conditions when assessing the scene through the viewfinder or when precise control of the capture time frame is not critical. The mirror lock-up is generally effective for controlling camera shake during exposures that range from approximately 1/4 second to a few seconds in length. During shorter or longer exposures, mirror vibration isn't a significant cause of reduced image sharpness.

- Remote timer, radio, or infrared releases can also be used to trigger a camera's shutter. Although costly, they are often employed by pros in situations when it is advantageous to be positioned away from the camera.

Lighting Accessories

Good lighting tools are indispensable for night photography. Their diverse functions range from the handy beam of a penlight to illuminate camera controls in extreme darkness to use as a focusing aid when pinpointing an object in a darkened space to the power of supplemental lighting from a spotlight or strobe to control contrast or incorporate creative lighting effects in a scene.

Any flashlight or lighting device can be useful in nighttime conditions, but for creative effects such as light painting (see page 106), it's important to choose gear for intensity, quality of illumination, and battery life. Companies that specialize in lighting for police, military, or nautical purposes manufacture lighting tools that provide superior illumination for serious use in the field.

When doing extensive light-painting work, consider the balance between power and portability. Portable, rechargeable spotlights come in a variety of strengths and are readily available in the automotive or outdoor departments of major department stores. Spotlights in the 1-to-2-million-candlepower range will provide good power while not being too heavy to carry and hold for an extended period. Lights are available from many different manufacturers and each brand will have a slightly different color cast.

!

When you're caught in the field without a flashlight or other light to check camera settings, the light from a cell phone can provide sufficient illumination to work in the dark.

A SAMPLING OF DEVICES

- Brinkman Q beam spotlights are a popular option for light-painting work. These lights can sometimes be found in a package that includes the light, rechargeable batteries, and primary-colored filters that clamp across the front for gelled lighting effects.
- Inova LED flashlights are long lasting tactical lights when used with lithium batteries. These lights offer the choice of a momentary ON/OFF switch or a constant stream of light and the LED is less subject to breakage that an incandescent bulb.
- Surefire flashlights are powerful, compact lighting devices available in either LED or incandescent Xenon types. These lights also have accessory colored filters useful for gelled lighting and a removable diffuser for lighting effects with a very soft touch.
- Marine spotlights, available from nautical suppliers, cast a very blue, cool light and are said to penetrate fog. This can be useful for illuminating the subject with a cool, bluish cast without needing to add the time that would be required when using a gel. When filters and gels are applied to a camera lens or in front of a light, this cuts down on the intensity of the light and extra time needs to be added to the shot.
- The Streamlight stylus is a miniature light that is the size of a ballpoint pen, which works extremely well for detailed work. These come in a variety of colors and have a little snoot on the front to help direct the light toward the object.
- Laser pointers emit a powerful LED point light source. These ballpoint pen–sized lights are available in colors of red, green, or blue and are readily available online. The stream of light generated from these sources is extremely powerful, and they should be used with care because they could cause momentary blindness if they are directed into someone's eyes.
- Another consideration for soft-fill light in nighttime images is to use miniature reflectors in tandem with a flashlight. This can add imperceptibly to an image and is especially useful to make the printing easier when applied to dark shadow areas.

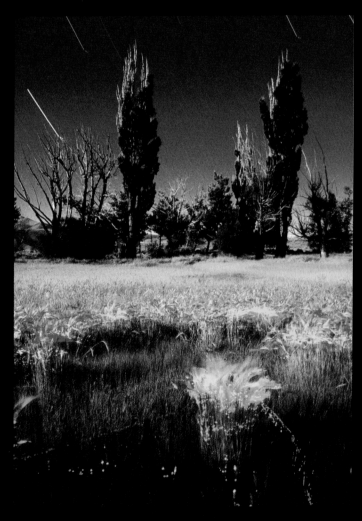

© JILL WATERMAN

Camera	Nikon F3HP
Lens	Nikkor 28mm, 1:2.8
Aperture	about f/16
Exposure	30 minutes
Film	Fujichrome Velvia 100
Lighting	red and green laser pointers in foreground

Penlight laser pointers emit an intense stream of colored light that makes an extremely precise tool for light painting. These implements should be pointed with caution, since the high-powered light carries for great distances and can be disturbing to others, whether they be other photographers aware of your presence or ordinary citizens who could be startled by the bright light.

Creature Comforts

For both safety and comfort, there are several important additions to photographic gear that should be considered before planning an extended nighttime shoot. Proper wardrobe is a key concern, since plunging temperatures or sudden weather inversions can quickly turn an enjoyable evening into an endurance test for the unprepared, even in temperate climates. A sufficient power supply and reliable transport are other vital necessities when working at night. And items like changing bags and shooting tents can be invaluable assets for protecting equipment when out in the elements.

Dress for Success

When shooting for prolonged periods at night, especially in inclement weather or cold conditions, creature comforts must be carefully considered. Iceland-based photographer Ragnar Th. Sigurdsson specializes in photographing in low-light conditions and cold climates. The photographic exploration of such extreme conditions can be exhilarating, but he is pragmatic about the critical importance of advance preparation in order to stay safe and warm in the cold and dark. In cold weather, Sigurdsson recommends dressing with four to five times more clothing than usual to provide proper insulation against the elements while standing still and not generating internal heat. Rather than a specific piece of photographic gear, Sigurdsson's most valued accessories for night photography are his warm boots.

Automotive Base Camp

As extreme in his choice of equipment as the conditions in which he works, Sigurdsson went to great time and expense to have his vehicle customized so that he could use it as a base of operations for extensive periods during the long dark winters of the Arctic North. Added features include custom openings that allow him to shoot from inside the vehicle when conditions require it and a generator-powered electrical supply for running computers and camera gear.

When working at night and traveling in a vehicle with a hatchback, position the car pointed into the wind, set up your camera behind it, and open the back to provide a wind block or shield from rain and the elements. This will also provide a clean work area and cozy seat to use as a base.

© RAGNAR TH. SIGURDSSON/ARCTIC-IMAGES

Camera	Mamiya 7 6x7		Exposure	5 – 10 minutes
Lens	55mm		Film	Fuji negative film
Aperture	f/8			

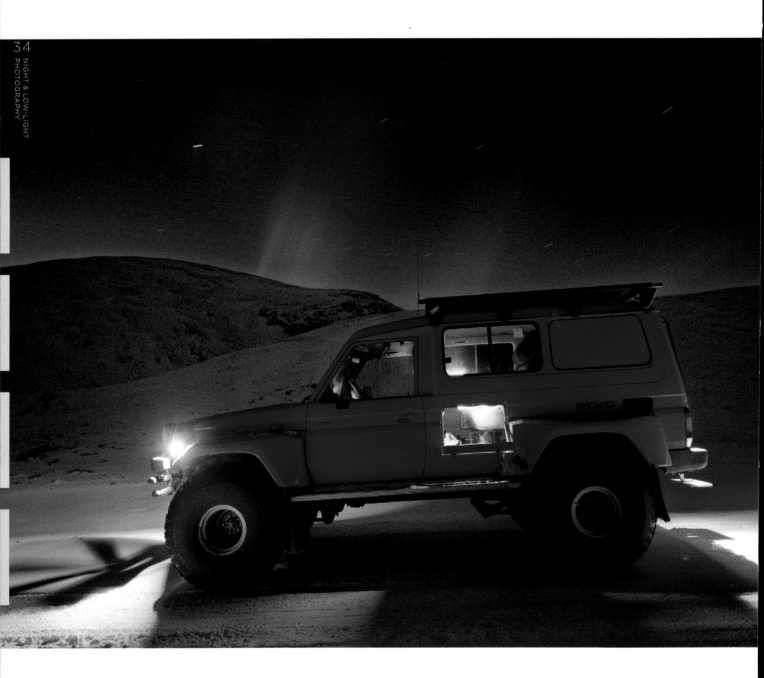

To keep himself warm, dry, and fully powered in the Arctic North, Ragnar Th. Sigurdsson works out of a customized military Land Cruiser that has a generator to produce 220 volts of AC current, the European standard for electricity. Working from this base, he can recharge all his gear, run computers, and live for days at a time. The vehicle has a diesel engine with a 300-liter tank.

© **JIM REED**

Camera	Nikon D100 with MC-20 remote trigger release	**Lens**	14mm f/2.8D Nikkor
ISO	400	**Aperture**	f/4.5
		Exposure	2.9 seconds

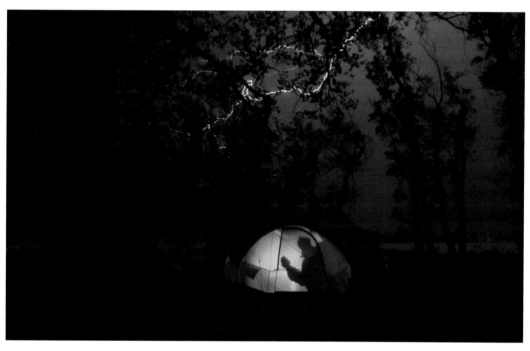

Power Packs

In addition to being prepared with sufficient insulation for one's body to function, photographers working in extreme cold need to pack an excess of batteries for cameras and other electronic items, because cold weather eclipses battery power at a very quick pace. Power inverters and external battery packs can be very useful here. One option, an external pack called the Digital Camera Battery, is designed to provide an extended power supply to both cameras and lights.

Shooting Tents

Often known as an accessory for photographing tabletop objects in the studio, shooting tents are also available for outdoor photographers. With a tall conical shape that's more compact than a regular tent, these items are highly portable and easily assembled to enclose the photographer and camera and offer protection from the elements.

During a storm-chasing trip in northern Nebraska, Jim Reed and his chase partner were awakened in their tent by an approaching storm in the middle of the night. Grabbing his gear, Reed headed outside to record the storm, while his partner stayed inside and consulted a Storm Hawk weather-tracking device. They were prepared to move to a nearby vehicle, rather than stay beneath overhanging trees, but the lightning was short-lived.

A transition from sunset sky to night lighting becomes a colorful canvas for an industrial view shot on daylight-balanced transparency film with no added filtration. Tom Paiva previsualized the colors that would be created in juxtaposing the twilight against the heavy mercury-vapor lighting of this ship-loader conveyor belt and the sodium-vapor lamps on the concrete support structure.

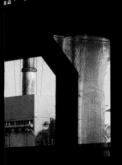

Color of Night 2

To the uninitiated, the night may seem lacking in color and tone, but when a nocturnal scene is recorded on film or digital media, a wide spectrum of colors can assert themselves in a range that pits photographic materials against the color temperatures of the Kelvin scale. Controlling these forces to make the scene conform to how one wants, or needs, the image to appear in the final result takes a fine eye for detail, careful planning, and accurate measurement of the elements in the frame.

© **TOM PAIVA**

Camera	Toyo G 4×5 monorail
Lens	210mm
Aperture	f/16
Exposure	15 seconds
Film	Fujichrome Provia 100F

White tanks illuminated by lamps of varied color temperatures make this combined-lighting situation impossible to balance. Tom Paiva used daylight film and filtered the lens with a CC30 magenta filter to neutralize the background mercury-vapor lamps that otherwise would have been green. The foreground tanks, lit by sodium vapor lamps, shifted even warmer than normal due to the combination of color temperature, filtration, and film.

Color Temperature

Night photography often requires working in conditions with great amounts of artificial light present, either directly in the scene or ambient in the atmosphere. Light pollution from street lighting, vehicles in transit, illuminated buildings, as well as other sources that are miles away can all spread through the night sky and show up as an element or color cast in photographs. Even in situations like a rural landscape lit by the full moon, illumination from distant artificial sources may be looming on the horizon or reflected through the air by low cloud cover or humidity in the atmosphere.

The manner in which light is rendered as color is known as *color temperature*. Every light source has a specific color temperature that is measured in units called *degrees Kelvin*. Light recorded in a scene may vary widely across a spectrum of colors. This is influenced by the color temperature of the light sources and by camera settings or the photographic materials used.

The Kelvin Scale

The Kelvin scale has a wide spectrum that, for general photography purposes, covers roughly 10,000 degrees. Light measured at the low end of the Kelvin scale (roughly 2,000 K to 4,000 K) has a warm cast, such as the morning sunrise, an incandescent bulb, or a candle flame. Measurements at the high end (roughly 7,000 K and above) have a cool cast, such as a cloudy sky, the outside shade, the illumination from certain types of artificial lighting, or a TV screen. The color temperature for daylight falls in the middle of the range, at roughly 5,000 to 6,000 degrees Kelvin. With analog photography, color temperature is balanced by the selection of film type and the use of color correction filters to neutralize color casts. A discussion of this appears on page 48.

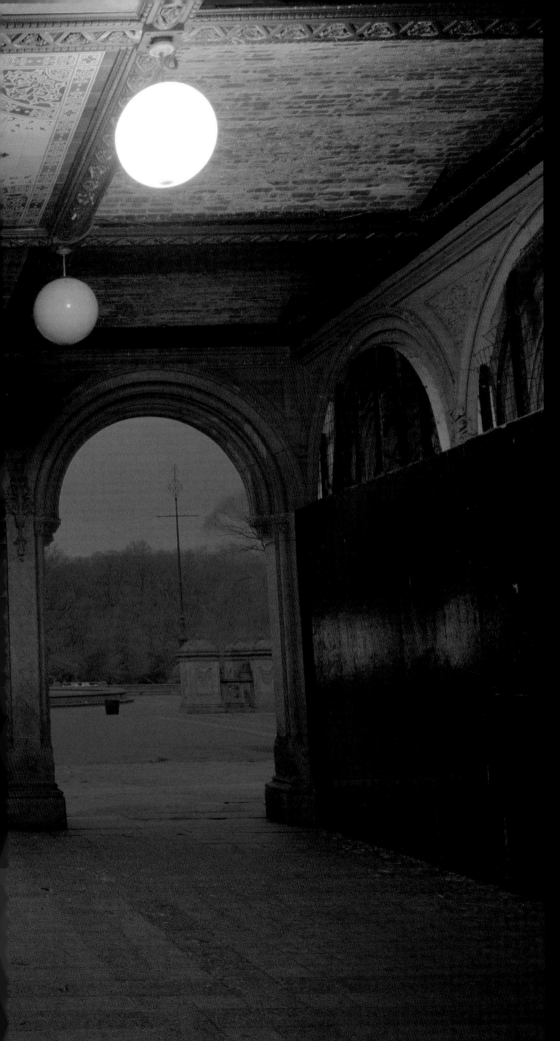

The cool blue of early twilight creates a dramatic contrast against the warm sodium vapor lighting inside the vestibule of the Bethesda Fountain in New York's Central Park. This marked contrast makes this image particularly challenging to print. After many attempts to print this in the darkroom with a C-print process, Saville opted to have the negative scanned and output digitally, because this allowed greater subtlety in balancing the interior and exterior lighting.

© LYNN SAVILLE

Camera Fujifilm 6x4.5
Lens 45mm
Aperture f/16
Exposure 5 seconds
Film Fujicolor NPH 400

light sources in a mixed lighting situation can help to identify the contrasting color casts of warm sodium-vapor and cool mercury-vapor lamps.

TYPES OF ARTIFICIAL LIGHTING

Artificial lighting comes in many types, and each will display a slightly different color cast in a photograph. Some types—such as incandescent, mercury vapor, and metal halide—are full spectrum lights. These produce a much more evenly distributed color range and are easier to color correct in an image. Other types—such as sodium vapor, florescent, and neon—are monochromatic lights. When correcting for color casts caused by these types of lights, the nature of the light source will produce an image that appears neutral yet monochromatic or dull.

The type of light, its strength, and even its age play a factor in how the lighting will record in an image. The most common types of artificial lighting and their general characteristics are BELOW:

- Incandescent lighting, often seen in home interior situations, uses tungsten or halogen bulbs. The color shifts are highly dependant on the specific type and age of the bulb.
- Tungsten lighting can cause a warm color shift in images, which tends to get warmer as the bulb ages.
- Halogen lighting is often color corrected to daylight and can, therefore, display a relatively neutral tonality in images.
- Sodium-vapor lighting, typically used for street lights and industrial lighting, has a yellow color cast to the eye and often causes a yellow-green color shift in images.
- Mercury-vapor lighting, also often used for street lights and industrial lighting, appears cooler to the eye and often causes a cyan-green color cast in images.
- Metal halide lighting is seen in large public venues, such as stadiums, ballparks, and parking lots, as well as in industrial settings. This lighting closely resembles mercury vapor and often causes a bluish color cast in images.
- Florescent lighting is found in a wide range of locations, from home to office to industrial settings. Compact florescent lighting is popular as an energy-efficient light source and is often used as a replacement for incandescent lights. Florescent lights come in many types that have different color temperatures. This lighting often causes varying degrees of a greenish color cast in images.
- Neon lighting is typically used in advertising signage and specialty displays of different colors. Colored neon lights will tend to cause an image to have a strong overall color cast that's not easily neutralized except by converting the image to black and white.
- LED lighting is becoming common as accent lighting in limited interior and exterior settings. It can have varied color casts but can typically be photographed successfully using daylight film.
- Xenon lighting is sometimes used for car headlamps or industrial purposes. It appears cool white to the eye and often causes a blue color cast in images.

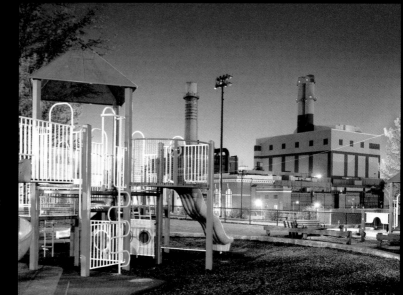

© **CHRISTIAN WAEBER**

Camera Ebony Wide 45
Lens Rodenstock Grandagon 90mm, 1:4.5
Aperture f/11
Exposure 3 to 4 minutes
Film Fujicolor NPH 400

Mercury vapor lights on the playground resulted in a strong green color cast in the foreground while sodium-vapor lamps illuminated the background factory with a contrasting warm color cast. An overall neutral color balance would have been impossible to achieve in a situation with this degree of mixed lighting, so Christian Waeber opted to neutralize the green cast in the foreground by filtration with the complementary

© DARYL-ANN SAUNDERS

Camera	Olympus IS-3 SLR
Lens	Integrated 35–180mm, 1:5.6 zoom
Aperture	f/22
Exposure	between 4 seconds and 1 minute
Film	Fujicolor NPZ 800

The metallic surfaces of a New York subway platform become a rich canvas for extreme color casts from multiple light sources. Rather than trying to neutralize the color shifts, Daryl-Ann Saunders works with a high-speed negative film that heightens the color palette and adds to the surreal look of these environments.

Heightening the Effect of Mixed Lighting

Mixed lighting can be impossible to correct. Instead of neutralizing color casts, it may be advantageous to consider the other extreme: exaggerating color casts and adding contrast to lights. In these conditions a high-speed film will intensify colors and boost contrast to balance garish lighting with added grain and rich blacks.

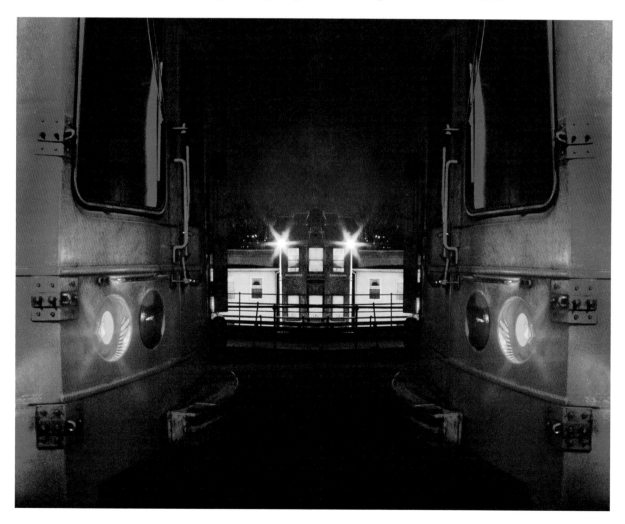

The reciprocity failure inherent in film often requires using much longer exposures in low light with film-based cameras than exposures made with digital cameras under the same conditions.

© JILL WATERMAN

Camera	Nikon FE
Lens	50mm
Aperture	f/8
Exposure	1 hour
Film	Fujichrome Velvia 50

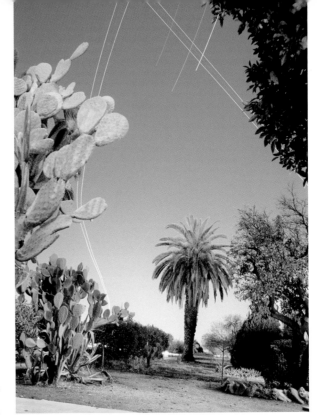

Reciprocity Failure

As a general photographic term, *reciprocity* refers to the relationship between different settings for aperture and shutter speed that will result in an identical exposure. During regular daytime operation and pointed at the same subject, a camera set at *f*/5.6 and 1/125 second will produce an image that looks the same as a camera set at *f*/16 and 1/15 second, ignoring issues of depth of field and parallax. However, as light levels fade and exposure times lengthen, this relationship breaks down. The light that hits the film emulsion isn't sufficient to cause a reaction on the film within a normal time frame. This phenomenon is known as *reciprocity failure.*

When this occurs, the time required for film to expose a scene properly begins to increase exponentially. Metered exposure times need to be interpreted differently. Color shifts begin to occur with certain films. As can be seen from the charts on page 51, each film has a different compensation rate for reciprocity failure and is influenced by these conditions in a different manner. Newer films—such as Kodak T-grain black-and-white, Fuji Neopan Acros black-and-white, and Fuji Provia 100F color-transparency film—exhibit much less reciprocity failure than films made with older technology. With these newer films, normal performance can extend to exposures that are several minutes in length. But with older films, a 1-second exposure is generally considered the duration at which reciprocity failure can begin to affect normal behavior.

Reciprocity failure is strictly a film-based issue. Digital low-light and nighttime photography will continue to benefit from a consistent relationship between camera settings and exposure time.

While reciprocity failure is considered by many to be a limiting factor for accurate results, it is possible to apply the rules of this phenomenon for creative effect. The reciprocity failure of certain films allows the exposure time to slow to such a degree that photographs lasting several hours in duration are not uncommon. Although the resulting images are never predictable, these types of experiments can often have surprising effects and can produce photographs that are distinct from images made under more controlled circumstances. ▪

The limited light in this situation dictated a long exposure time to counter the reciprocity failure of the film. Overall low contrast allowed the exposure to build slowly and evenly throughout the scene. Ambient light and color shifting during the exposure turned the sky a bright turquoise. The complementary patterns made by passing airplane lights could never have been predicted.

RECIPROCITY CHARTS

The following charts, furnished by Tim Baskerville, Kit Courter, and Chip Forelli, provide general guidelines for troubleshooting the reciprocity failure exhibited by a number of different films. As with any exposure charts of this type, this information is merely a beginning guide. Long-exposure night photography is extremely situational, and results will vary greatly between different shoot situations or even the same location from one night to the next.

T-Max 100 Roll or Sheet film

Indicated Exposure Time	Corrected Exposure Time
1 second	2 1/2 seconds
5 seconds	7 seconds
10 seconds	15 seconds
15 seconds	24 seconds
20 seconds	33 seconds
30 seconds	50 seconds
1 minute	2 minutes
2 minutes	4 1/2 minutes
4 minutes	10 minutes
10 minutes	28 minutes
20 minutes	1 hour 5 minutes
1 hour	1 hour 50 minutes

Tri-X 400 Roll Film

Indicated Exposure Time	Corrected Exposure Time
1 second	1 1/2 seconds
2 seconds	4 seconds
3 seconds	7 1/2 seconds
4 seconds	12 seconds
7 seconds	28 seconds
10 seconds	50 seconds
15 seconds	1 minute 35 seconds
20 seconds	2 minutes
30 seconds	3 1/2 minutes
40 seconds	4 minutes 40 seconds
1 minute	8 minutes
1 minute 20 seconds	10 minutes 40 seconds
2 minutes	18 minutes
3 minutes	25 minutes
4 minutes	40 minutes
6 minutes	1 hour
8 minutes	1 hour 38 minutes
10 minutes	2 hours
15 minutes	3 hours 20 minutes
20 minutes	4 hours
30 minutes	6 1/2 hours
40 minutes	8 hours
1 hour	12 1/2 hours

Tri-X 400 Sheet Film

Indicated Exposure Time	Corrected Exposure Time
2 seconds	3 seconds
5 seconds	8 seconds
10 seconds	18 seconds
15 seconds	30 seconds
20 seconds	45 seconds
30 seconds	1 minute 15 seconds
1 minute	3 minutes
2 minutes	7 minutes
4 minutes	16 minutes
10 minutes	50 minutes
20 minutes	2 hours 20 minutes
30 minutes	4 hours

Ilford HP5 (400), Ilford FP4 (125)

Indicated Exposure Time	Corrected Exposure Time
5 seconds	13 seconds
10 seconds	31 seconds
15 seconds	55 seconds
20 seconds	1 minute 23 seconds
25 seconds	1 minute 57 seconds
30 seconds	2 minutes 35 seconds
1 minute	7 minutes 8 seconds
2 minutes	17 minutes 21 seconds
4 minutes	36 minutes
6 minutes	55 minutes
10 minutes	1 hour 32 minutes
20 minutes	3 hours
1 hour	9 hours 20 minutes

Fuji Velvia 50, Fuji 64T

Indicated Exposure Time	Corrected Exposure Time
4 seconds	5 seconds
8 seconds	12 seconds
10 seconds	16 seconds
16 seconds	28 seconds
20 seconds	39 seconds
30 seconds	1 minute
40 seconds	1 minute 28 seconds
1 minute	2 1/2 minutes
2 minutes	4 minutes 50 seconds
4 minutes	10 minutes
6 minutes	15 minutes
10 minutes	25 minutes
15 minutes	37 minutes
20 minutes	50 minutes
30 minutes	1 hour 14 minutes
1 hour	2 1/2 hours

Kodak 160 Tungsten

Indicated Exposure Time	Corrected Exposure Time
4 seconds	5 seconds
8 seconds	12 seconds
16 seconds	26 seconds
30 seconds	54 seconds
1 minute	2 minutes 6 seconds
1 1/2 minutes	3 minutes 26 seconds
2 minutes	5 minutes
3 minutes	8 minutes
4 minutes	11 minutes 22 seconds
6 minutes	18 minutes 39 seconds
8 minutes	26 minutes 29 seconds
12 minutes	43 minutes
16 minutes	1 hour
30 minutes	2 hours
1 hour	3 hours 50 minutes

The level of detail contained in the deep shadows and the contrast in the glass blocks embedded in the ground are what make this image special. Although the light source is around the corner and hidden from view, Lance Keimig noticed that the glass reflected more light where it was in shadow, so he composed the image to include both areas in the frame. Only one negative was shot, and the film was processed normally in T-Max developer. A keen awareness of the delicate lighting, plus a bit of luck in judging both exposure and development, made this shot a success.

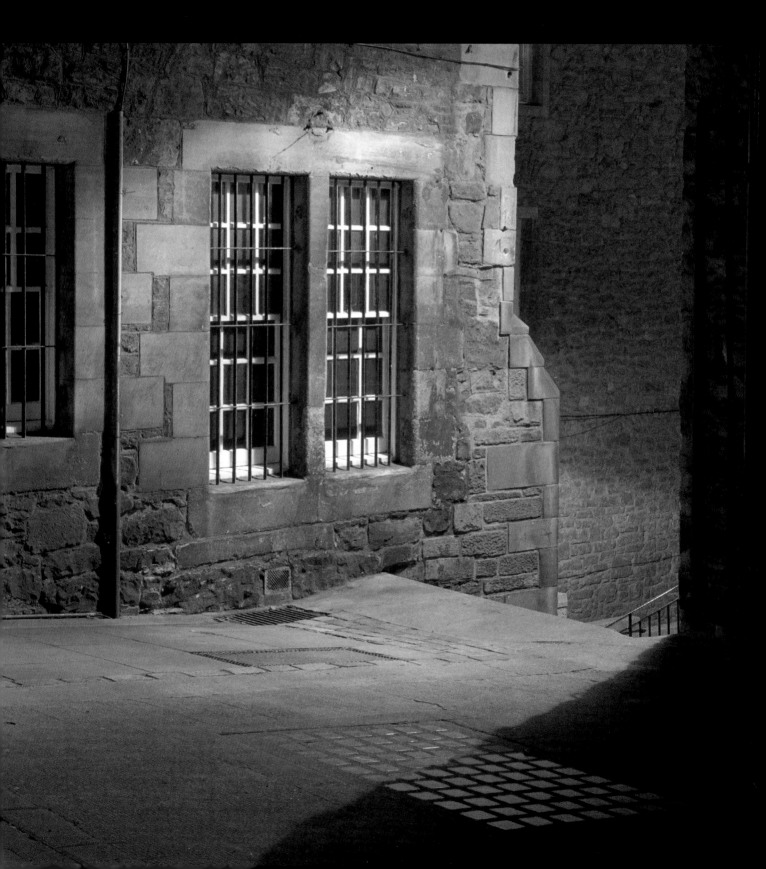

3

Black And White At Night With Film

The first and most daunting question every photographer asks when he or she encounters a nighttime subject is: How long should the exposure be? Traditional exposure grids can provide a starting point, and the advances in digital metering sensors—both in the camera and through high-end external meters—have greatly improved methods for accurately calculating exposure in low-light and nighttime settings. Yet, to be totally honest, the answer to the dreaded exposure question is always both heavily situational and highly subjective. A wide range of variables need to be considered in order to determine the best estimate for any desired outcome. One piece of common wisdom to consider is this: There are no bad exposures at night, only different ones.

LANCE KEIMIG AND CHIP FORELLI:
NIGHTTIME EXPOSURE GUIDELINES FOR FILM
The exposure guidelines that follow are teaching tools used by Lance Keimig and Chip Forelli, both of whom are highly experienced instructors of night photography workshops. As one may note by comparing the divergence between the two lists, these settings are merely a rough starting point. When shooting at night, the best results can often be had not by consulting a list but by going with what feels right. Unless otherwise noted all times are for an aperture of $f/8$. In all cases, for snow scenes, cut exposures in half!

Integrated Exposure and Development

For film photographers who desire rich tonality, a full range of contrast, and control of how their negatives will look, the adoption of an integrated system for exposure and development cannot be stressed strongly enough. This is an important consideration for all situations, both day and night, but the added variables of long exposure times and inherent high contrast common to nighttime subjects make it ever more important to consider film exposure and development as interdependent parts. This section profiles the methods of two photographers who have refined an integrated approach to exposure and development that coaxes the most from their film. To follow the exposure methods of one system and the development procedures of another will yield much less effective results. Their exposure charts are provided first, followed by a discussion of their techniques.

Given this base, it is still crucial to accept the fact that parameters for shooting at night are highly subjective and are best based upon the personal vision and tastes of the individual photographer. Experimentation is key, because there's no one firm and easy answer to what exposure time will work best. Bracketing within a range of exposure times and camera settings is also a must. Making notes in the field to document this process is a great learning tool that can serve in the development of personal vision, as well.

Exposure with Fuji Neopan Acros and Development with Diafine

Since he first started shooting at night in the late 1980s, Lance Keimig has experimented with different techniques for development of black-and-white film to find an ideal solution to the contrast issues that night photography entails. Although he often works digitally for commercial clients, Keimig prefers a medium-format film camera for his black-and-white, fine-art night photography. He is a firm believer that film exposure, development, and the creation of the print are all interconnected and uses modified

The adage "Expose for the shadows and develop for the highlights" is never more appropriate than when working with film at night when the brightness range between shadows and highlights may be 15 stops or more. Put lots of exposure on the film to make sure the information is recorded, and then control the development in one way or another to limit contrast. Of course, extreme highlight overexposure is an insurmountable problem, so most of the time, it's best to minimize light sources in the frame.

Street Scenes, Urban Areas: Average Brightness, High-Contrast Lighting* *Try metering first.

Keimig Guidelines	Forelli Guidelines
ISO 64/100 EPY, RTP, TMX, Delta 100: 15 seconds, 30 seconds, 1 minute	ASA 64 EPY, RTP: 5 seconds, 10 seconds, 20 seconds
No data	ASA 100 Acros B&W: 3 seconds, 6 seconds, 15 seconds
ISO 160 NPS, NPL, Portra: 30 seconds, 1 minute, 2 minutes	ASA 160 pro color negative: 5 to 10 seconds
ISO 400 HP5, Tri-X, color negative: 10 seconds, 20 seconds, 45 seconds	ASA 400 pro color negative: 3 to 10 seconds
ISO 400 TMY, Delta 400: 5 seconds, 10 seconds, 20 seconds	No data
No data	ASA 800 pro color negative: 2 to 6 seconds
ISO 3200 (rated at 1600): 1 second, 2 seconds, 4 seconds	ASA 3200 (rated at 1600): 1/2 second, 1 second, 2 seconds at f/4

Street Scenes, Urban Areas: Bright Lights in Scene, Very High-Contrast Lighting

Keimig Guidelines	Forelli Guidelines
ISO 64/100 EPY, TMX, Delta 100: 5 seconds, 10 seconds, 20 seconds	ASA 64 EPY, RTP: 2 seconds, 4 seconds, 10 seconds
No data	ASA 100 Acros: 1 second, 3 second, 10 seconds
ISO 160 NPS, NPL, Portra: 10 seconds, 20 seconds, 45 seconds	ASA 160 pro color negative: 2 seconds, 8 seconds
ASA 400 pro color negative: 1 second, 5 seconds	ISO 400 HP5, Tri-X, color negative: 4 seconds, 8 seconds, 15 seconds
ISO 400 TMY, Delta 400: 1 second, 2 seconds, 4 seconds	No data
No data	ASA 800 pro color negative: 1/2 second to 2 seconds
ISO 3200 (rated at 1600): 1/2 second, 1 second, 2 seconds	ASA 3200 (rated at 1600): 1/25 second, 1/2 second, 1 second at f/4

Darker Urban Area, No Direct Light

Keimig Guidelines	Forelli Guidelines
ASA 64 EPY, RTP: 3 minutes, 5 minutes, 10 minutes	ISO 64/100 EPY, RTP, TMX, Delta 100: 2 minutes, 4 minutes, 8 minutes
ASA 100 Acros: 1 minute, 3 minutes, 10 minutes	No data
ASA 160 pro color negative: 1 minute, 2 minutes, 5 minutes	ISO 160 NPS, NPL, Portra: 3 minutes, 6 minutes, 12 minutes
ASA 400 pro color negative: 30 seconds to 3 minutes	ISO 400 HP5, Tri-X, color negative: 2 minutes, 4 minutes, 8 minutes
No data	ISO 400 TMY, Delta 400: 30 seconds, 1 minute, 2 minutes
ASA 800 Portra, NPZ: 30 seconds to 2 minutes	No data
ASA 3200 (rated at 1600): 2 seconds, 4 seconds, 10 seconds at f/4	ISO 3200 (rated at 1600): 4 seconds, 8 seconds, 15 seconds

Moonlight

Keimig Guidelines	Forelli Guidelines
ASA 64 EPY, RTP: 20 to 30 minutes	ISO 64/100 EPY, RTP, TMX, Delta 100: 20 to 30 minutes
ASA 100 Acros: 10 to 15 minutes	No data
ASA 160 pro color negative: 8 to 12 minutes	ISO 160 NPS, NPL, Portra: 15 to 20 minutes
No data	ISO 400 HP5, Tri-X: 15 to 20 minutes
ASA 400 pro color negative: 5 to 10 minutes	ISO 400 color negative: 10 to 15 minutes
No data	ISO 400 TMY, Delta 400: 5 to 10 minutes

© LANCE KEIMIG

Camera	Hasselblad 500C/M
Lens	50mm Distagon lens
Aperture	f/11
Exposure	25 minutes
Film	Ilford Delta 400

In this detailed view of an industrial mining winch at Bodie ghost town, a full moon rising low in the southeast backlights the winch and lightens the sky along the ridgeline. Lance Keimig placed the moon behind the winch to keep the contrast down and used a flashlight bounced off a collapsible reflector disk to soften dark foreground shadows to further reduce contrast.

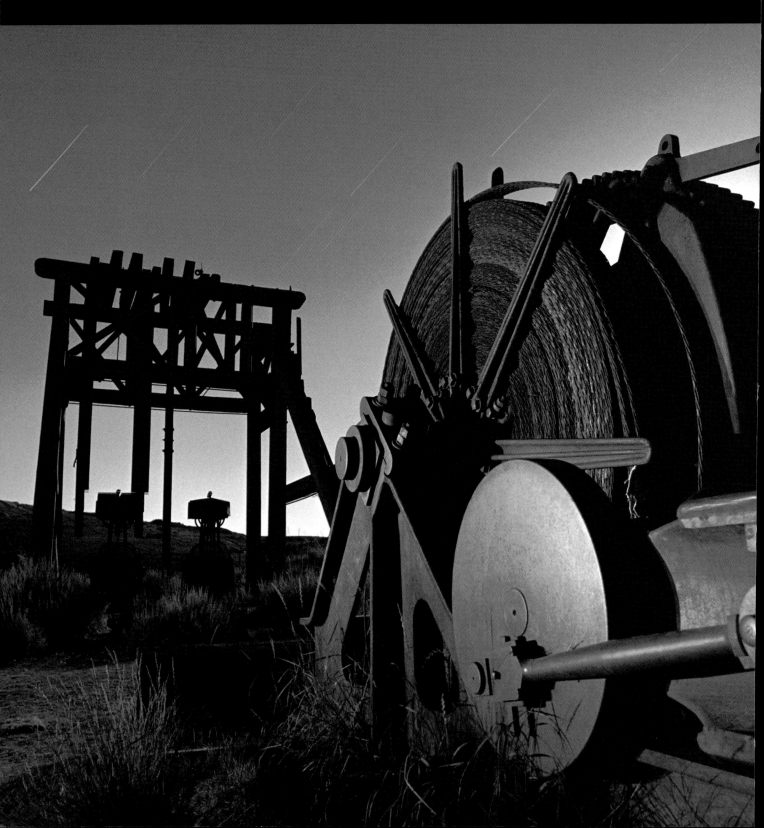

Zone system techniques to produce images with limited contrast and maximum detail in both shadows and highlights.

After working with many different emulsions, he settled on 100 ISO Fuji Neopan Acros developed in Diafine because of its fine grain, excellent reciprocity characteristics, and transparent film base. The only disadvantage to this film is the thin film base that can buckle or "pop" in the negative carrier under the heat of a condenser enlarger. Keimig uses the following printing technique to prevent buckling and to avoid a compromise in print sharpness:

- Tape all four sides of the negative to the negative carrier before placing it in the enlarger.
- Once the film and carrier are in the enlarger, preheat the assembly for 30 seconds or more.
- Refocus the image and adjust the lens aperture to the desired setting.
- With the enlarger still on, put a cap on the lens to block the light from hitting the printing surface.
- Place unexposed paper in the easel, and assemble tools for burning and dodging.
- Once all the elements are in place, turn off the enlarger light momentarily, gently pull off the lens cap, turn the enlarger back on, and immediately start timing the exposure before the negative has had a chance to cool.

Using this method ensures that the negative remains focused and that the resulting print is tack sharp without the risk of Newton rings that can arise from using a glass carrier to flatten the negative. These precautions are generally only necessary for medium- and large-format film.

Controlling Contrast in Film Development

When considering options for the processing of black-and-white film, there are several ways to minimize contrast. Since more densely exposed highlight areas develop more slowly than thinner shadow areas, overall contrast can be reduced by "starving" the highlights in several different ways.

- *Pull the film up to 3 stops.* Overexpose and reduce development time by 15 percent per stop of overexposure. For example, with Ilford Delta 400, if the film is exposed at ISO 50 (3 stops over) and development time is reduced by 45 percent (15 percent x 3 stops), this would result in a 3-stop contrast compression. Reducing development time by more than 45 percent will result in underdeveloped shadows and isn't recommended. Therefore, this method is useful for only moderately high-contrast lighting (8- to 10-stop contrast range between shadows and highlights).
- *Decrease agitation of the film tank.* Film development occurs when fresh chemistry is in direct contact with the film emulsion. By minimizing agitation of the film tank, the developer has less ability to act on the film, thereby decreasing overall contrast. An apt analogy for this reaction is picturing the bubbles that form in carbonated water when shaken as opposed to when kept immobile. A good benchmark for decreased agitation is three to five rotations every two minutes. Any less than three rotations every two minutes may result in uneven development.

- *Increase dilution of developer rather than working with a stock solution.* Consider diluting the stock solution more than the standard dilution for a given developer. Development time will increase as a function of dilution. Diluted development is not recommended for certain film/developer combinations, so check manufacturer or user recommendations for the specific products and appropriate times to ensure that results will be stable and consistent. D76 can be diluted up to 1:4, XTOL works very well at 1:3, and T-Max RS and Ilford DDX provide considerable contrast reduction at 1:15 dilutions. Decreased agitation and increased dilution are generally used in combination for maximum benefit. Certain film/developer/dilution/agitation combinations can compress contrast up to about 5 stops.
- *Use a water bath in conjunction with development.* When regular film develop-ment is alternated with immersion in a water bath, development is slowed differentially. The development of highlights is held in check while shadow areas develop fully for a resulting negative that shows reduced contrast. The alternation between baths can be extended for as long as necessary to achieve the desired contrast. Further details about this method can be found in Ansel Adams's book *The Negative.*
- *Use a "magic soup" recipe of two-part (or divided) developers, such as Diafine.*

Controlling Contrast with Diafine

Lance Keimig has been working with Diafine since 2001, and it's his preferred film developer to achieve maximum detail when he needs to keep the contrast in check. A divided developer, Diafine is packaged in two parts that are mixed separately for use in successive baths. Exposed film is developed in each solution and then rinsed in a water bath before normal fixing. Presoaking the film before development and use of stop bath after development are not recommended.

Diafine can generally be used within a wide temperature range, from 70 to 85 degrees Fahrenheit, as long as the temperature of all solutions is kept uniform. Development times do not vary between films of different speeds or brands, so a standard development time of three minutes in each bath can be used for all film. This enables the simultaneous development of different types of film together in a shared tank. Development of film for longer than three minutes in either bath will have no practical effects on the resulting negatives. Diafine does cause an increase in film speed, especially with older, non-T-grain films, so it may be necessary to reduce exposure with older emulsions like Tri-X or HP5. Specific details for film speed and other relevant data can be found on the developer packaging. To prepare a working solution of Diafine, follow the directions on the packaging and use distilled water to mix.

Keimig points out that Diafine is superior for extreme-contrast situations or in conditions when light sources are present in the frame. Diafine is not the best developer for low-contrast situations such as a completely overcast, foggy night. Most Diafine negatives will print well with a #2 or #2 1/2 filter. Diafine-developed negatives from low-contrast lighting situations may require a #4 filter to yield normal contrast in the print.

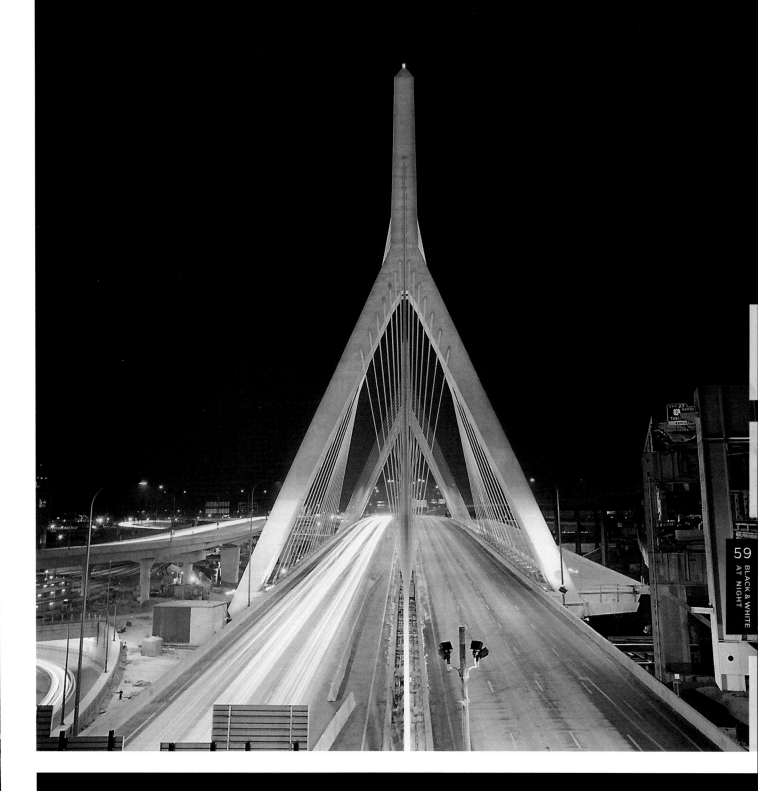

© **LANCE KEIMIG**

Camera	Ebony 23 SW
Lens	Nikkor SW 65mm
Aperture	f/16
Exposure	10 minutes
Film	Fuji Neopan Acros

The headlights from oncoming cars, the floodlit bridge, and the clear winter sky made this scene extremely high in contrast. In order to maximize detail in both the highlight and shadow areas, Lance Keimig exposed the shot for maximum shadow detail and then processed the film in the compensating developer Diafine.

HOW A DIVIDED DEVELOPER WORKS

Solution A is the developing agent. Once this is added to the tank, chemistry is absorbed into the film emulsion and becomes fully saturated within three minutes. Solution A is then drained for reuse. Solution B is the accelerator. This is added directly after A is poured out, without washing between the two solutions. Development of the film begins at this point.

With a split developer such as Diafine, the only chemistry available to affect the film is the solution from Solution A that was absorbed by the emulsion. Development begins only when the film is immersed in Solution B, which activates the developer absorbed from Solution A. Once the chemistry that soaked into the film is exhausted, the development process is over. Shadow areas of the film, which have less exposure, are able to develop fully with the small amount of developer absorbed from Solution A. The more densely exposed highlight areas begin to develop but exhaust the chemistry before they are fully developed. This prevents the overexposed highlights from blowing out, which is what happens when exposures are calculated for the shadows in the high-contrast situations that characterize night photography. With a perfect exposure, Diafine can reduce negative contrast up to about 7 stops. While Diafine is a superior developer for extreme-contrast situations or in conditions when light sources are present in the frame, this is not the best developer for low-contrast situations, such as a completely overcast, foggy night. Most Diafine negatives will print well with a #2 or #2 1/2 filter. Diafine developed negatives from low-contrast lighting situations may require a #4 filter to yield normal contrast in the print.

OTHER BLACK-AND-WHITE DEVELOPMENT METHODS

There are many different formulas for compensating film development that can help extend contrast range for hard-to-control night shots. The following few additional options come courtesy of Keimig's teaching archives. The standard development temperature for the following methods is 68 degrees Fahrenheit. All development times assume reciprocity failure is factored into exposure. In all cases, try to meter the scene in a shadow area if possible. For full-moon exposures use normal development.

Development Strategies for High-/Highest-Contrast Scenes When Diafine Is Not Available

Ilford Delta 400
Expose at an ISO of 200. Develop film in Kodak Xtol diluted at 1:3 for 13 minutes. Agitate continuously for the first 30 seconds, then for five seconds every two minutes.

Ilford HP5+
Expose at an ISO of 100. Develop in Kodak D76 diluted at 1:3 or 1:4 for 13 to 16 minutes, depending on the contrast range of the scene. Agitate continuously for the first 30 seconds, then for five seconds every two minutes.

Ilford Delta 3200
Expose at an ISO of 1000 to 1600. Develop in Ilfotec DDX diluted at 1:9 for 13 to 15 minutes. Agitate continuously for the first 30 seconds, then for five seconds every two minutes. Since 3200-speed film is best suited to low-light situations requiring short exposure times, such as to prevent blur from a moving object, this combination of film and development is most effective for exposures between 1/4 second and 30 seconds.

Fuji Neopan Acros 100
Expose at an ISO of 100. Develop in Kodak Xtol diluted at 1:3 for 12 to 13 minutes. Agitate continuously for the first 30 seconds, then for five seconds every two minutes.

Development Strategies for Scenes with Moderately High Contrast

Ilford HP5+
Expose at an ISO of 100. Develop in Kodak D76 diluted at 1:2 or 1:3 for 12 to 14 minutes. Agitate continuously for the first 30 seconds, then for five seconds every minute.

Ilford Delta 400
Expose at an ISO of 200. Develop in Kodak Xtol diluted at 1:2 for 11 to 12 minutes. Agitate continuously for the first 30 seconds, then for five seconds every minute.

Fuji Neopan Acros 100
Expose at an ISO of 100. Develop in Kodak Xtol diluted at 1:2 for 11 to 12 minutes. Agitate continuously for the first 30 seconds, then for five seconds every minute.

© **LANCE KEIMIG**

Camera	Ebony 23SW	Lens	Nikkor SW 65mm
Aperture	f/11	Exposure	about 10 minutes
Film	Fuji Neopan Acros		

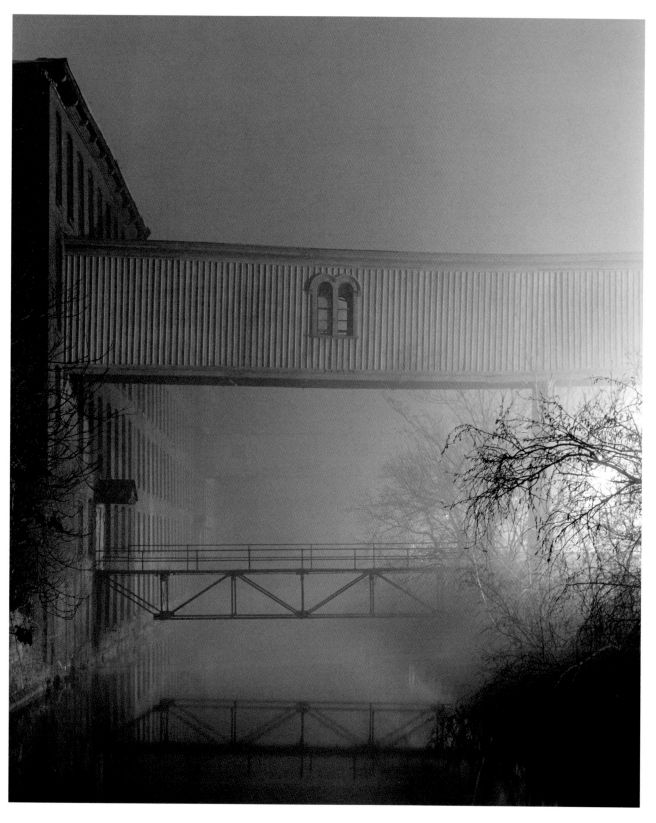

Foggy conditions reduce overall contrast to night scenes. Although this can yield exciting atmospheric effects, it can make exposure and development tricky. This scene was particularly challenging, because while the overall contrast was very low, there was an area of localized high contrast from the light source in the right side of the frame. The negative was processed in Diafine to maintain detail around the light source but required a #4 filter in printing to gain adequate overall contrast in the final print.

Exposure with Kodak T-Max 100 and Development with T-Max RS Concentrate

Chip Forelli first took up night photography as a supplement to his work as a commercial still-life photographer. He feels that the stillness of elements and lighting conditions in the environments he photographs are akin to working with a still life set. The graphic, delineated look of nighttime subjects appeals to his aesthetic, as well.

Forelli shoots Kodak T-Max 100 black-and-white film with 4x5- or 2 1/4-format cameras. He finds this film has an incredibly elastic contrast range that, with careful exposure and development, can be stretched to successfully control challenging situations of extreme contrast. He rates his film at an ISO of 40 to 80 instead of the off-the-shelf rating of 100. The slower film speed dictates bumping up the shadows with some additional light. Forelli always errs on the side of caution with his nighttime exposures, and he, therefore, adds 1/2 to 2/3 stop more light to these subjects than what his meter tells him.

Compensating Development Method for Kodak T-Max 100 with T-Max RS Concentrate

Chip Forelli uses a compensating development procedure to control the high contrast inherent in night photography. He works with T-Max RS developer, a liquid developer known for offering enhanced shadow detail, and uses a formula he learned from black-and-white master photographer John Sexton.

- Don't make up a stock solution by diluting the developer; start with T-Max RS developer in its concentrated form.
- Add the small packet of Part B to the main developer.
- Measure a small portion of the developer relative to the tank or tray being used, and dilute 1:15 (1 part developer to 15 parts water). Regulate the temperature to 75 degrees Fahrenheit as recommended by the manufacturer. According to Sexton, the higher temperature enhances shadow detail.
- Place two rolls of 35mm film or one roll of 120mm film in a 32-ounce tank, or process individual sheets of film in a small tray.
- Agitate the tank continuously but gently for the first minute and then very sparingly thereafter, inverting the tank for 10 seconds every two minutes.
- Develop for 8 to 11 minutes to start, and adjust the time based upon initial results.
- Finish the process with stop bath, fix, Permawash, and a final water wash as usual.
- Depending on storage conditions, the concentrated developer prepared in this fashion should last on the shelf for up to two months.

A light snow appears like fog on the film in this predawn view of the Brooklyn Bridge. The high-key tonality of the snow, mixed with the lights on the bridge and the reflective surface of the water, made for bright lighting conditions and a low-contrast negative. Before printing this image, Forelli soaked the negative in a dilute selenium bath to bump up the contrast in the scene.

© CHIP FORELLI

Camera	Hasselblad
Lens	60mm
Aperture	f/22
Exposure	30 seconds
Film	Kodak T-Max 100

Personal Vision

So much about the way an image looks happens after the exposure is made. It is the imaging, the darkroom work, that ultimately makes the image.

— Chip Forelli

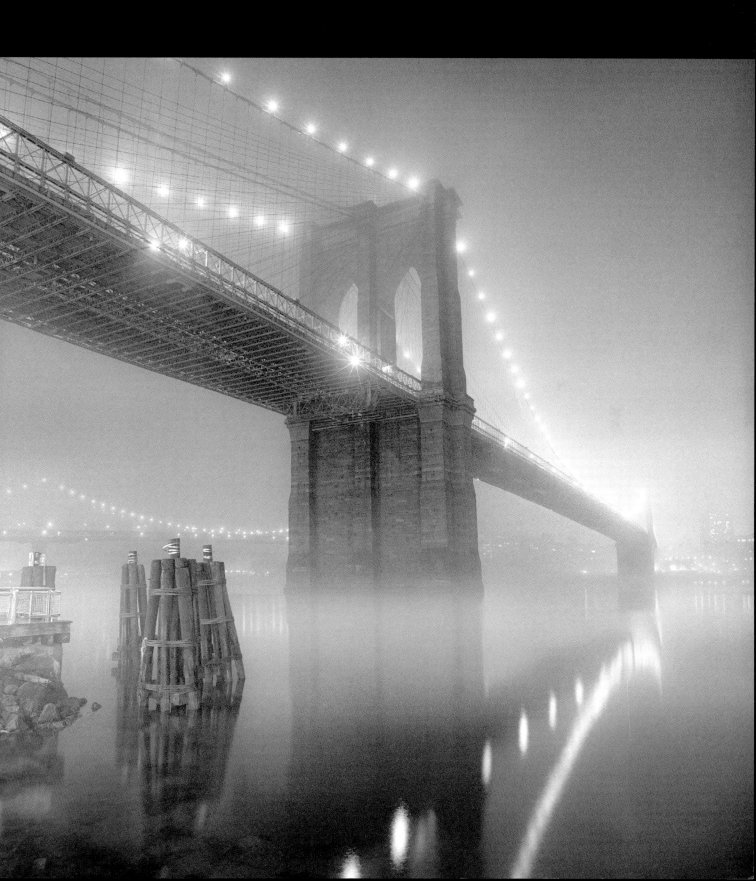

With this method, the lack of agitation restricts the highlight areas of the film by not letting them develop fully. Shadow areas develop completely because they require less action from the developer to show detail. Using this combination of film and development, Forelli finds it possible to reduce contrast from an off-the-chart situation with 15 stops of differential and produce a negative with a more manageable contrast range of around 8 stops.

When he shoots medium format, Forelli prefers to shoot 120-roll film, which gives him 12 exposures per roll. He will often dedicate a whole roll to one subject so that he can tailor his development methods to the specifics of the atmospheric and lighting conditions. When a scene is extremely contrasty, he will develop the film differently than other night subjects by giving it less time in development to prevent the highlights from blowing out. ■

© CHIP FORELLI

Camera Hasselblad
Lens 60mm
Aperture f/22
Exposure 4 minutes
Film Kodak T-Max 100

An isolated detail of shiny industrial piping in Los Angeles adds graphic breadth to Chip Forelli's assignment coverage of fine-art industrial photography for an oil-exploration company. He framed the shot strategically to position one of the lights behind an undulating pipe and thus eliminate what would otherwise be an eye-catching distraction. Compensating development helps him fit the excessive range of tones on the film. The compression of the tonal scale due to compensating development also flattens out the local contrast, especially in the sweating pipes. This is brought back by locally increasing contrast in printing or in Photoshop.

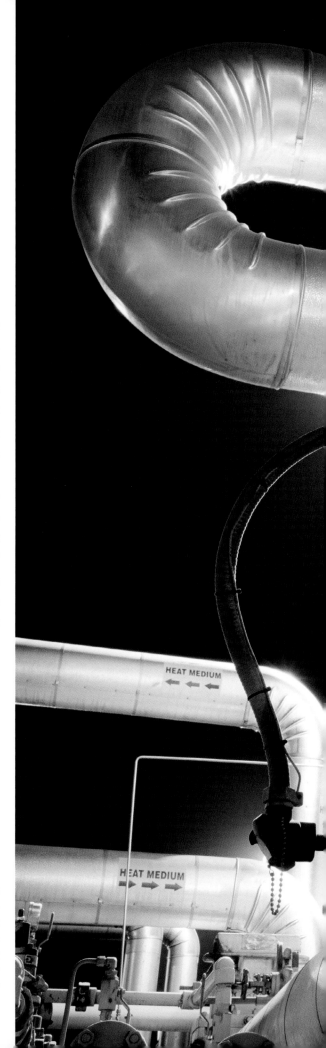

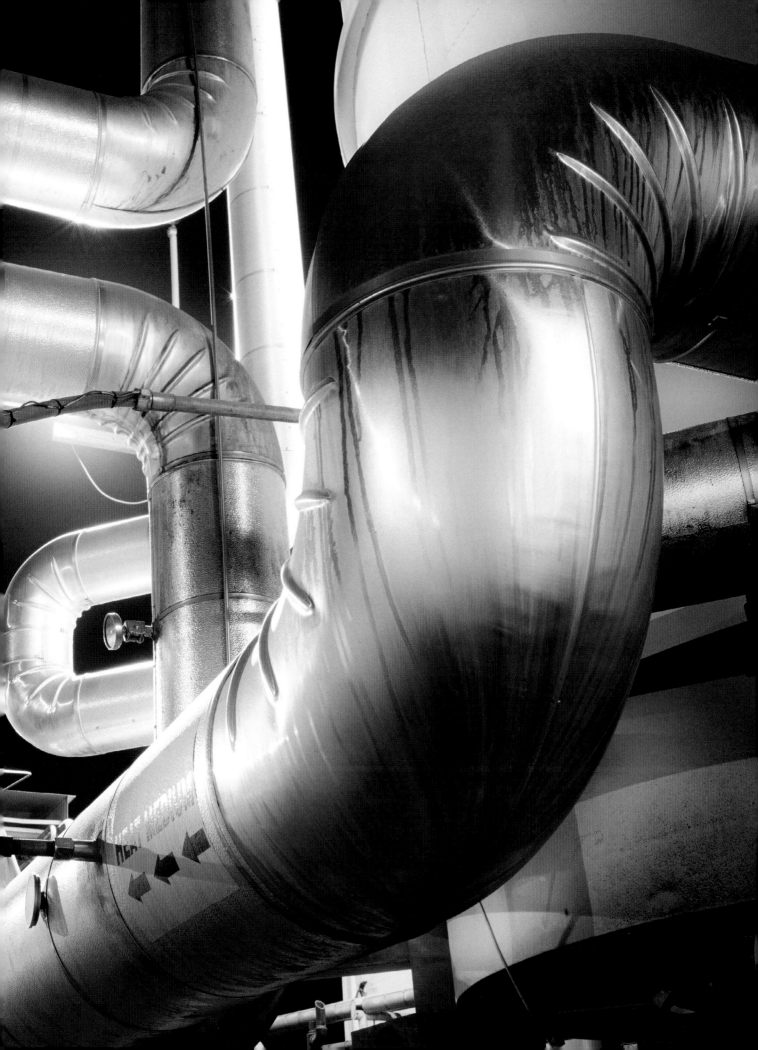

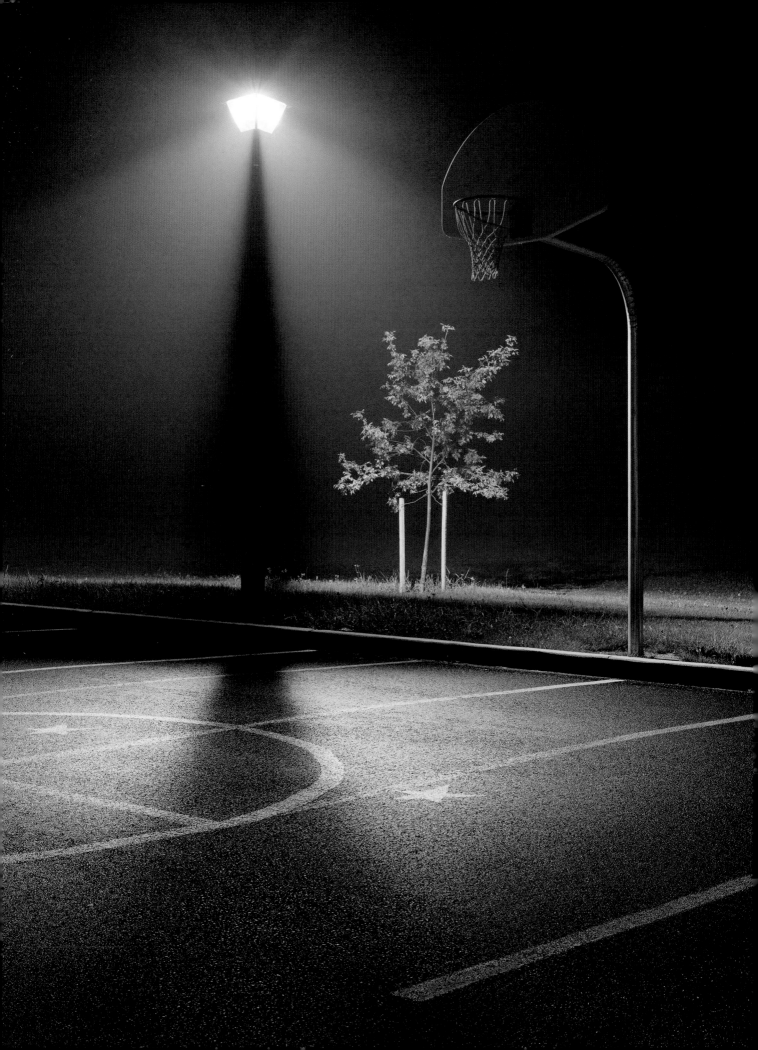

© **CHIP FORELLI**

Camera	Linhof Technika 2000 4 x 5
Lens	90 mm
Aperture	f/4.5
Exposure	15 minutes
Film	Kodak T-Max 100

4

Nighttime Subjects

When shooting at night, creative possibilities and preferred techniques vary greatly between individual photographers, as well as from one subject area to the next. The right approach to a nighttime subject is always highly situational. Past experience in a specific location is often the best teacher—however, site conditions can vary dramatically from one night to the next. Since this is not an exact science, shooting decisions need to be weighed against the variables at hand and the limits of what will be possible to achieve from a given environment.

Moisture in the nighttime atmosphere carries light and can create shadows out of thin air. Chip Forelli took advantage of a foggy night to position his camera in the sweet spot of the shadows created by this overhead lamp next to a rural basketball court. The shadowy rays emanating from the periphery of the lamp are caused by four tiny metal tabs that connect the panes of glass. The small amount of light they block is usually invisible to the eye, but here their effect is magically spread through the air by the fog.

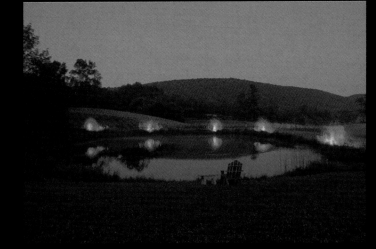

© JILL WATERMAN

Camera	Nikon H3HP
Lens	Nikkor 50mm
Aperture	f/5.6
Exposure	about 5 minutes, timed to the burning of the flares
Film	Fujichrome Velvia 50

As the last bits of twilight disappeared from the sky, red highway flares were lit for this fire ritual at the edge of Saltonstall Pond in Ithaca, NY. Figures standing behind each flare waved stringed batons through the air. Light caught by the movement of the strings surrounds each flare with a glowing fountain of red and is reflected in the pond, which also picks up the reflection of the distant mountains and the deep night sky.

THE MAGIC HOUR

Among photographers and filmmakers, twilight is often referred to as *the magic hour,* thanks to the rich effects of color and lighting that can be captured during this time period. The time leading to sunrise also produces magic-hour effects and can also be a good time for photography while the rest of the world is sleeping. Yet, because ideal conditions for an early-morning shoot are fleeting, the setting sun and subsequent slide into darkness are generally more conducive to a lengthy shooting experience.

The duration of time between twilight and sunset or sunrise will vary depending on latitude and time of year. The farther north you go in the Northern Hemisphere, the longer twilight lasts. In the Southern Hemisphere, the situation is reversed. At equatorial latitudes, twilight lasts only a few minutes. Consequently, at dawn it can go from pitch dark to broad daylight very quickly, or vice versa at dusk. Additionally, twilight is divided into three periods: civil, nautical, and astronomical.

CIVIL TWILIGHT

This is the period in morning and evening when the sun is below the horizon but when it is light enough to work outside without the aid of artificial lighting. At sunrise, civil twilight begins when the sun is still 6 degrees below the horizon. In the evening, it begins just after the sun sets below the horizon and lasts until the sun is 6 degrees beneath the horizon.

NAUTICAL TWILIGHT

This refers to the period, either sunrise or sunset, when the sun is between 6 and 12 degrees below the horizon. It is relevant to mariners as a time when the horizon line can be distinguished at sea and used for taking readings with a sextant, yet it is dark enough to see celestial bodies.

ASTRONOMICAL TWILIGHT

This is the period before sunrise and after sunset when the sun is between 12 and 18 degrees below the horizon. At the start of this period in the morning and at its end in the evening, the sun doesn't contribute to the illumination of the sky, and astronomers are able to observe faint stellar objects.

© TOM PAIVA

Camera	Camera: Canon 5D
Lens	35mm
ISO	400
Aperture	f/5
Exposure	30 seconds

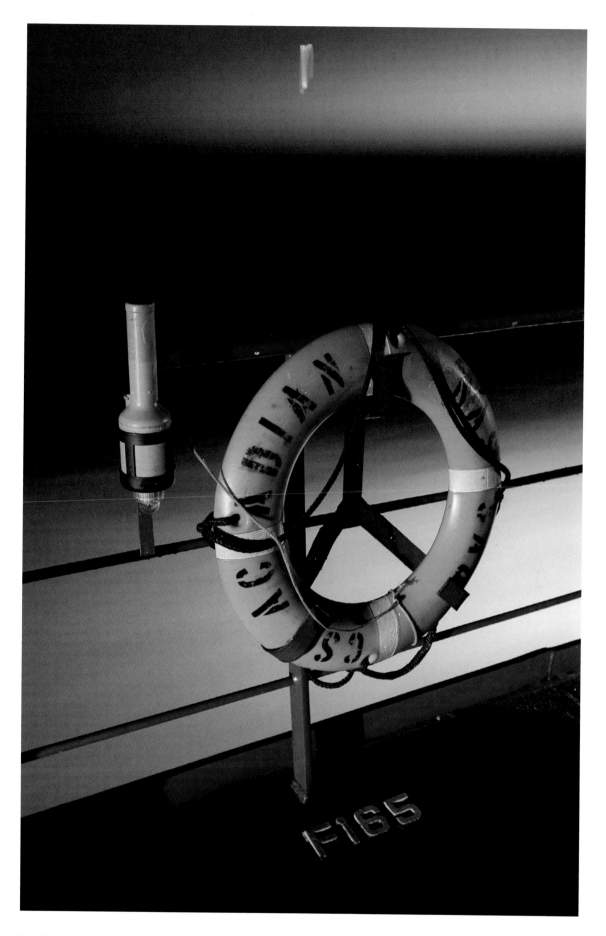

The distant horizon, visible here after sunset, is an indicator of nautical twilight, when the sky can still be discerned from the sea. Tom Paiva made this shipboard capture during a shooting expedition from British Columbia to San Francisco on board a freighter operated by a client. Illumination from a spotlight on deck caused light to reflect from the ocean surface just beyond the rail. The white line above the horizon is Venus, which recorded as a vertical blur due to the rolling of the ship.

© **CHIP FORELLI**

Camera Hasselblad
Lens 60mm
Aperture f/22
Exposure 5 minutes
Film T-Max 100

The Landscape at Night

At first glance, the darkened expanse of a night landscape can appear impenetrable and overwhelming. Elements of majesty and mystery, however, are generally in abundant supply. Night photographers often gravitate to wide-angle views, especially when shooting an expansive space. This choice often means a faster lens and greater depth of field, which are important advantages in low light.

Otherworldly Realms

The landscape at night often can appear transported to a distant place. A deserted beach illuminated by the full moon, for example, can resemble a lunar landscape with the moon's light raking shadows across the furrows in the sand.

NUANCES OF LIGHT

Nocturnal lighting can be widely variable and hard to predict. Changes to weather or atmospheric conditions can cause the same scene to take on a very different appearance from one night to the next, or even within a matter of hours during the same night.

© **M. J. SHARP**

Camera 4 x 5 Speed Graphic
Lens 135mm Graflex or
 180mm Schneider
Aperture f/11
Exposure Pre Dawn Trees (orange)
 20-minute exposure made shortly
 before the sky was beginning to
 lighten, plus dense fog. Dawn Trees
 (blue) Image made directly after the
 first and exposed for less than 20
 minutes, just as dawn was beginning
 to lighten.
Film Kodak 160 NC negative

Two identical landscapes, made with same daylight film (Kodak 160 NC) and camera settings, illustrate the extreme difference in color and tone that occur as dawn rises and the warm color temperature of artificial lighting spread by fog is replaced by the cooler temperature of early daylight. In the orange predawn, this densely foggy image was a 20-minute exposure made shortly before the sky was beginning to lighten.

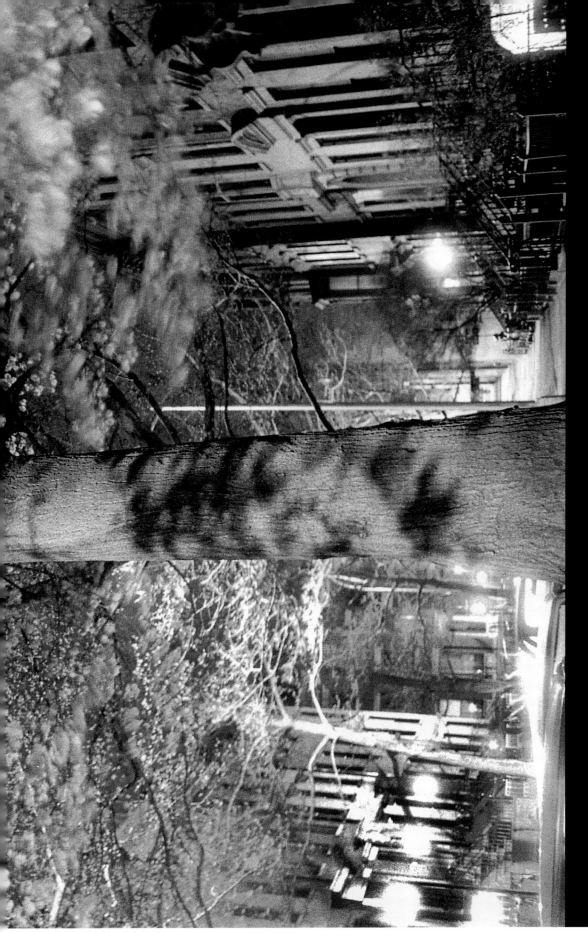

Working with the Elements

© **LYNN SAVILLE**

Camera	Leica M 6	Film	Ilford HP5+
Lens	35mm	Exposure	10 seconds
Aperture	f/8		

LEFT: Artificial lighting gave an overall color cast to this digitally captured southern Louisiana landscape. Beau Comeaux removed the existing color using Photoshop Curves adjustments before adding a golden color palette to the grass and selectively blurring the scene to heighten the mood. **RIGHT:** M. J. Sharp placed a large-format field camera at ground level for this intimate portrait of dew-drenched tulips on a dark garden path. A bicycle headlight attached to a mini tripod served as an improvised light source outside the frame. **OPPOSITE PAGE:** The combined lighting in these images includes the full moon, light painting on the tree trunks with a flashlight, ambient lighting from pathway globes, and stadium lighting from a nearby tennis court. The earth's rotation is evidenced in the distant star trails created during the long exposures. The trajectories of their arcs offer directional orientation: The trails curve up to the right in the image facing northeast (TOP), and they curve down to the right in the image facing west (CENTER). Instead of trails, one would see concentric circles around the stars in an image that faced north toward the North Star.

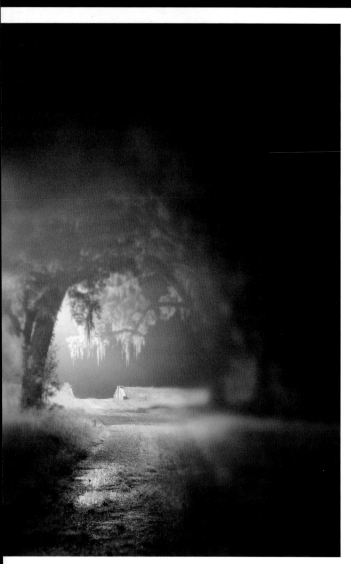

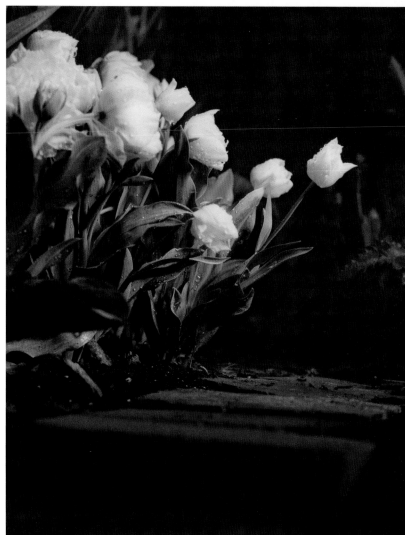

Personal Vision

At night, with the different kind of lighting, the plants were just totally different. So vulnerable and fragile. It's the world that people don't see—because it's nighttime, and people don't look at flowers at night. – M. J. Sharp

© **TIM BASKERVILLE**

Camera	Hasselblad 500C/M
Lens	80mm
Aperture	*f*/11 (TOP),
	f/8 (CENTER AND BOTTOM)
Film	Fujichrome 64 tungsten
Exposure	30 minutes

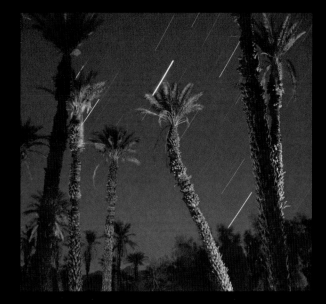

Significant Details

The concept of *landscape* includes more than grand vistas, especially at night when a restricted composition focused on close up objects or intimate details can be more readily seen and easier to achieve.

Subjects in Series

The vast stillness of the night landscape makes a perfect setting for exploring one subject in an extended series. During repeated trips to Death Valley to teach full-moon night photography workshops, Tim Baskerville discovered a palm garden that he transformed into a series called Dream Dates. The selection here shows the wide range of moods that can be achieved with a single subject. Some of his images are warm and inviting, while others seem more sinister.

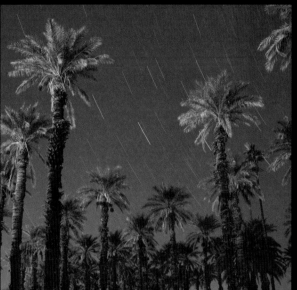

Framing objects in a clustered group can be difficult. Each time Tim Baskerville backed up when capturing these palms, another tree would appear in the frame. In such situations, consider isolating a manageable section instead of moving back to fit everything into the frame.

With nighttime exposures, it's important to keep thorough records about each picture, including the camera settings used and anything that happens during the time of the exposure. For a valuable learning experience, return to photograph the same location on different nights and compare the results.

❗ Winter is an ideal time of year to work in urban environments. There are fewer tourists in popular destinations and more hours of darkness for exploring the sites. It's also the best time for shooting at dawn, since sunrise occurs at its latest at this time of year.

Urban Night

The urban environment involves an enticing mix of color, contrasts, and motion after dark. Vantage point is everything when making nighttime exposures of urban subjects. Framing the desired scene—in a manner to set it off from an environment that is rapidly changing or contains distracting elements—is an important consideration for success in urban locations, especially in situations where contrast levels are high.

© **LYNN SAVILLE**

Camera	Bronica 6x4.5
Lens	45mm
Aperture	f/16
Exposure	5 seconds
Film	Fuji NPH 400

Commissioned by the Central Park Conservancy to photograph the park, Lynn Saville sought out a friend with an apartment in the area. In addition to completing the work for her client, she scored this aerial view of Columbus Circle in New York from a spectacular vantage point.

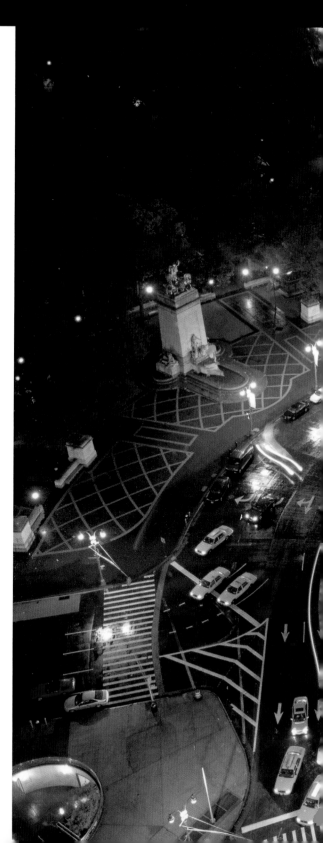

Personal Vision

I like shooting at *f*/16 or *f*/22. I like the stars they facilitate and am always looking to capture those star elements in my pictures. I also wanted a long depth of field for this series to give the images clarity and crispness. I guess I didn't want to miss anything. – Robert Vizzini

© ROBERT VIZZINI

LEFT

Camera	Hasselblad 503cw
Lens	Zeiss 50mm F4 CF Distagon FLE T*
Aperture	*f*/16
Exposure	about 30 seconds
Film	Fujichrome Provia RDPIII 100Fa

RIGHT

Camera	Hasselblad 503cw
Lens	Zeiss 50mm F4 CF Distagon FLE T*
Aperture	*f*/22;
Exposure	9 minutes
Film	Fujichrome Provia RDPIII 100F

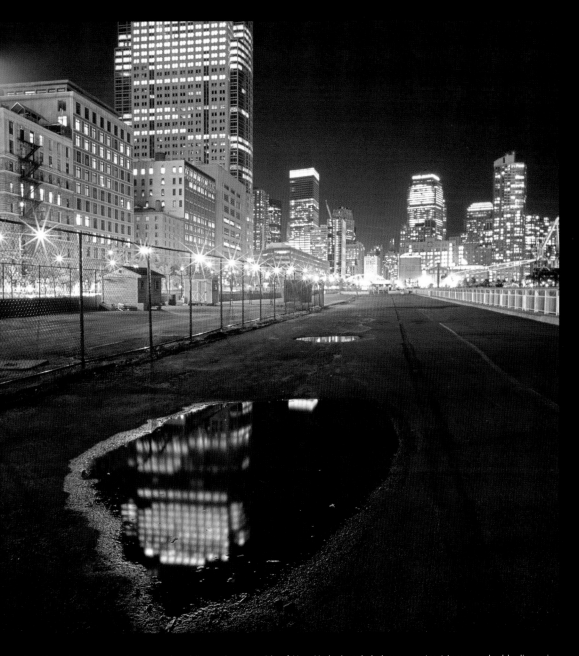

Including the reflections in a foreground puddle on the west side of New York cleverly balances contrast issues and adds dimension to this urban landscape. The small aperture enables maximum depth of field and creates a starburst effect in the streetlights. In order to photograph a series on the nearby Hudson River Park without being stopped by park police, Robert Vizzini contacted the park administrators, pitched his project, and requested a permit.

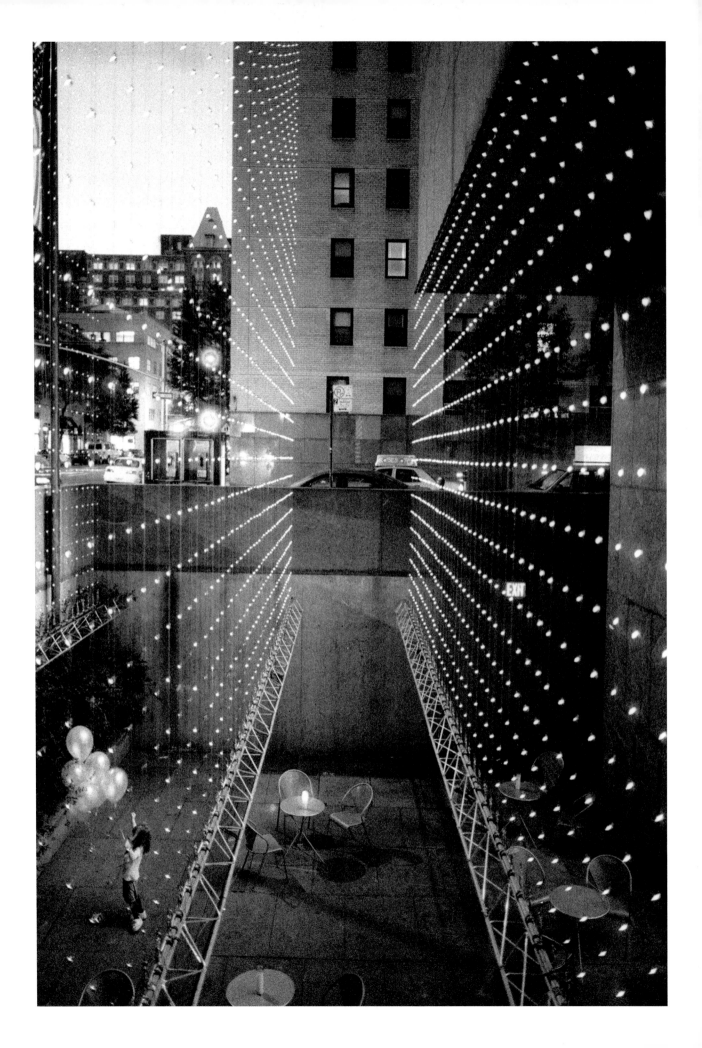

New York street photographer Orville Robertson works extensively at night with a handheld rangefinder camera and high-speed black-and-white film. His favorite time to photograph is after the workday has ended, when there are people in transit and a fair amount of light still remains in the sky. Robertson's approach to his subject matter is slow and methodical, and he is very sparing in the frames that he makes. Yet, he is rarely without his camera so that he can be ready when the right situation presents itself.

Robertson will often spend a great deal of time waiting for elements to converge in a shoot situation, but he works quickly to compose and focus once the moment is right. In order to be fully aware of his surroundings, he often shoots with both eyes open in order to see not only what is within his composition but also what is about to enter or leave the frame. While this shooting method takes some concentration to master, it allows him to anticipate and react instantly to the unpredictable changes that happen on the street.

Personal Vision

When I'm shooting there are dozens of little places I'll go back to a lot. I often respond to something as a stage set for an activity that takes place. Some of my images are quick shots but others represent a lot of time invested in waiting.

– Orville Robertson

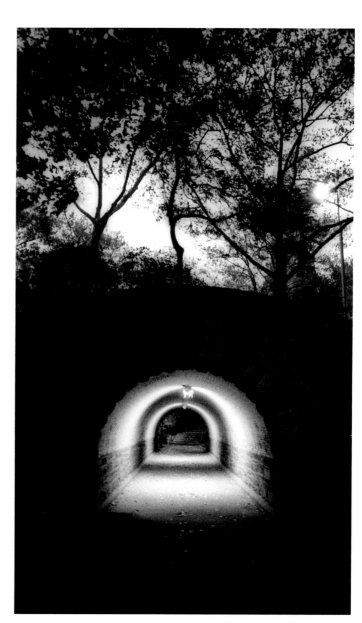

© ORVILLE ROBERTSON

OPPOSITTE

Camera	Leica M6 TTL
Lens	Canon RF 35mm
Aperture	unrecorded
Exposure	unrecorded
Film	Kodak TMAX 3200

RIGHT

Camera	Minolta CLE
Lens	Minolta 40mm
Aperture	unrecorded
Exposure	unrecorded
Film	Fuji Neopan 400

85 NIGHTTIME SUBJECTS

OPPOSITE: A lighting installation in a museum courtyard creates a hypnotic effect when captured together with the geometries of an urban street scene. Robertson spied this scene out of a window during an evening event and framed the image to align layers and shapes for greatest clarity and maximum effect. **RIGHT:** The lighted interior of this Central Park archway adds depth to this image and helps to create a pleasing balance between shadows and highlights. Orville Robertson has learned from experience about the limitations of his tools and working methods. He often walks away from a subject when he knows a scene is too dark or that the film can't capture the full range of contrast.

BOTTOM LEFT		BOTTOM RIGHT AND OPPOSITE		OPPOSITE BOTTOM RIGHT
Camera	Mamiya RZ-6×7	Camera	Canon 5D	Aperture f/13; Exposure: 30 seconds
Lens	65mm	Lens	28-70mm	
Aperture	f/8	ISO	100	BOTTOM RIGHT
Film	Fuji Pro 400H, rated at			Aperture f/2.8; Exposure: 1 second
	200 ISO			
Exposure	5 seconds			OPPOSITE BOTTOM LEFT
				Aperture f/4; Exposure: 3.2 seconds

BOTTOM LEFT: Kenny Trice traveled the southern states to photograph crowds browsing at fireworks stands at night. An extra tall tripod and an eight-foot ladder helped him to achieve an architecturally correct vantage point and limited compression in the foreground of his images. The stands' brightly lit interiors posed an exposure challenge, so Trice began working while there was still ambient light in the sky. He used his camera's prism meter to establish a baseline exposure, and then shot a wide bracket for the option to add highlight detail by scanning additional frames after the fact in post-production. **BOTTOM RIGHT AND OPPOSITE:** In this assignment for a landscape lighting client, Kenny Trice made nocturnal visits to a number of manicured properties to photograph the dramatic pinpoint lighting that ornaments these suburban landscapes. In order to achieve detail in the sky and to limit the contrast from the artificial lights, he concentrated most of his shooting around dusk and dawn. Because of the wide range of the scenes he needed to cover and the rapid changes to the ambient light, digital capture was essential for this shoot. Trice made baseline exposures using his camera's program mode and then switched the camera to MANUAL to adjust the exposures himself for a wider bracket. **OPPOSITE TOP:** A low camera angle was used to diffuse the bright lights of a motel courtyard behind the row of hedges in the back of the lot. The bright colors of fall foliage are also enhanced by the light reflected from a red neon sign that is hidden from view. Vernacular objects from suburban settings, such as the colorful TV antenna and satellite dish seen here, can be strategically placed in the frame to add character to images made in suburban environments.

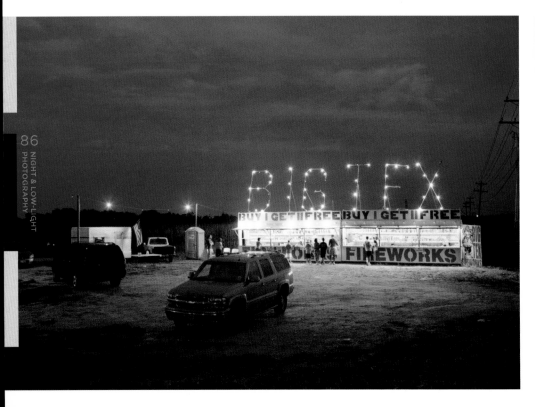

When planning for a predawn shoot, always check the orientation of the sunrise in relation to the subject to be photographed. In ideal circumstances, the subject should be opposite the brightening sky, so that it feathers the scene with soft illumination as light levels increase.

Camera Canon T90 **Lens** Vivitar 19mm **Aperture** f/5.6 **Exposure** 8 minutes **Film** Kodak 160 tungsten

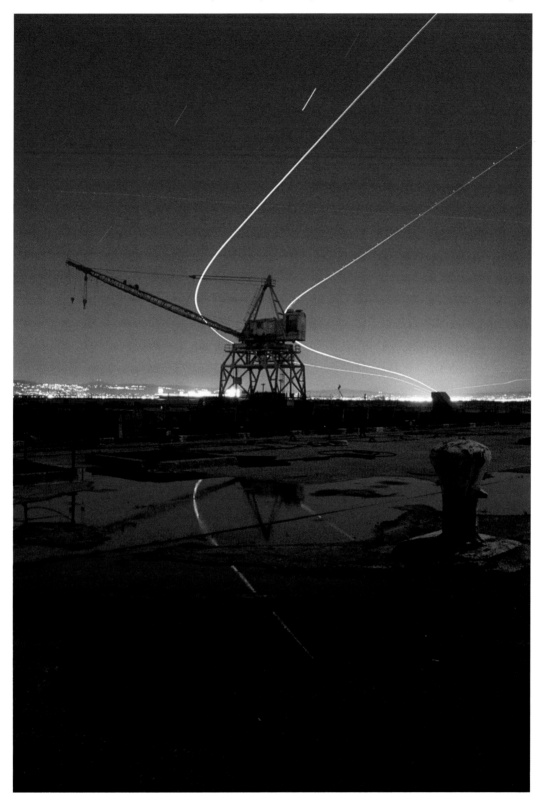

Troy Paiva was granted night access to shoot this abandoned shipyard over the course of five consecutive full moons. In this image, the longer exposure time needed for a film-based capture takes best advantage of the airplane wing lights on departure from a nearby airport. Aircraft light trails can add an interesting design element to nighttime images, especially near an airport, where patterns repeat themselves as multiple planes take off and land. In these circumstances, the lights tracing through the sky become another form of light painting (see Chapter 5), albeit one over which the photographer only has limited control. A red-gelled flashlight adds a subtle touch of warmth to the foreground and is most noticeable on the iron post at the right side of the frame.

 © **CLAIRE SEIDL**

LEFT

Camera	Hasselblad 500 C
Lens	Carl Zeiss 80mm planar
Aperture	f/11
Exposure	20 to 30 minutes
Film	Kodak Tri-X

 © **STEVE HARPER**

RIGHT

Camera	Mamiya RB 6x7 ProS
Lens	90mm
Aperture	f/8
Exposure	18.10 minutes
Film	Kodak 160 tungsten
Lighting	Vivitar handheld flash with warming filter

LEFT: A half-hour exposure causes figures to blur as they move during a dinner party in a log cabin. The architectural elements, furniture, and tabletop accessories appear fixed in time and balance blur with stability. The central chair, draped with a jacket, was moved slightly during the exposure time and caused a slight ghosting at the right-hand edge. **RIGHT:** During a shooting expedition at Yosemite National Park, Steve Harper's dog, Stick, sat for a portrait with a strobed flash. A warming filter was used to naturalize the cool color temperature of the tungsten-based film. Harper called the dog away from the scene as soon as the flash popped, but he continued the exposure for eighteen minutes to render the background sky a deep blue. The dog's face and torso appear distinct against the dark background landscape, yet a slight ghosting of the body emerges where the film picks up the lighter tonality of the grey rocks against which the dog was seated.

The Figure at Night

The human figure can be especially challenging to photograph at night. During long exposures the human form is often reduced to a blur in an image that is otherwise sharp. The high contrast, deep shadows and strong color casts prevalent in many nighttime scenes will yield less than photogenic results when applied to a human subject. Lighting tools and a basic understanding of their use are indispensable for making accurate and appealing images of people at night.

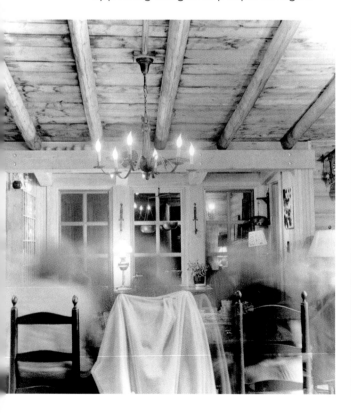

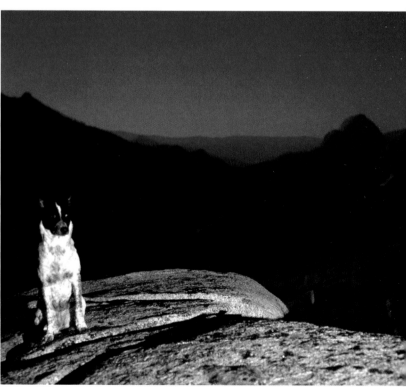

For a unique approach to a nighttime portrait, pose your subject against the darkest area you can find. Use a strobed flash to freeze the subject in place, then let the subject move away. Let the rest of the scene burn in for a longer time with only ambient lighting on the scene. If the subject was posed against a very dark background, it will appear as if he or she posed for the duration of the shot.

Personal Vision

I prefer long exposures so I can get the ambient light. The colored lights are so charming, and I don't want to blow them out, so I use the flash to give a little fill to my subjects yet not lose the balance with the background lighting.

– Deborah Whitehouse

DEBORAH WHITEHOUSE'S WORKING METHODS

During many years spent photographing people out on the town after dark for her series *Saturday Night*, Deborah Whitehouse has perfected multiple techniques for balancing ambient lighting and strobed flash. These are two of her favorites.

When shooting moving subjects, such as people dancing, she uses high-speed film, a camera handheld at 1/15th of a second, and an off-camera strobe to freeze the action up close. She gets into the mix and moves with her subjects to capture points of sharpness surrounded by a feeling of motion within motion. When working with high-speed film, color accuracy in an image is highly dependent on the effect of the flash, where the subject is being revealed by a white light.

For more deliberately posed environmental portraits, Whitehouse works on a tripod and shoots longer exposures with a slow film (ISO 100) to make the most of the ambient light in a scene. Slow-speed film offers a richer color palette, and the color shifts caused by the mix of daylight film and artificial light can lead to magical effects in an image. Whitehouse likes to work with a wide-angle lens and get close to her subjects, so the figure appears large in the foreground and is balanced by the ambient lighting and the surrounding environment. For a touch of crisp light on the subject, Whitehouse pops a flash powered to its lowest setting and tempered with a softbox, just before closing the shutter.

 © DEBORAH WHITEHOUSE

Camera	Nikon FM2
Lens	Nikkor 28mm
Aperture	f/5.6
Exposure	1/15 second
Film	Fujicolor Professional 800, pushed to ISO 1600

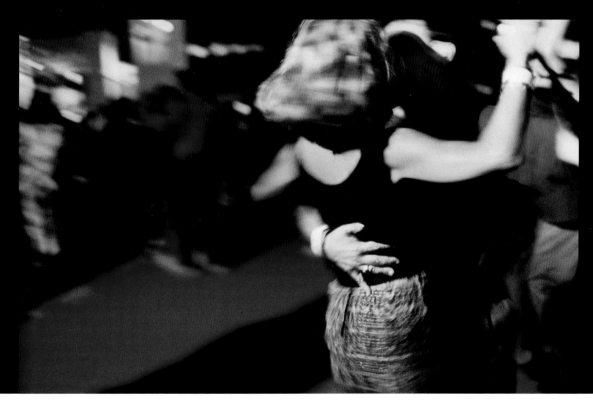

Deborah Whitehouse used a strobe synched to a slow shutter speed to balance the crispness of her flash with the movement of the figures in this ballroom-dancing shot. In order to work quickly she zone focused her lens while moving with the dancers. Her efforts to get in close to the action paid off in the tack-sharp detail on the man's hand.

© DEBORAH WHITEHOUSE

	LEFT		RIGHT
Camera	Nikon FM2	Camera	Nikon FM2
Lens	Nikkor 28mm	Lens	Nikkor 28mm
Aperture	f/8	Aperture	f/8
Exposure	10 seconds	Exposure	10 seconds
Film	Fujicolor Professional 100	Film	Fujicolor Professional 100
Lighting	ambient light plus fill flash	Lighting	ambient light plus fill flash

LEFT: Deborah Whitehouse was set up in the hallway of an Atlanta club when a woman in white walked through an adjacent doorway into the frame. Whitehouse started an exposure and called to the woman, who paused long enough for her to pop the flash. The brightness of her white dress and blond hair can be seen in clear detail, yet the movement of her arms and skirt hem became ghosted like a phantom as she moved through the frame. The woman was stationary in the image for about half of the exposure time and the hallway details continued to expose on the film after she slipped away from the scene. **RIGHT:** Ambient light from different sources illuminates two sides of this portrait made with a long exposure and flash fill. Deborah Whitehouse works on a tripod and uses a shutter speed of eight to ten seconds, then ends the shot with the pop of a strobe powered down to its lowest setting for a touch of crisp lighting on the subject. She often counts down the exposure time to indicate that her subject should remain still until after the strobe fires.

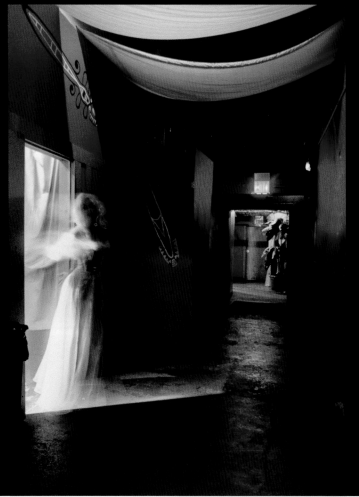
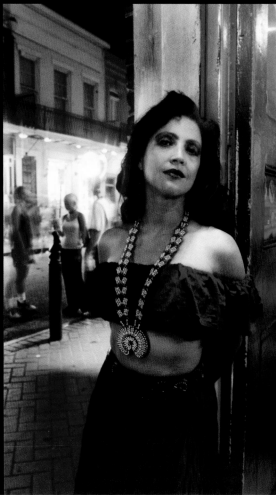

Mix ambient light with flash for an atmospheric portrait effect by setting the camera on a tripod and using an exposure of eight to ten seconds. Pose the subject and start the exposure using just ambient light. To make sure the subject does not walk away before the shot is done, wait until the end of the exposure to pop the flash.

STEWART COHEN'S WORKING METHODS

A big admirer of the unique qualities of nighttime light, Stewart Cohen is rarely without his camera after dark. He used to carry a Leica but now works with digital for both personal projects using available light and commercial assignments with professional lighting gear. Since he also shoots commercial film footage, Cohen prefers working with continuous light sources (such as HMI's or Kino-Flows) rather than strobes, that tend to create hard-edged effects.

Even when Cohen's working in situations with a lot of lighting, he likes to keep his shoots loose and kinetic. He often sets his camera's ISO at 800 in order to be able to handhold a shot. In these conditions he finds that working with a 35mm digital with a full-frame sensor is the best way to keep noise issues in check. Especially in his commercial work, Cohen is always balancing the equipment needed to sufficiently light the scene and do a good job for his client with creating images that feel natural and real. When working with models and high-powered lighting it's important to be judicious and to know the line where less can be more rather than risk overlighting a shot.

 © **STEWART COHEN**

LEFT		RIGHT	
Camera	Canon EOS-1Ds Mark II	Camera	Canon EOS-1Ds Mark II
Lens	145mm	Lens	70mm
ISO	400	ISO	800
Aperture	f/4.0	Aperture	f/2.8
Exposure	1/100 sec.	Exposure	1/30 second
Lighting	1200 par HMI/Kino flash	Lighting	Kino-Flow "Car Kit"

LEFT: In this colorful detail of a model descending the stairs, a Kino-Flo florescent light gives a soft wash to the foreground while a small HMI comes in from the back right to provide a bit of edge light on the figure. When shooting at night, Cohen will sometimes tweak the camera's white balance depending on the situation. Sometimes he'll use the florescent setting, or in situations that are heavily tungsten, he will set the white balance between 3,400 to 4,000 degrees Kelvin. At other times he sets the camera to auto white balance to test the light and then sets the color temperature to where it feels right for the mood of the shot. **RIGHT:** In the cramped quarters of a moving limousine, Cohen maximized his resources by grabbing handheld stills in addition to footage during a commercial film shoot. The driver's face was lit using tiny florescent-type tubes that were taped to the steering wheel. This miniature Kino-Flo "Car Kit" can be inexpensively rented from a cinema supply house and even comes complete with a dimmer and plug to power the unit from the car's cigarette lighter.

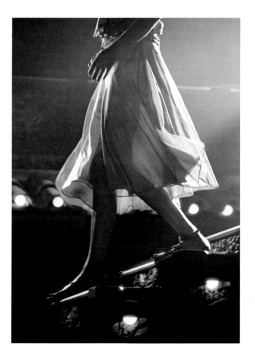

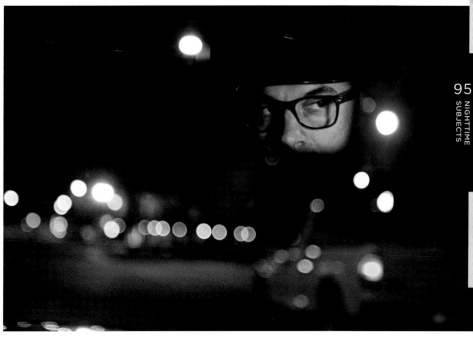

For a handy do-it-yourself continuous source lighting unit, take a florescent fixture, some daylight balanced tubes, and connect this to a power supply. When placed adjacent to the camera, just outside the frame, this unit will cast a soft quality of light on the foreground of the scene. An inexpensive specialty lighting unit that can be powered by a car battery can also be purchased from Sears.

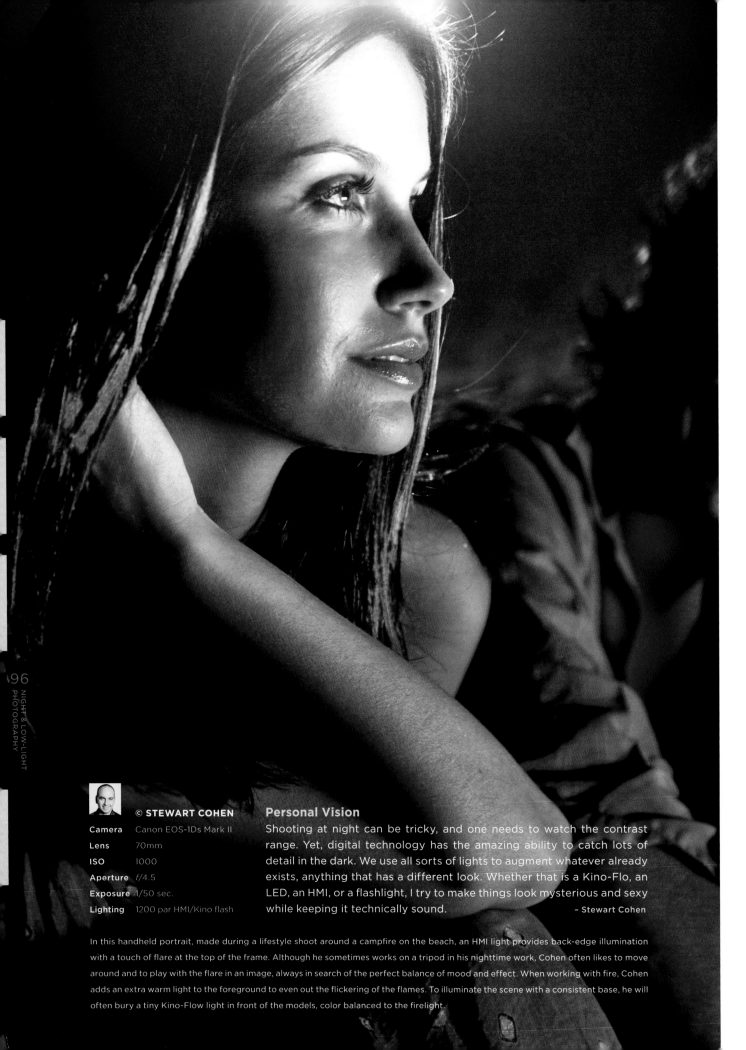

© **STEWART COHEN**

Camera	Canon EOS-1Ds Mark II
Lens	70mm
ISO	1000
Aperture	f/4.5
Exposure	1/50 sec.
Lighting	1200 par HMI/Kino flash

Personal Vision

Shooting at night can be tricky, and one needs to watch the contrast range. Yet, digital technology has the amazing ability to catch lots of detail in the dark. We use all sorts of lights to augment whatever already exists, anything that has a different look. Whether that is a Kino-Flo, an LED, an HMI, or a flashlight, I try to make things look mysterious and sexy while keeping it technically sound.

– Stewart Cohen

In this handheld portrait, made during a lifestyle shoot around a campfire on the beach, an HMI light provides back-edge illumination with a touch of flare at the top of the frame. Although he sometimes works on a tripod in his nighttime work, Cohen often likes to move around and to play with the flare in an image, always in search of the perfect balance of mood and effect. When working with fire, Cohen adds an extra warm light to the foreground to even out the flickering of the flames. To illuminate the scene with a consistent base, he will often bury a tiny Kino-Flow light in front of the models, color balanced to the firelight.

© JILL WATERMAN

LEFT

Camera Nikon F3HP

Lens 50mm

Aperture about f/5.6

Exposure 1 to 2 minutes

Film Fujichrome RDP III Provia

CENTER

Camera Nikon F3HP

Lens 50mm

Aperture f/8

Exposure about 1 minute

Film Ilford HP5 400

© RAGNAR TH.
SIGURDSSON/ARCTIC-IMAGES

RIGHT

Camera Canon EOS-1Ds Mark II

Lens 24mm

ISO 100

Aperture f/11

Exposure 4 seconds

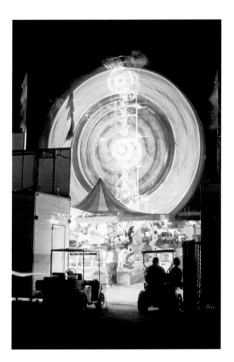
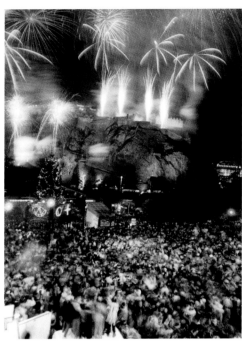
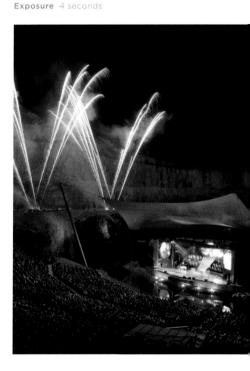

Nighttime Events

Photo opportunities during nighttime events are always popular, but success with this subject is often more a matter of careful planning than just being there to grab a quick shot. The frenetic activity or complex logistics characteristic of most events calls for directed focus as an antidote. Set parameters with a specific photographic goal in mind and then explore the periphery of both the visual and the technical elements of the scene. ◼

LEFT: The bright lights and busy activity of a fairground midway are framed by the more subdued lighting in the public-access area leading into the main subject. Shot from a tripod, the image was composed to feature the colored flags and the empty golf cart as primary elements amid a wash of color and movement. The fair workers in the golf cart at right entered the scene after the exposure had started. The exposure continued for as long as they were stationary. Although never predictable, this improvisational method for measuring exposure time can often lead to dramatic results. **CENTER:** Access was vital when shooting fireworks over Edinburgh Castle on New Year's Eve with a crowd of 20,000 people in the park below. Gaining entry to the building required a press pass, but the space for a tripod at the window ledge was strictly first come, first served. This image was made within the first minute of the fireworks display. The best shots are usually made before the magnificence of the bursts is diminished by heavy smoke that builds in the air during the show.
RIGHT: Careful planning before and during the event was the secret to success in catching the action of fireworks exploding during a concert finale in a Swedish coal mine. Before the concert began, Ragnar Sigurdsson took a meter reading off the screen on the lit stage. Positioned on a rocky ledge 800 meters above the venue and diagonal to where the fireworks would appear, he framed the scene with a wide-angle lens to include all elements, with extra room in the sky for the fireworks. He knew that reflected light from the exploding fireworks would illuminate the audience with a nice sidelight. The crucial component was to allow sufficient time for an impressive display while not overexposing the highlights of the bursts. A midrange aperture of f/11 helped keep highlights in check and allowed for the recording of detail in the falling sprays.

When challenged by shooting fireworks from a vantage point that is subject to movement—a highway overpass or the deck of a moored boat, for example—start a long exposure using a tripod and cable release, then cover the lens with a black card between each individual fireworks blast. Estimate the total exposure time based on the placement and timing of the individual bursts, and add extra time to compensate for when the card covers the lens. If the exposure is long enough, the sudden bursts of the fireworks will appear sharp against the night sky, while constant lighting in the scene will show motion-blur effects.

USEFUL TIPS FOR PHOTOGRAPHING FIREWORKS

Fireworks are popular events for photographers and onlookers alike. To ensure the best vantage point for photography, scout for a shooting location in advance, and arrive onsite well before the show begins.

A polite question posed to an event organizer during setup can often result in helpful details about the planned trajectory of bursts, special features such as color schemes, as well as the timing and duration of the show.

To guarantee image sharpness, secure the camera on a tripod and make sure to use a cable release. If this is not possible, brace the camera against a solid surface, such as a window ledge or the side of a building.

When photographing fireworks, avoid using a flash or shooting at fast shutter speeds. Use a bulb setting or a long exposure program mode and compose the scene so to comfortably capture multiple bursts in one frame.

For fireworks images with optimum color and detail, use a low ISO setting or slow speed film. Transparency film has greater contrast than print film. When fireworks are the primary subject, this film choice will generally boost color saturation and image sharpness.

Depending on the specifics of camera settings and event logistics, bracket exposures in a range from several seconds to a minute or more. Longer exposures are possible when firework bursts are brightly colored or widely spaced in the sky.

Although depth of field is generally not an issue when shooting fireworks at a distance, a mid-range aperture will result in bursts with greater detail and better color than images made with the aperture wide open.

Unless a filter is needed to protect the lens from weather or dirt, remove the lens filter to avoid the possibility of ghosting and reflections from bright lights.

For the clearest images of a fireworks display, plan to start shooting as soon as the show begins before smoke from successive bursts has a chance to accumulate in the atmosphere.

Most fireworks displays include a finale when the bursts are much more plentiful and sometimes contain a higher quantity of bright white bursts. To avoid images that are overexposed, reduce the exposure time during this part of the show.

© RAGNAR TH. SIGURDSSON/ARCTIC-IMAGES

Camera	Hasselblad H1 with Phase One P45 digital back	ISO	100
Lens	24mm	Aperture	f/10
		Exposure	10 seconds

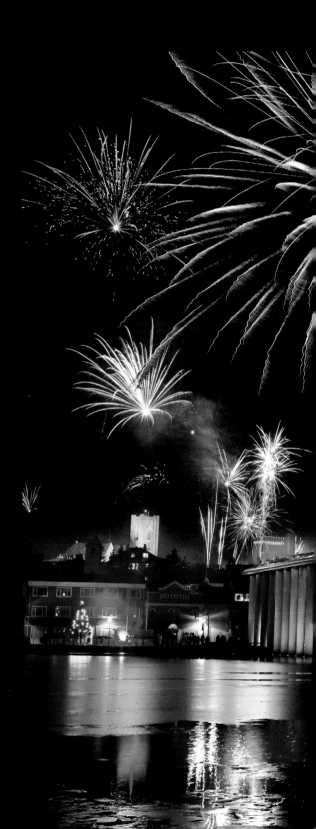

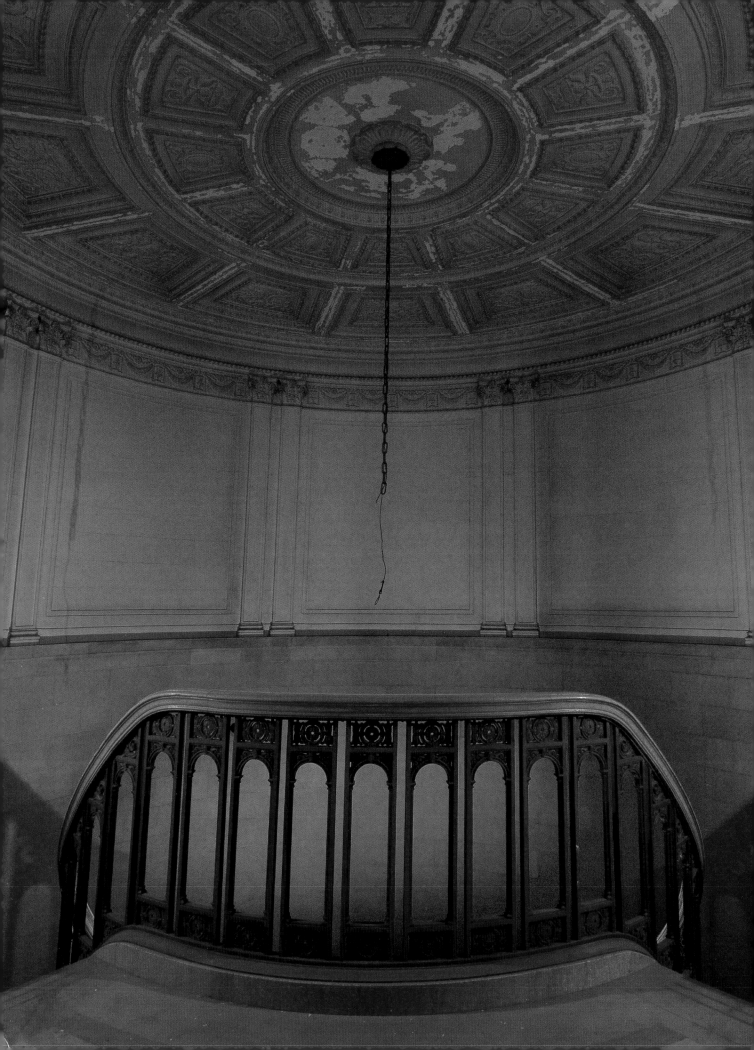

Lighting
Techniques

5

At its essence, photography is about light. Since existing light in nighttime scenes often has impenetrable darks or extreme contrast, many photographers use supplemental lighting or light painting to add richness, control, and individual expression to their work. The photographers profiled in this chapter employ carefully honed strategies for mastering the night and use a variety of lighting implements with a steady hand and studied techniques.

Troy Paiva lit this completely darkened space from outside the frame with blue- and red-gelled strobes. A fundamental principal of successful light painting is to make sure that your remote flashes and body are not in view of the camera.

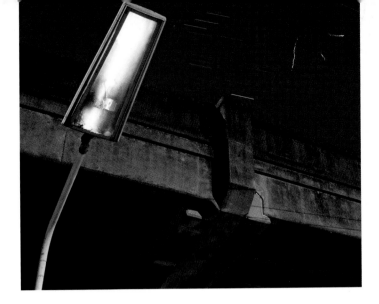

© **TIM BASKERVILLE**

Camera	Hasselblad 500C/M
Lens	80mm
Aperture	f/8
Exposure	20 minutes
Film	Fujichrome tungsten 64

Sculpting the Night with Light

The first consideration to lighting at night is to develop a keen awareness of the dimensions, contrast levels, and textures inherent in a scene. When setting up a shot, beware of extreme highlights and, if possible, plan the composition to hide or avoid direct lights inside the frame. Pay close attention to the direction in which existing light is cast, as well as any ambient light or color casts that may unwittingly act on an image. Identify areas of deepest shadows and determine how the scene might be revealed most effectively with the available lighting tools.

Be judicious in selecting the lights to work with and resist the temptation to use every tool in the arsenal or to "overlight" the shot. Pick the right lighting accessory for the desired effect and add light to the scene with a deliberate touch. In order to create dimension in an image, work from oblique angles rather than from behind, or close to, the camera itself. Foreground areas require less illumination than objects that appear at a distance, so attend to distant objects first and foremost. When working with constant source lighting keep the lights moving to avoid creating hot spots.

The immediate feedback of digital capture can be especially beneficial when working with lighting, yet make sure the LCD screen is set to the lowest brightness level for greatest accuracy in reviewing works in progress. Take notes in the field and keep a record of tools employed, exposure times, and the process used for lighting each shot. The review of these notes in postproduction will be a valuable guide for ongoing refinements to lighting technique.

When working with lighting, remember to be respectful of others, both fellow photographers and regular citizens, who may be unfamiliar with the unique activities of night photography buffs. By using keen observation together with a strategic approach, a deliberate hand, a touch of creative invention, and a bit of practice, one can transform a pitch-black scene into a dynamic space that draws from a rich palette of moods and effects in sculpting the night with light.

Illumination from this light fixture in the Presidio in San Francisco was only visible as a dim glow to the human eye, but it records as a bright light to the camera during the accumulated time of a long exposure. Intermittent cloud cover tempered the brightness of the star trails and caused them to show up as broken lines on film. The parallel direction of the roadway and the trails provides a good example of the happy accidents that can occur when shooting at night.

POPULAR LIGHTING TOOLS AND THEIR RESULTING EFFECTS

• Off-camera strobes provide illumination in consistent bursts with a crisp, hard-edged feel.

• Large spotlights offer even illumination with a softer edge and a wide spread.

• Flashlights, Mag-Lites, and penlights are best for smaller areas, yet they also offer greater control.

• Laser pointers and specialty items such as Sparklers are particularly useful for drawing with light.

• Reflectors can be valuable for adding an imperceptible touch of fill light bounced into the scene from the reflector's surface.

• Snoots or cookies will help to direct light onto a scene at a focused location or in a specific pattern.

• Gels are available in a wide range of color casts and are placed over lights to add color to a scene.

TIM BASKERVILLE'S WORKING METHODS

Tim Baskerville has been making nocturnal images since the late 1970s. Working in and around his hometown of San Francisco, he has developed an experimental and experiential approach to his composition and lighting that adds an edge of mystery to his work. Rather than being highly structured and technical in his working methods, Baskerville improvises and adapts his techniques to whatever is needed for any given site.

Baskerville shoots with a medium-format Hasselblad and prefers using tungsten-balanced Fuji ISO 64 transparency film for his work. Harsh lighting from mixed sources is a factor in many of the environments he frequents. The combination of high-contrast light and the limited exposure latitude of a film positive makes him particularly attentive to the placement of elements like streetlights or other bright hot spots. Experience has taught him to manage these situations with in-camera dodging whereby he actively crops out unmanageable highlights from a scene by carefully setting up his framing and camera angle. He recommends the following options to isolate lights and separate them from the framing of an image:

• Control the contrast by framing the image so that lights are outside the edges of the frame.

• Obscure direct lighting by placing light sources behind other compositional elements.

• Shoot from a high vantage point. This will isolate street-level lighting below the frame to minimize direct glare while still allowing lights to cast an ambient glow on the scene.

• Drop the composition to a low camera angle. This will cause street-level lighting to be pushed above the edge of the frame.

For Baskerville, it's important that the image results from a compression of time. He prefers working with film over digital capture precisely because of the extra time needed to complete an exposure—during which synchronistic happenings and subtle atmospheric effects can occur. He finds this implied sense of time to be particularly appealing as an underlying concept in his work.

Baskerville's working methods are highly process oriented. He previsualizes what he wants to get from a scene and then gets involved with the frame by adding light. He prefers to work with small 3D- and 4D-cell Mag-Lites because of their intuitive, painterly control and subtle lighting effects. Lately, he has added various LED flashlights from Inova and compact, high-powered incandescent tactical flashlights by SureFire, as well as larger 1-million to 3-million candlepower lights to his arsenal of nocturnal illumination. He judges the exposure time for each situation on a case-by-case basis and generally relies on past experience in factoring his exposure time rather than using a light meter, which might be ineffective in these low-light situations. Since his film speed is slow and the direct lighting is limited, his exposures often last between 10 to 30 minutes.

Cross Lighting

Cross lighting can help to control the high contrast and deep shadows often present in nighttime scenes. With this technique two lights are directed towards the subject from opposite sides of the camera. When lights of similar intensity are positioned equidistant from the subject at 90 degrees from the camera to subject axis, shadows can be minimized to the point where an object appears as if it is suspended in the scene. This is a real-world extension of the copy-stand lighting techniques that are commonly applied in tabletop or macro photography setups.

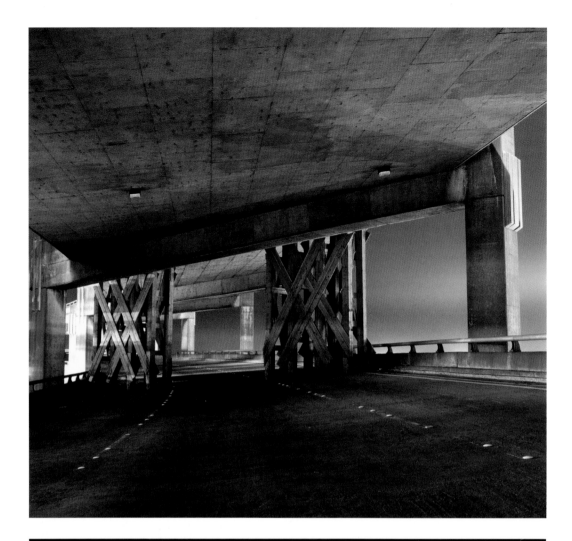

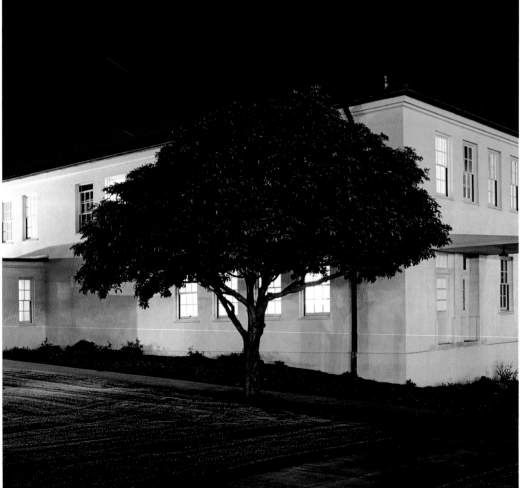

 © **TIM BASKERVILLE**

OPPOSITE TOP		OPPOSITE BOTTOM	
Camera	Hasselblad 500C/M	Camera	Hasselblad 500C/M
Lens	80mm	Lens	80mm
Aperture	f/8	Aperture	f/11
Exposure	10 minutes	Exposure	15 minutes
Film	Fujichrome 64 tungsten	Film	Fujichrome 64 tungsten
Lighting	ambient urban light, flashlight	Lighting	heavy urban ambient light and fog, Mag-Lite

TOP: When framing this image, Tim Baskerville positioned his camera at a low angle to avoid the streetlights visible at eye level. He knew the lane dividers were reflective, so he shined a Mag-Lite across the surface of the roadway to accentuate the dots. Foggy weather conditions allow the ambient light to lighten the background sky. **BOTTOM:** Green foliage sucks up light, but cross lighting helped to bring out both the color and texture of details that were otherwise hard to capture around Building 220 of the Presidio in San Francisco. A flashlight was used at opposing 45-degree angles to create the lighting effect on the tree and lawn.

TIM BASKERVILLE'S TECHNIQUE FOR SUBTLE CROSS-LIGHTING EFFECTS

When adding light to a situation, Tim Baskerville often uses different applications of cross-lighting techniques for subtle illumination of his subjects to achieve a variety of effects. Two aspects of this technique were applied to the image at lower left to brighten the foliage and add dimension and texture to the grass.

Lighting to Achieve a Balanced, Shadowless Effect

The human eye is accustomed to light that creates shadows from a single direction. This technique will erase or "soften" shadows and give an object a slightly unreal look of floating in space. It was used to light the foliage in the image at lower left.

- Position yourself outside the image area at the same height as the object, and light it from an equal distance on both sides of the scene that is framed.
- Standing at an oblique angle, shine a flashlight toward the foliage while moving the light in a slow but steady motion to illuminate the front of the tree evenly.
- To ensure balanced lighting, use a timer or manually count down the time spent lighting each side.
- Because of their deep green hue, which often renders as black in low light conditions, foliage and heavy shrubs generally require a greater amount of lighting in order to show color and detail in the dark. With this subject, a general benchmark for adding light is 20 to 25 percent of the overall exposure.
- Be careful not to "overlight" the shadows, in order to maintain the mood that drew you to the scene in the first place.

Lighting to Achieve Texture

This technique was used to light the grass in the image at lower left.

- Position yourself at a low angle, and work from an equal distance on both sides.
- Starting at a distance, shine the flashlight across the surface (in the case at lower left, the surface of the grass) in a slow but steady motion to illuminate the area contained within the frame.
- Spend less time lighting the foreground because the strength of the light will increase as it gets closer to the object being lit.
- Keep the light low to the ground, and skim the surface closely. In the image here, this created little shadows behind each blade of grass and added texture and dimension to the field.

The power of the flashlight used and the distance between the light and the object are key factors for determining how much time is needed to light the object. Practice makes perfect, especially when seeking to achieve subtle effects. Make tests to get familiar with your tools and take detailed notes to allow accurate interpretation of your results.

When you add light to an image, start with a benchmark of about 10 percent of the overall exposure. The scene will also accumulate light over time from ambient sources, so during a ten-minute exposure, light painting for no more than one minute should be a good place to start.

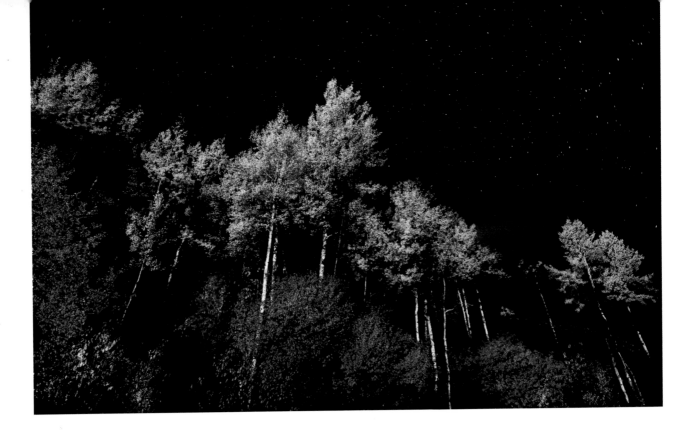

Light Painting

A creative technique that is especially well suited to low-light and nighttime shooting conditions, light painting employs supplemental lighting tools to add detail, dimension, drama, and / or color to an image. Common tools used for light painting include strobes, spotlights, flashlights, or other types of portable lighting—with or without colored gels. Snoots can be useful to direct and contain light to specific areas of an image. Reflectors can be employed to bounce light indirectly towards a scene for soft fill effects. For further details about the range of equipment that can be useful for light painting, see page 32.

Each light-painting tool produces a different feel in an image and, as with any new technique, there is a learning curve to master the tools for best results. Keep in mind that with a technique such as light painting, it can be overwhelming to begin with a larger-than-life subject. Master the concept with a small object or still life and then work up to larger subjects and landscapes.

Successful light-painting technique is often a question of speed. A light held in one spot for a long period of time will result in a hot spot, but if it is kept moving, the light will take on an amorphous glow. Each different lighting instrument has a different diameter, intensity, degree of spill, and throw. It is important to select the right tool for each situation.

The varied effects that can be created when light painting might best be compared to the distinctive marks of an individual's fingerprint—every exposure will be a little bit different. But it is specifically this challenge and uniqueness that many photographers find creative and fun.

Dave Black revealed the autumn splendor of Aspen trees outside Jackson Hole, Wyoming, against a magnificent starry sky in this exposure. To maximize the abundance of stars recorded in the shot, Black boosted his ISO to 400 and opened his aperture to its widest setting of f/4. He waited until clouds obscured the moon to lessen the ambient light on his subject. It didn't take much to illuminate the trees, so he used his spotlight sparingly. The combination of a 12mm lens and the centering of the North Star at the top of the image helped to hold the stars fixed in the sky and kept the length of the star trails in check. The location's high altitude and clear, dry climate also helped to make the stars pop.

DAVE BLACK'S WORKING METHODS

As a commercial sports photographer, Dave Black has been sculpting form and revealing space with light for many years. When he began light painting small still lifes and outdoor landscapes in his personal work in 1999, he first experimented on film. After running tests with both digital and analog cameras, he decided that digital capture provided the soft painterly quality he was looking for, with smooth transitions from darks to lights.

Black uses several different lighting devices depending on the subject matter and distances involved. For macro work or still lifes, a tiny Stylus Streamlight penlight allows him to light small objects with a high level of precision that can be controlled through either a momentary blink or a constant ON switch. He carries a compact Inova XO3 LED flashlight at all times. The light output is very bright, and the color temperature is just a touch cooler than daylight. When light painting, this flashlight can easily illuminate a person or midrange objects. It's also generally useful in areas that require a touch of fill light.

For landscapes, Black's current tool of choice is the Brinkmann Q-Beam spotlight. He recommends 2 million candlepower rather than the less powerful 1 million model or the larger models, which are bulky and hard to maneuver. Portable spotlights are made by several other brands, but the Brinkmann is light, powerful, and has an easy-to-load rechargeable battery. It has a slightly warmer white balance than true daylight and is well suited to Black's aesthetic.

To light paint outdoors at night, Black recommends arriving early at the site. Surveying the area and preparing a strategy for lighting the scene before it gets dark will allow more productivity after nightfall. While it's still daylight, set up the tripod, frame the shot, focus the image with the camera's autofocus control, and then turn the autofocus off. Once the sun has set, it will be much more difficult to compose and focus on the subject. If needed, a spotlight can be turned on to focus an image in the dark. It's important to realize that spotlights don't last long on one charge, however, and this method wastes valuable battery life.

Black generally shoots at ISO 100 unless factors of exposure time or preferred contrast dictate a higher sensitivity. He starts out with his lens set to f/8 and shoots a baseline image with no illumination. From this, he will study the lighting situation and evaluate any ambient light that may be seeping into the shot. If he's happy with the framing, light balance, and exposure time of the subject in silhouette, he'll begin painting with his second shot and then refine the image by studying the histogram and flashing highlights on his camera's LCD preview.

When determining the exposure for a light-painted scene, Black uses the ambient light of the background as a benchmark, and then factors the following variables to give him a well-exposed image after he reveals his subject with light:

• The size of the subject to be painted.
• The power of the spotlights.
• The relative distance between subject, camera, and lights.
• The speed and pattern of illumination used to light the scene.

When he's light painting tabletop still lifes in a darkened room, his exposure times might average from 15 to 30 seconds, but outdoors, he may expose a darkened landscape for 2 to 5 minutes or longer. For best results, Black advises not to rush and to be thoughtful and painterly about the process. The darker the overall situation, the longer and more contemplative one can be when revealing the subject with light. Keep in mind that complications can arise when light painting for too long. In addition to the power drain to lights and the camera battery, it's easy to lose track of one's progress in painting the scene. Areas that receive too much light will overexpose, and areas that are overlooked will block up.

For most of his outdoor scenes, Black handholds two lights and paints with both hands. He illuminates the scene from an oblique angle, which is sometimes more than 100 feet away from his camera position. He uses a self-timer or infrared remote to trigger the shutter once he is in place with his lights. The pistol grip on his spotlight has a sensitive trigger, and Black has perfected the following technique for feathering his light by flicking the trigger of the unit and allowing the illumination to slowly fade: Turn the light on full blast while it's pointed away from the subject; then, remove your finger from the trigger, and turn the unit back toward the subject as the bulb slowly reostats out. As the spotlight dims, the color temperature gets warmer and warmer and creates beautiful sun-ray streaks. For more about light painting and other photography tips, Dave Black's Web site (www.daveblackphotography.com) has multiple sections with images and techniques that are updated monthly.

© **DAVE BLACK**

Camera Nikon D200

Lens Nikkor 17–55mm 1:2.8 zoom at 35mm

ISO 100

Aperture f/8

Exposure 13 seconds at EV -2

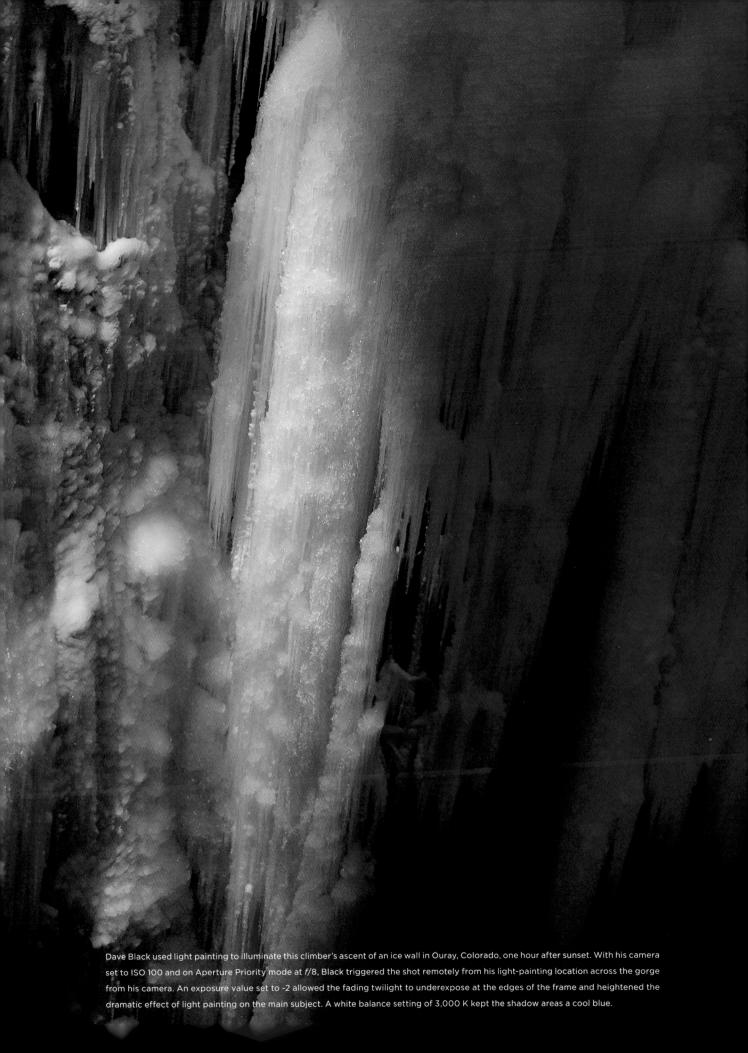

Dave Black used light painting to illuminate this climber's ascent of an ice wall in Ouray, Colorado, one hour after sunset. With his camera set to ISO 100 and on Aperture Priority mode at *f*/8, Black triggered the shot remotely from his light-painting location across the gorge from his camera. An exposure value set to -2 allowed the fading twilight to underexpose at the edges of the frame and heightened the dramatic effect of light painting on the main subject. A white balance setting of 3,000 K kept the shadow areas a cool blue.

© **TROY PAIVA**

OPPOSITE: When the aperture is stopped down on the lens, you can still visually see the strobe lighting hit the subject, but the camera will not record the effect of the strobe in your image. This test shows a lighting setup photographed with similar exposure values. Troy Paiva kept the shutter open for increasing amounts of time to compensate for increasingly smaller aperture settings. It's the *f*-stop that causes the drop in flash distance, not the time. The more you stop down, the shorter the distance before falloff happens.

TROY PAIVA'S LIGHT PAINTING TECHNIQUES

An avid urban and ghost-town explorer, Troy Paiva is a master of light painting with an assortment of gelled strobes, Mag-Lites, LED penlights, and a million-candlepower spotlight. He sometimes visits up to five sites a night and may travel hundreds of miles in his urban explorations. His equipment needs to be compact, easy to carry, and practical to deal with.

Paiva powers his Vivitar 285 flash with a Quantum external battery unit strapped to his waist. He always works with the flash at full power, because colored gels can cut the intensity of the flash by as much as 50 percent. Darker colors, especially blues and purples, cut the intensity the most. Paiva works primarily with gels made by Roscoe, a manufacturer of filters for stage lighting and theatrical events.

For a reliable benchmark in judging exposures, Paiva keeps the ISO of his Canon 20D at 100. He generally works with his camera on MANUAL, uses the BULB setting, and keeps his aperture at *f*/5.6. If the aperture is closed down to a smaller setting, the resulting flash falloff will kill the intensity of the light that hits the subject.

In each situation he photographs, Paiva previsualizes where he will place himself with his lights, as well as how the direction and color combinations of the lighting will play out to achieve his desired effect. To illuminate a large area and retain shadow delineation, he recommends popping a strobe multiple times and pivoting on a heel from one central point before each pop. When moving around to light the space and popping the strobe from many different positions, the lighting that results will flatten the scene.

Every object has a different degree of specularity, so Paiva gives careful consideration to the materials he lights. Matte finishes and lighter-colored objects illuminate better than shiny finishes and darker colors. Multiple pops of a strobe or extra time with a flashlight are needed for dark or shiny objects. Photographing expansive scenes with a long relative distance between the object, camera, and lights will require more lighting. Paiva knows from experience that his gelled strobes have a maximum distance of about 25 feet, and his strongest flashlight will give good light up to 100 yards or more. When he was shooting with film, he spent years experimenting and taking notes. Now that he's working digitally, he can preview images on the fly to fine-tune his lighting until he gets exactly what he wants.

When he's light painting a scene, Paiva works from broad strokes to finer details. If he's using an electronic flash in an image, he'll generally start with that. The illumination from a direct flash will light the entire scene either with white light or with an overall color if a gel is applied to the front. In order to achieve maximum subtlety and detail in his images, Paiva pays close attention to the shadows caused by the strobed light source, and he considers illuminating these areas with flashlight fill.

When lighting a scene already illuminated by strong ambient light (such as bright moonlight), Paiva recommends concentrating the light painting on shadow areas rather than spots that are brightly lit, since adding light to bright areas will show little added effect, and will also increase contrast and risk overexposing the highlights.

Paiva suggests the following handy technique to temper the effect of colored illumination spilling onto the highlights of an object painted with a gelled light source: Light paint the object with the lighting tool that has the optimal power, size, and color temperature for the given situation; then keep the exposure going for an additional minute or two after the light painting is completed. This extra exposure will allow the ambient light that bathes the scene to bleach the color cast from the object's highlights.

Paiva's style and technique are the result of years of experimentation—and a great deal of trial and error with balancing colors and lighting effects. His early background in theater and 3-D computer modeling plus his current occupation as a graphic designer inform his work, too. Experience has taught him that, when it comes to light painting, sometimes less is more. Over the years, he has observed that many inexperienced light painters get carried away with gels and use the full color spectrum in one shot. As Paiva advises, the occasions are very rare when you really need—or can get away with—that degree of lighting in an image. That said, it's no secret that, whether painting with light or practicing other styles of night photography, the palette is wide open to experimentation and new mutations of creative techniques. Paiva likes to say, "There are no rules, only guidelines." Additional details about Paiva's techniques for light painting can be found on his Web site, www.lostamerica.com/technique.html.

When light painting, use your body as a snoot to selectively block illumination from parts of your image. Stand backwards or sideways with the light behind you, and aim it obliquely at the area you want to illuminate.

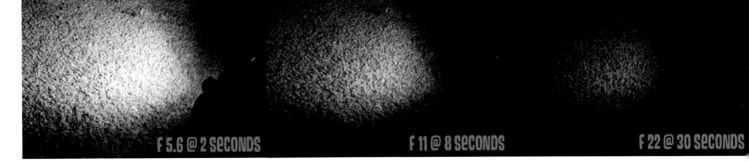

F 5.6 @ 2 SECONDS F 11 @ 8 SECONDS F 22 @ 30 SECONDS

© **TROY PAIVA**

LEFT		RIGHT	
Camera	Canon EOS 20D	Camera	Canon FX
Lens	12–24mm F4.0 zoom at widest setting	Lens	Vivitar 19mm
ISO	100	Aperture	f/5.6
Aperture	f/5.6	Exposure	8 minutes
Exposure	94 seconds	Film	Kodak 160 tungsten

LEFT: Complementary colors amplify the three-dimensional effect of this corrugated metal wall. Troy Paiva added color to the rippling metal by standing on opposite sides of the camera close against the wall and aiming a purple-gelled flash from the left and a yellow-gelled flash from the right. The colored rectangle around the number 5 was made with a red-gelled flashlight and its natural falloff. **RIGHT:** The skeletal structure of a former bank makes an ideal subject for strobe-lighting effects. Troy Paiva fired six to eight pops of a red-gelled strobe from a single location inside the ruins out of the camera's angle of view. He pivoted 180 degrees with the flash to illuminate both sides of the interior making sure to overlap the light evenly.

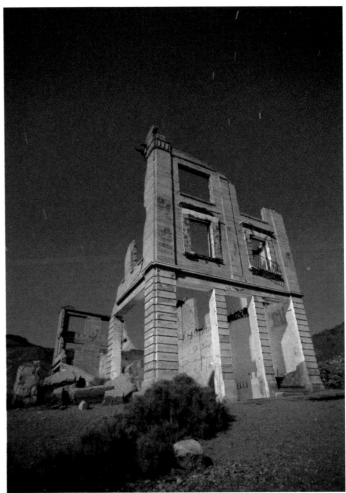

Light painting is all about oblique angles. To create a three-dimensional lighting effect with complementary colors, stand to one side of a textured object and pop a gelled flash toward your subject. Then move to the other side and pop another flash using a gel of the complementary color.

© **TROY PAIVA**

Camera	Canon EOS 20D	Lens	12–24mm F4.0 zoom at 17mm
ISO	100	Aperture	f/5.6
Exposure	63 seconds (OPPOSITE)		
	73 seconds (BELOW)		

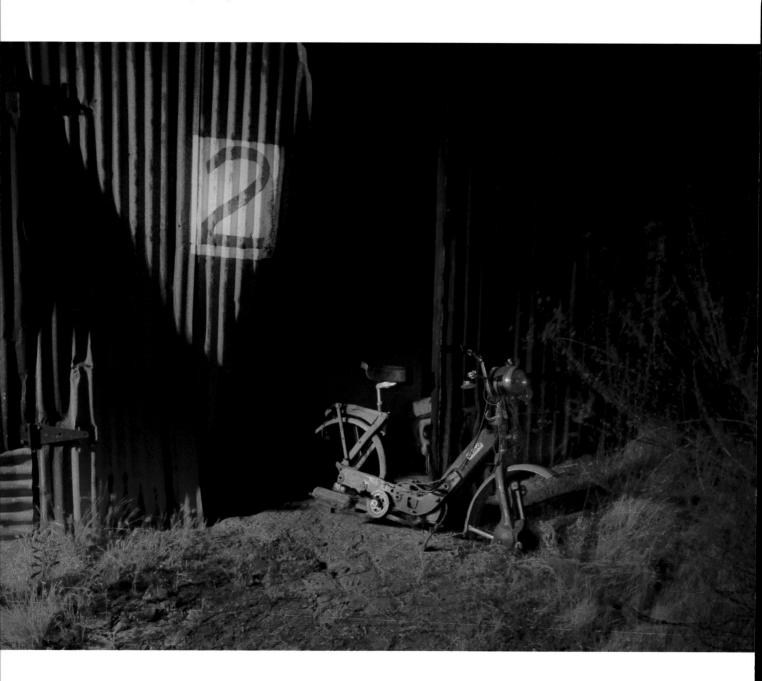

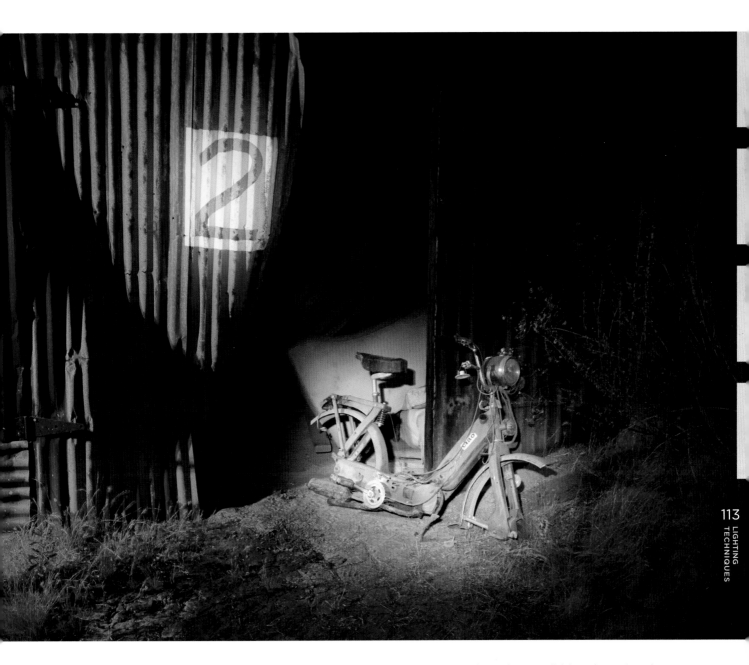

A master at mixing colored gels and multiple lights, Troy Paiva treated the same scene with complementary lighting schemes. In each image he added dimension to the corrugated wall by popping a flash close against it from the left. In the green image, the moped and number were painted with ungelled incandescent flashlight. In the red image, he used a green-gelled flashlight. Both pictures were captured digitally at a remote California ghost town at about 2 a.m. with the scene in deep "moonshadow."

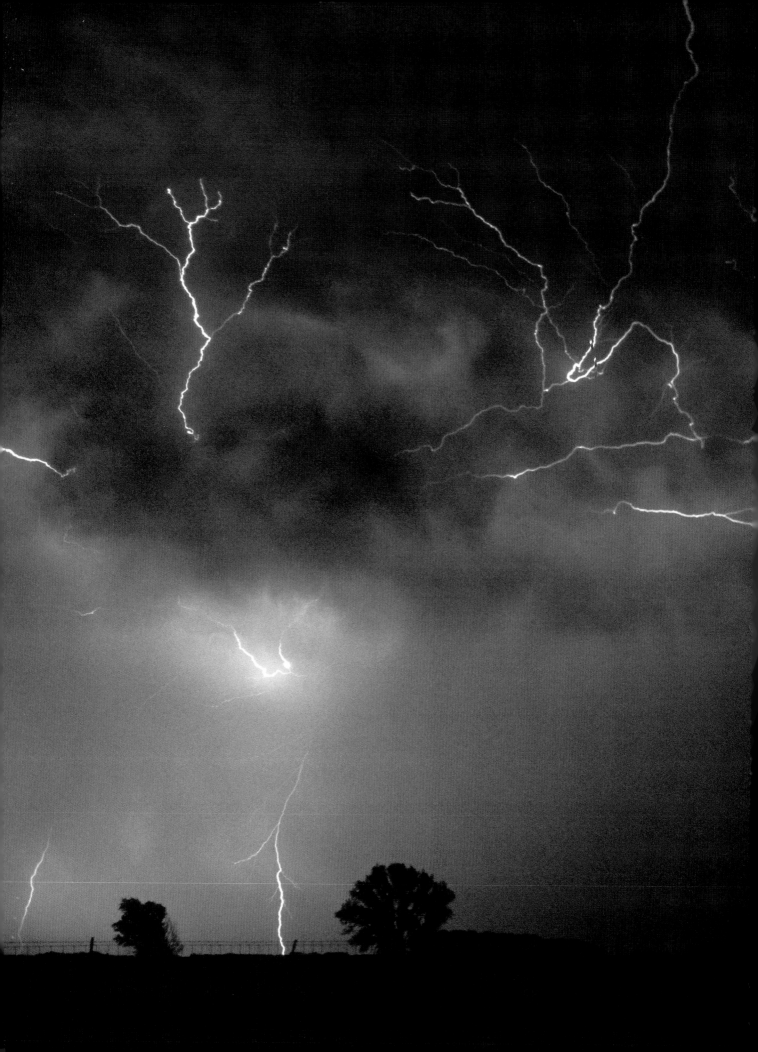

6

■ Weather

When the sun disappears and the earth settles into darkness, other elements begin to assert their influence on scenes recorded by the camera's shutter. Although images can be more challenging to capture in active weather, the results are generally unique and dramatic. Humidity levels in the atmosphere begin to rise after dark, and these conditions can act on an image to produce effects that range from a subtle touch of mist to a pervasive veil of fog. Wind can be disruptive to long exposures; however, when properly managed, it can provide a great image-making challenge. Rain and snow are far from ideal conditions for photography, yet intrepid photographers can benefit from the jewel-like effects that occur after dark when precipitation interacts with light. Recording severe weather on film is a serious endeavor, so always consider safety first. With this subject matter, dramatic pictures and a respect for the elements always go hand in hand.

Cloud-to-cloud crawlers and cloud-to-ground lightning bolts strike near a tree and light up the night sky. Jim Reed captures his most scenic shots of lightning by getting into the rhythm of the storm. He opens and closes his shutter almost musically to meet the bolt an instant before the lightning strikes.

© **TIM BASKERVILLE**

Camera Hasselblad 500C/M **Exposure** 30 minutes

Lens 80mm **Film** Fujichrome 64 tungsten

Aperture f/8

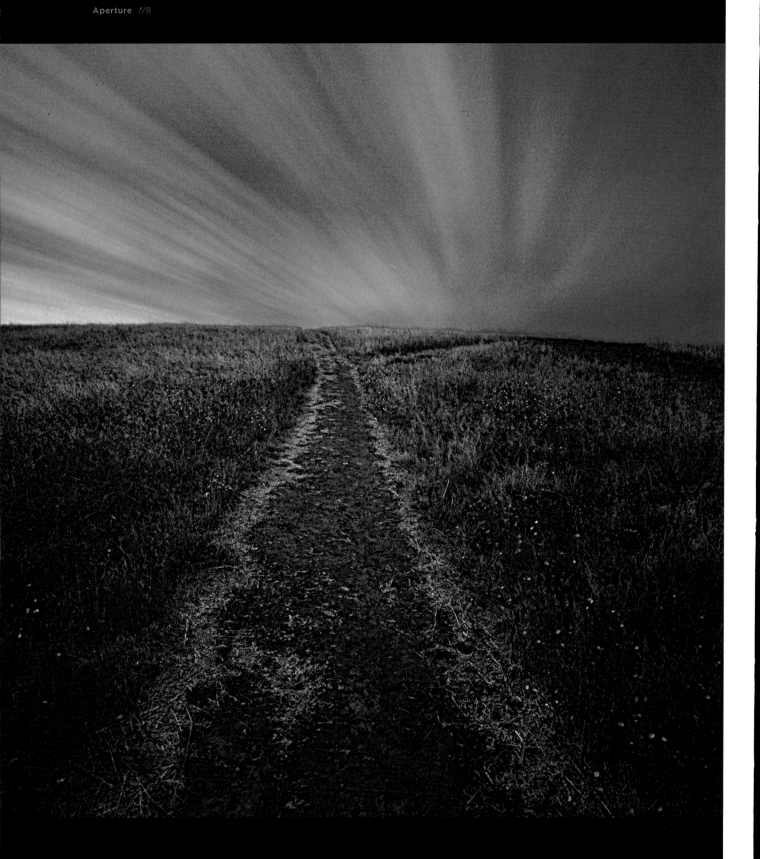

Clouds moving toward the camera recorded on film as ribbons of white against the deep blue sky. Clouds moving across the frame would have blended to mush during this long film exposure. A touch of light painting was used on the foreground to subtly define the path in relation to the grassy fields.

Clouds

Although clouds make an easy subject for scenic daytime snapshots, the key challenge to photographing them at night is to mesh a longer exposure time with cloud movement. Determining the direction of this movement should be the first step. It's sometimes hard to do this by sight, especially if the clouds are moving slowly. Since clouds generally move with the prevailing wind at their altitude, the most effective way to determine the direction is to line the edge of a cloud up against a stationary object and track its progress. Other, less conclusive options for determining direction of movement include feeling the wind against your body or referencing an object blowing in the breeze.

If lighting conditions require a long exposure or if the clouds are moving quickly, a vantage point that positions cloud motion toward or away from the camera (perpendicular to the film plane) will yield the most definition in the sky. If the camera is pointed so that the clouds are moving across the frame, the sky may turn to a blurry mush within 30 seconds to a minute.

One photographic option for this subject is to maximize the relative contrast that exists between the clouds and the night sky. Setting a higher ISO under these conditions will boost contrast and reduce the exposure time needed to record the scene properly. Use of a wide aperture setting can also help trim the exposure time. This is especially useful if clouds are faint and if the foreground contains no close-up detail so that limited depth of field is not a concern. If the conditions are right, it will allow for maximum separation between the sky and the clouds.

Mist and Fog

Moisture in the air spreads light magically, sometimes extending it much farther than one might realize. Since atmospheric conditions may appear to the eye quite differently than how they are recorded by the camera, nighttime photography in these settings is an inexact science.

Mist and fog will tend to lower contrast in a scene. This can have beneficial results for photography; however, estimating exposure times in these conditions can be challenging as less stable weather can change dramatically in the window of a single exposure. Added light carried by mist or fog may trick the meter into reading the scene as brighter than it really is. This is the same principle as photographing a snow scene, where the predominance of brightness will result in a meter reading that registers as 18 percent gray rather than white. In order for fog or mist to appear on film as bright as it does to the eye, use the exposure indicated by the meter as a starting point, and then increase the exposure by 1 or 2 stops, especially if there are light sources in the scene. In these situations, bracketing exposures is highly recommended as added insurance for good results.

! To best capture clouds in a darkened night sky, consider using a faster ISO and a wider aperture setting. This will shorten the exposure time and increase the contrast of the scene.

© JILL WATERMAN

Camera	Nikon FE
Lens	Nikkor 50mm
Aperture	f/5.6
Exposure	1 to 2 hours
Film	Kodak Lumiere X

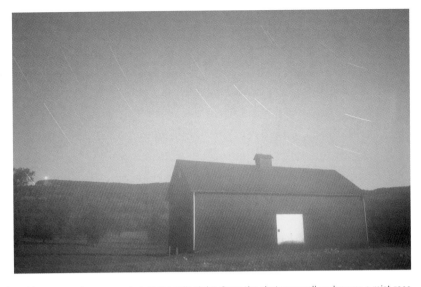

The atmosphere was clear and dry when this exposure began on a bright moonlit night. Once the shot was well underway, a mist rose from the valley to cover the ground with an impenetrable blanket of white, just below the height of the tripod. Above this line of mist, the atmosphere remained crystal clear. The effect of the increased humidity level recorded on film with a uniform soft-focus effect, which was very different from how the scene looked to the eye.

Moisture particles can interact with light to create stunning visual effects. Under atmospheric conditions, light radiating from behind an object can create shadows in thin air. This effect is intimately linked to an ideal angle of view, otherwise known as the sweet spot of the light. When setting up in this type of situation, establish a basic composition first, and then move the camera slowly on a tripod, carefully shifting height and angle of view to the position where the effect of light and shadow is at its most acute.

Atmospheric conditions can draw artificial lighting like a magnet. While it may not be readily visible to the eye, this may result in a misty scene with a pervasive color cast. An awareness of color temperature and different types of light sources is especially useful in these situations. This can provide an opportune time to make creative adjustments to camera white balance, as well as to pull out flashlights and gels to experiment with the effects that occur when the atmosphere is mixed with color and lighting.

LENS FOG

An unforeseen challenge that can arise in moist or humid conditions is lens fog. This can often occur in the process of a long exposure when the temperature reaches the dewpoint. Moisture on the lens can seriously interfere with, or totally block, light passing through it. This can result in soft blurry images or even frames that register no exposure at all. When photographing in humid conditions, keep an eye on the lens, and if fog has accumulated, carefully wipe it with a tissue or a soft cotton cloth. If the environment is dark and the exposure time is lengthy, the interaction with the lens shouldn't compromise the image as long as the equipment remains totally still.

In conditions that are prone to lens fog, adding a clear filter can protect the optical glass from direct exposure to moisture; however, this may cause ghosting or flare in an image if direct lighting is present in the scene. A lens hood can also help reduce moisture buildup on a lens. Other methods to prevent lens fog involve heating the lens so that it's warmer than the dewpoint. Astronomy buffs use portable heating devices for their telescopes to keep optics free of moisture. Accessories such as telescope dew chasers or heat ropes are designed to be wrapped around a lens and attached to a low-voltage power supply. Another way to keep the lens moisture-free is to attach portable hand warmers to the lens barrel. In these situations, it's advisable to attach the heating device before the lens fogs up, since it can be time consuming and difficult to eliminate moisture that has already condensed.

Without ignoring proper security measures, keep cameras and equipment outside or in your car several hours before going out to shoot so that the gear will acclimate to exterior temperature and humidity levels. This will limit the risk of the lens fogging up

! A tree with a thick, immovable trunk and thin branches that wave in the breeze can make an ideal subject to photograph on a windy night for an image that contrasts the stability of the base with the elusiveness of the moving branches.

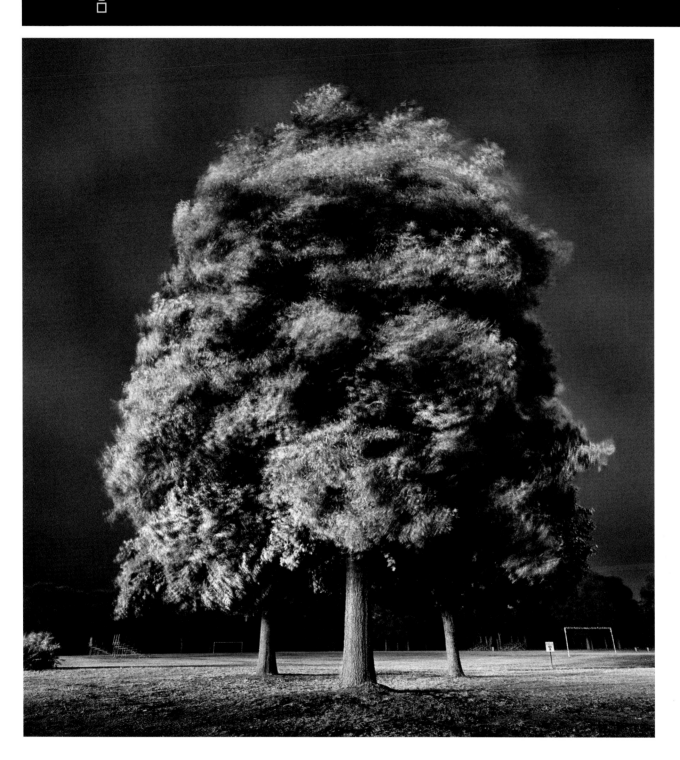

The three trees in this image are cleverly merged into one through careful observation and camera placement. To make the most of rustling trees on a blustery night, Chip Forelli broke down the required 6-second exposure time into three 2-second intervals. He opened the shutter while the lens was covered with a black velvet board and then moved the board away during each gust of wind until his exposure time was completed.

Wind

Although it's often thought to put a damper on night photography, wind—when properly managed—can result in distinctive visual effects. In windy conditions, the equipment used is an important factor in image-making success. A sturdy tripod is indispensable, and sandbags can also be handy to secure the tripod with extra weight at the base. Some tripods are designed with a hook underneath the center column from which a heavy item such as a camera bag can be suspended. When using this method, make sure the object is not suspended in midair and, therefore, subject to movement. If a long cable release is attached to the camera, secure it with tape or in some other manner that will prevent it from moving during a long exposure and contributing to camera shake.

Site selection is all-important to maintaining control when the wind is an active element in the image. Choose a vantage point that provides a good view of the desired scene yet offers the camera some protection from the elements. To reduce the likelihood of camera movement in a high wind, keep the tripod low to the ground. When selecting the subject and composing a shot, look for opportunities to contrast the motion caused by the wind with solid areas or immovable objects that will lend stability to a scene in flux.

Windy conditions can also provide a good opportunity to experiment with lighting or stop-action strobe effects. When lighting is used judiciously to illuminate the scene and freeze motion for an instant within a longer exposure time, an image with added dimension and atmosphere may result.

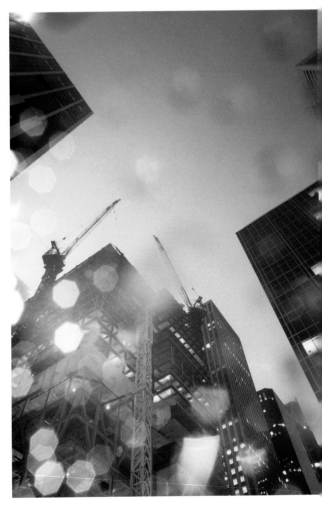

Rain and Snow

Night photography is never easy, and the challenge of facing the darkness in foul weather with camera gear in tow may seem like an unpleasant suggestion and a futile effort. Yet images that result from excursions made under these circumstances are often surprising. While the motivation to venture forth in rain or snow can be difficult to muster on an individual basis, finding a shooting partner with whom to tempt the elements and share valuable resources might provide the needed impetus for a different kind of image-making experience. Consider this: From the pioneering work made in snow and ice by Alfred Stieglitz to prized images made by attendees of night-photography workshops, the most remarkable photographs are often made during shooting excursions on nasty nights.

© JILL WATERMAN

| **Camera** Nikon F3HP | **Lens** Tokina AT-X Pro 28–70mm zoom | |
| **Aperture** f/8 | **Exposure** 2 minutes | **Film** Fujichrome 64 tungsten |

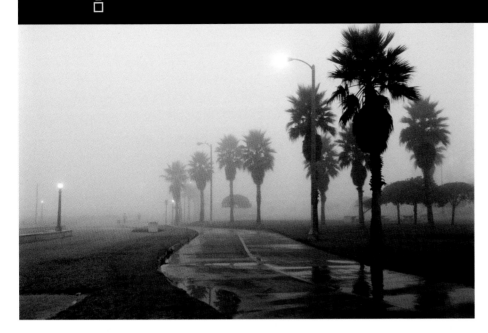

© HELEN K. GARBER

Camera	Nikon 8008s
Lens	Nikkor 20–35mm zoom
Aperture	auto
Exposure	1/15 second
Film	Kodak T-Max 400

© RAGNAR TH. SIGURDSSON/ARCTIC-IMAGES

Camera	Canon EOS-1Ds Mark II
Lens	24mm
Aperture	f/5
ISO	100
Exposure	1/160 second
Lighting	Visatec strobe lights

OPPOSITE: Inclement weather often enhances the potential for atmospheric shots. A rainy night didn't limit the possibilities for image-making at this urban construction site in Times Square. Before the rain reached its peak, the camera was pointed upward to allow raindrops to fall on the surface of the lens and create prismatic effects from the surrounding lights. The lens was wiped down with a soft towel between images, and the entire camera was carefully dried at the end of the shoot. **TOP:** Atmospheric conditions and heavy fog are common to the beach areas of Los Angeles. In these situations, Helen Garber finds that the quality of 400 speed T-Max film provides a needed boost of contrast and grain in images that suit the style of her L.A. noir theme. **BOTTOM:** A heavy wind, blizzard conditions, and a temperature of 14 degrees Fahrenheit didn't prevent Ragnar Sigurdsson from photographing a steaming hot spring on location with studio lights; his customized vehicle includes a generator to power the lights. Instead of a light stand, an assistant held the lights and umbrellas so that they wouldn't blow away on set. To freeze the steam and snow in the whipping wind, Sigurdsson synched the strobe to 1/1000 second. The camera was set to a slower shutter speed to record the ambient light and background detail.

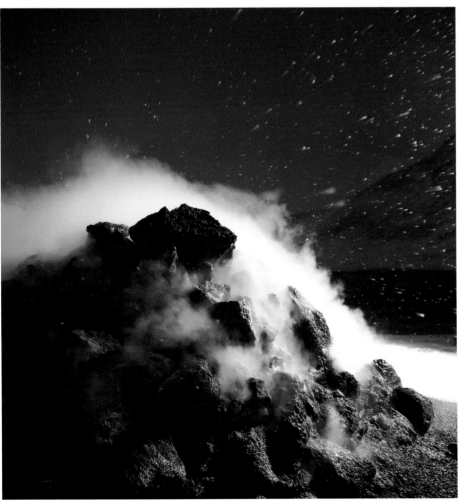

FOUL WEATHER CONSIDERATIONS

Wet surfaces reflect light in a kaleidoscopic fashion that can make the most mundane subjects glisten with photographic potential. The contrast generated from the mix of a dark and wet landscape intensifies color and adds drama to practically any situation. Objects and lights reflected in pools of wetness add a new dimension to the landscape and also become useful as light-gathering elements in a scene.

An ideal time for capturing rainy-weather pictures is directly *after* a storm. The combination of breaking weather and wet surfaces makes objects glisten in the clearing night. Streets are generally absent of people, and the rare individuals who are present can often become photogenic elements that enhance images with a sense of intrigue.

Equipment Concerns

Advance preparation before shooting in foul weather cannot be understated. It's especially important to be extra vigilant with details about handling gear. Although drenching camera equipment in water is never advised, most 35mm cameras of metal or plastic construction are sufficiently weather resistant to withstand moderate doses of moisture, provided they're dried off and maintained immediately afterward. Specialty equipment or cameras made of other types of materials may have more sensitive requirements; so if in doubt about weather resistance, make sure to check with the manufacturer first.

Keep equipment stored until you need it, and refrain from changing lenses, cards, or film when out in the elements. Carry towels and weatherproof storage bags to keep equipment as dry as possible at all times. Identify a sheltered location adjacent to the shooting area to use when an equipment change is required. If traveling with a vehicle, use this as a base of operations for equipment storage, camera maintenance, and shooting breaks. If rapid equipment changes are needed, position the vehicle so that one side faces away from the weather, and lean inside an open window to make any needed changes or adjustments.

When shooting in the rain, an umbrella or brimmed hat can help shield the camera from moisture, but water buildup can easily pour from the edges or brim, especially during movement. Be attentive to this possibility, and watch for water runoff when bending over to stow equipment or to access materials from a gear bag. A ground cloth or large plastic garbage bags can be helpful to carry during all outdoor shooting trips, and these become especially valuable in foul weather, when they can function as both insulation from wet ground and extra protection to place over gear in the event of a deluge.

When shooting in heavy rain or snow, or when moderate conditions suddenly degrade to severe weather, consider getting out of the brunt of the storm in the shelter of nearby architectural elements. Adequate visibility can be a huge issue in active storm conditions. Observe the direction of falling precipitation, and seek a shooting location that avoids direct impact. If working with a camera on a tripod, use your body as a shield and position it between the camera and the elements. When shooting in urban settings, public facilities such as parking garages can make an ideal vantage point because of their multiple levels and open-air construction.

Media Concerns

Digital media are generally well protected against moisture due to their sturdy housings. When working with film, however, it is crucial to avoid contact with moisture at all times. Use separate bags for individual rolls of film, or double-bag all rolls together as an extra precaution against the moisture absorbing into film and resulting in water damage upon development.

Desiccant beads are a commonly used drying agent that come packaged with many types of merchandise. Rechargeable desiccant containers can help control moisture in stored film and media or in a gear bag, and they can be purchased through many online suppliers. With rechargeable containers, once the silica beads change color, indicating saturation, they can be heated in a microwave or a warm oven for future reuse.

Cold Weather Battery Drain

Cold weather has a tremendous impact on battery drain. Multiple battery packs or an external supply are a necessity in winter conditions and extreme cold. If extended shooting times or large amounts of electrically powered equipment are required on a shoot, a generator may be useful if power requirements justify the extra weight and the added logistics. When carrying multiple packs, keep extra batteries warm by placing them in interior pockets or insulating them with hand warmers. If a battery becomes exhausted by the cold, warming it up may provide a temporary revival of power to allow it to fire another few shots.

Different battery technologies can make a huge difference in cold weather. Disposable lithium batteries can be extremely long lasting when used with a film camera. Most DSLRs run with custom rechargeable lithium ion battery packs specific to the manufacturer and camera model. When shooting at long exposure times in extreme cold, these packs may run through a charge very quickly, so it's always important to pack an extra supply as well as to recharge batteries promptly after use.

Condensation

Condensation can be an issue in cold-weather photography as well as in the rain. Cold exterior conditions are often much drier than warm interior air, and the increased humidity in the warm air will instantly condense on cold camera equipment. When coming inside from a winter shoot, make sure equipment is thoroughly dry and free of snow or ice. To prevent condensation, place equipment in a moistureproof bag while still outside, and keep it enclosed until it acclimates to interior temperatures. Allowing gear to warm up slowly by letting it acclimate to interior conditions in the coolest area possible, such as beside a window or in an unheated room, can also help to keep condensation in check.

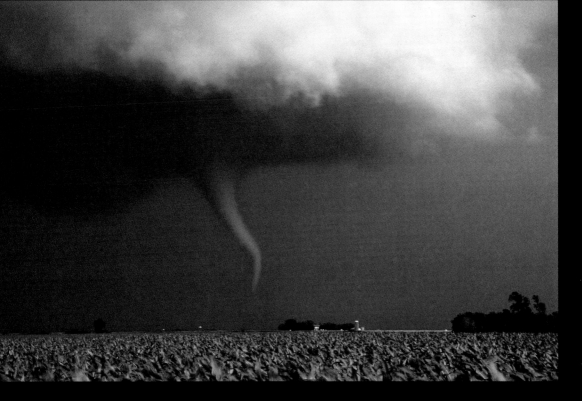

⚠ When using protective coverings over camera equipment in rainy or humid conditions, leave a bit of breathing room rather than completely sealing up the camera. Dampness that penetrates the covering and builds up inside could damage equipment if ☐ there's no potential for air circulation.

Severe Weather and Storm Chasing

Inclement weather and storm situations can yield pictures that are dramatic and unique. As the climate changes, the opportunities to shoot extreme and unusual weather related phenomena are becoming more and more frequent.

Weather photographer and professional storm chaser Jim Reed has logged over 360 official storm chases so far in his career. He is often faced with situations that are photographically challenging and extremely dangerous from a safety standpoint. Despite the perils inherent in the weather, he considers the number-one safety threat to a storm-chasing photographer to be the motorists encountered when traveling to and from a storm. Many motorists don't drive cautiously when faced with severe weather. Limited visibility and road conditions that may lead to hydroplaning are additional dangers. Reed warns anyone with an interest in shooting weather imagery to be vigilant while on the road and to avoid taking unnecessary risks.

The wind whips a cornfield in South Dakota as a tornado develops at twilight. Tornadoes are often accompanied by strong inflow winds that can require an enormous effort just to hold the tripod in place. In situations such as this, Jim Reed leans against the tripod, using his body weight to steady the legs. He also uses the automatic timer function of his camera, which he keeps set at 2 seconds.

❗ When photographing from inside a stationary vehicle,
☐ turn the engine off. Vibrations from the running motor
can cause camera shake and blurry photographs.

© **JIM REED**

Camera Nikon N90s with MC-20 remote trigger
Lens Nikkor 35–70mm 1:2.8D
 zoom at maximum extension
Aperture f/5.6
Exposure 1 second
Film Fujichrome Provia 100F

OPPOSITE
Camera Nikon D2X
Lens Nikkor 17–55mm 1:2.8 at 17mm
ISO 250
Aperture f/5.6
Exposure 1.4 seconds

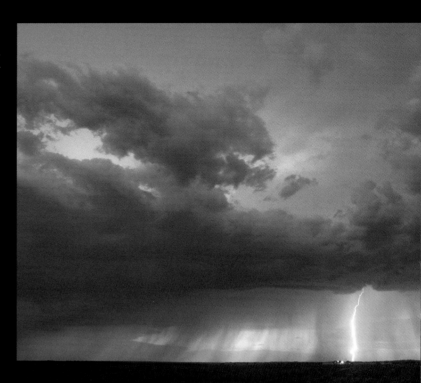

ALWAYS BE PREPARED

When he is tracking a storm, Jim Reed considers safety issues first. He's trained in adult cardiopulmonary resuscitation and carries a Coast Guard–approved first aid kit. He reviews radar returns and the most current weather updates on a laptop computer and a NOAA weather radio. He recommends the following:

For Information Gathering

- Get a NOAA (National Oceanic and Atmospheric Administration) radio. These are often built in to car radios or can be inexpensively purchased as a portable device. They provide a good heads-up, with information that's updated regularly.
- Use a laptop computer with the ability to go online inside the vehicle. A Blackberry or portable storm-tracking device will also work, but detailed Doppler radar returns may be hard to read on smaller devices.
- Subscribe to a weather service such as Weather Tap (www.wxtap.com) for access to radar, satellite imagery, warnings, and watches. This provides details on the position of lightning strikes and color codes the strikes to identify the age and frequency of the bolts.
- A two-way radio can be useful for listening to local storm spotters positioned by the National Weather Service to relay "ground truth" information about developing weather conditions.
- In certain geographic areas, truck stops and rest stops run weather devices or even radar. This can be a no-cost way to get updated information about local storm activity.
- Use a cell phone to communicate with someone "armchairing" at a remote computer to receive information and weather updates.

For Storm Tracking

- Observe the behavior of a storm, and note the frequency and placement of lightning strikes. Under ideal conditions, bolts will appear repeatedly in the same general area every few seconds. The more frequent the lightning, the better the chances of capturing a good shot.
- Assess conditions for wind and rain, and try to find a position where the equipment and the photography won't be negatively impacted by the elements.
- Once you identify a safe place for shooting, establish a vantage point for framing images that are free of visual distractions, such as utility poles, cell phone towers, billboards, and light pollution, like security lamps or street lights.
- Set up the camera on a sturdy tripod. Reed uses a tripod with an attachable plate that allows him to attach two cameras. When lightning is too close or particularly frequent, he uses a window mount that allows him to remain safely inside his vehicle while shooting.

TOP: A cloud-to-ground lightning bolt strikes during civil twilight in South Dakota. The angle of the sun, low-light conditions, and particles in the atmosphere help produce the arresting colors. No special effects filter was used. **OPPOSITE:** Jim Reed was on a storm chase with tornado researcher Jon Davies when he captured this dramatic lightning bolt from the passenger seat of a car driving at 55 miles an hour. The storm was producing frequent cloud-to-cloud lightning and there was very little rainfall. With his camera and tripod wedged between the car's dashboard and the seat, Reed played with the pan-tilt head for this dramatic angled effect. He bracketed exposures, averaging between overexposed shots and others that were too dark, until he saw this bolt flash. Illumination of the road and landscape is from the brightness of the lightning. The dashed yellow road markings record as a continuous stripe because of the long exposure.

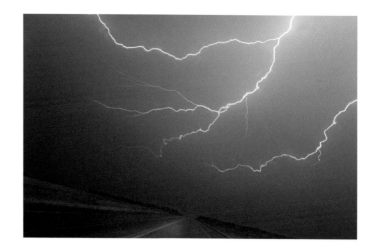

Lightning

The greatest atmospheric threat to the storm chaser—and, likely, the most popular type of severe weather to photograph—is lightning. Lightning kills more people than tornadoes, and it's not always the big storms that produce the worst strikes. Any storm that produces thunder and lightning needs to be evaluated very carefully, including the garden-variety, nonsevere thunderstorm moving through a local neighborhood. A general safety measure when dealing with a lightning storm is to stay at least 6 to 10 miles away from the activity. If you can hear thunder and you're outside and unprotected, you're close enough in relation to the storm to be struck.

Despite the risks, lightning bolts do make a dramatic subject and photographs of lightning have a wide variety of applications for commercial use. Although it may not be obvious to the casual observer, nature's electricity comes in a vast assortment of shapes, styles, and color temperatures. Colors are caused by the mixing of different gases in the atmosphere and can vary widely, from blue to magenta, orange, and white. The two most frequently witnessed types of lightning are cloud-to-cloud (CC) and cloud-to-ground (CG). It is cloud-to-ground lightning that is the most dangerous.

When he photographs lightning, Jim Reed opts for the shortest exposure that conditions will allow in an effort to record the sharpest lightning bolts possible. He is a big believer in fast lenses and typically buys lenses that are $f/2.8$ or faster. He generally sets his camera to ISO 200 and works with aperture settings between $f/2.8$ and $f/5.6$. Using the instant playback of his digital LCD, he studies the bolts to assess their color and intensity. He determines the f-stop based on this information and makes critical adjustments on the fly.

In many storm situations, Reed relies on his camera's self-timer to guard against camera shake. He keeps the timer set at two seconds. However, when he shoots lightning, he finds that a cable release or an infrared remote will allow him to capture his most scenic shots and to react to the rhythm of the storm. This shooting method requires a Zenlike focus to anticipate the timing of when a bolt will strike. Reed attempts to mesh his timing to that of the storm so that the lightning will strike within one second of his opening the shutter. As soon as he sees the flash of a bolt, he closes the shutter to maximize the image sharpness.

! ☐ In severe weather situations, the air moisture content can vary considerably between locations. When humidity levels are very high, the excessive moisture in the atmosphere can cause lightning to appear soft, even if the focus is tack sharp. Since moisture levels in the elevated terrain of the western and central United States are typically drier in spring and summer than in areas farther east, lightning bolts in those areas often appear more distinct and dramatic.

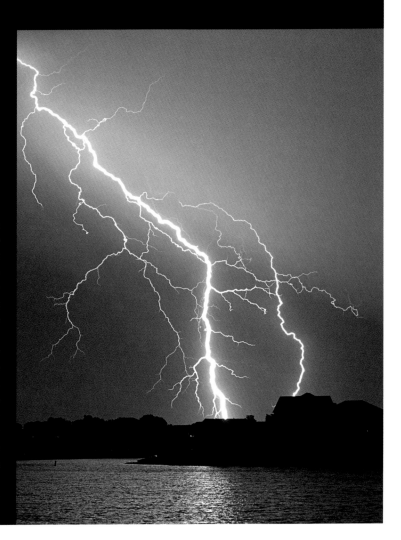

THE LIGHTNING TRIGGER

Jim Reed finds an added level of success in capturing extremely crisp lightning bolts using an accessory called the Lightning Trigger. This is an extremely sensitive optical flash sensor that attaches to the camera hot shoe. It responds to lightning flashes at distances of up to 20 miles during the day and 40 miles at night. Since the flash is so sensitive, it's easiest to use when photographing an isolated storm in which all the lightning strikes will be within the camera's field of view.

When shooting digitally with this device, shutter lag time is an important consideration. A shorter lag time can take advantage of capturing the first electrical stroke, usually a forked stroke. With some cameras, lag time will be shortest with manual settings for metering and focus, but other cameras exhibit no difference in shutter lag between automatic and manual modes. Given these parameters, there's a bit of a learning curve when determining optimal settings for best results within a specific storm situation. After much experimentation, Reed is convinced that this device helps him achieve a new level of clarity in his images.

Equipment Maintenance in Extreme Conditions

Photographing in daunting conditions results in considerable wear and tear on gear. The intense nature of the subject matter demands the use of equipment that's known for being well sealed. This allows photographers like Jim Reed to push the envelope a bit more with their approach to the situations they photograph. When he's on a storm shoot, Reed works the camera controls so fast that protective coverings are generally not effective. He often shields the equipment with his coat or even with plastic grocery bags if he's caught off guard. For photographers in search of portable camera coverings, the company AcquaTech makes a line of sleeves that slip up and over the camera for added protection with a minimum of restrictiveness.

To capture these vividly sharp cloud-to-ground lightning bolts near a residential lake in Wichita, Kansas, Jim Reed used a Lightning Trigger to trigger the shutter in tandem with the lightning strike. The short exposure time allows for maximum sharpness of the bolt and less impurities from ambient light. If longer exposures are made, the bolts can appear soft due to high amounts of humidity present in the atmosphere.

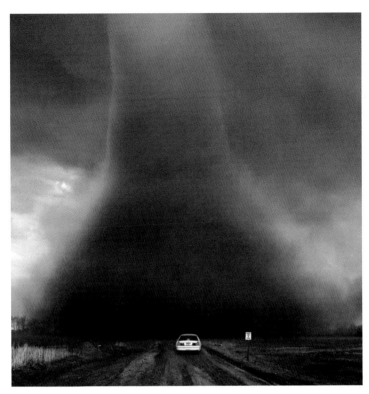

Camera Nikon N90s and low-resolution video still
Lens 35–70mm, 1:2.8 Nikkor zoom at widest setting
Aperture f/8
Exposure 1/45 second
Film Fujichrome Provia 100F

OPPOSITE
Camera Nikon D2X
Lens Nikkor 17–55mm 1:2.8 zoom at 38mm
ISO 200
Aperture f/2.8
Exposure .3 second

As mentioned previously, extreme humidity changes between moist and dry environments can lead to condensation on the camera lens and gear. This can sometimes completely shut down equipment until it dries out. Camcorders in particular are notorious for shutting down after only a few drops of water. One old yet reliable method to help remove condensation from equipment is to blow-dry it with a blow-dryer.

Saltwater is the biggest threat to Reed's gear. Saltwater will damage anything electronic as well as corrode metal parts, so he cleans his equipment as often as possible. Besides the risk of water damage, dust and dirt can also have a detrimental effect. A gust front frequently precedes a severe storm; the winds will kick up to as high as 30 to 40 knots or more and send dirt and debris flying. In addition to having his gear professionally serviced, Reed maintains his camera's sensor with a sensor brush made by Visible Dust.

One common household item Reed finds extremely useful in the field is a rubber jar opener, which he uses to help remove lens filters when the threads get jammed by dust and dirt. He nearly always works with a UV filter or something comparable to protect his outer lens glass against dirt, rain, and flying objects. In his line of work, having the lens hit by a flying object can be a common occurrence. While he has used up a lot of outer protection filters from dings or breakage, his lenses generally remain intact.

As a final note, keep the following advice from Reed in mind: "There are so many people out there now wanting to be entertained by storms that we are literally witnessing traffic jams. The weather is an awe-inspiring phenomenon, but it needs to be kept in perspective. Rather than setting out alone, consider taking a storm-chasing vacation tour led by trained meteorologists. The people running these organized tours work very diligently not to get in the way, and the best companies out there have a reputation for keeping their customers safe."

Jim Reed and his chase partner, Katherine Bay, captured this scene simultaneously while making an emergency evacuation from this tornado's approach after it made a 180-degree turn toward them. Reed's photographs, made from behind the wheel of his vehicle, showed the tornado after it had cleared the center of the road. Bay recorded the whole event on low-definition video. A still from the video was composited with Reed's image to create a simulated view of what they witnessed of the storm at its most intense. A police car with red taillights can also be seen evacuating the scene. Although Reed is a firm believer in getting the shot, he cautions that damage or injuries would have likely occurred in this situation had he not acted quickly and backed up.

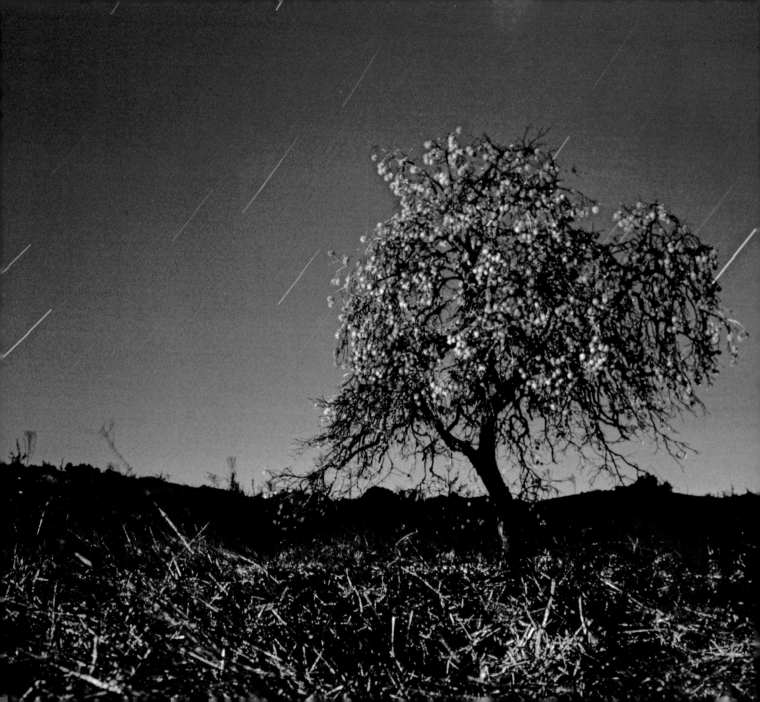

Nighttime
Phenomena

7

Celestial bodies come alive in the nighttime sky and make photographing this subject an active sport. Because these elements are always in flux, astronomical data and environmental factors must be carefully considered before planning a shoot. The time of the year, the phase of the moon, and the direction of the compass are all important elements to consult in order to get conditions right. The practice of shooting the moon extends beyond a mere documentation of the object itself to the investigation of the effects of its elusive light on the landscape. The stars can be captured as bold curved designs or fixed points of light, depending on equipment used and personal preference. The aurora is most often recorded in arctic latitudes, yet it is also possible to photograph this phenomenon in more temperate climates. While the highly specialized subject area of astronomical photography is beyond the scope of this book, an awareness of the forces at work in the nighttime sky provides a basic introduction to approaching celestial elements as photographic subjects.

© ROBERT VIZZINI

Camera	Hasselblad 503CW
Lens	Zeiss 250mm f5.6 CF Sonnar T*
Aperture	f/5.6
Exposure	5 seconds
Film	Fujichrome Provia RDPIII 100F

In order to get a close-up shot of the full moon surrounded by a rainbow effect, Robert Vizzini used a 250mm telephoto. Because depth of field was not a concern, he set the aperture to its widest setting to allow the shortest possible exposure time. The rainbow around the moon is actually a halo, otherwise known as a corona, produced by very small water droplets or ice crystals in clouds.

Shooting the Moon

The hour at which the moon rises can be related to its phase and is calculated for all geographical locations and dates of the year. A new moon will rise around sunrise, and it will rise progressively later each day in its cycle. Night shoots planned in the days just before the full moon take best advantage of photography by moonlight, because during this phase the moon rises about the time that the sun sets. As it wanes, the moon rises progressively later in the night until it is back to where it began, the dark, new moon.

Full-moon photography is very popular among nocturnal shooters and full-moon workshops or group shoots are common practice. However, night photography specialists are less inclined to photograph the moon itself than to capture the effects of its radiant light on the rest of the landscape. The best season for full-moon photography is in winter. Nights are longest during this time of the year, and because of its inverse relationship to the sun, the moon has a higher trajectory in the sky during winter months.

© CLAIRE SEIDL

Camera Hasselblad 500 C
Lens Carl Zeiss 80mm planar 1:2.8
Aperture f/16
Exposure About 5 minutes
Film Ilford Delta 3200

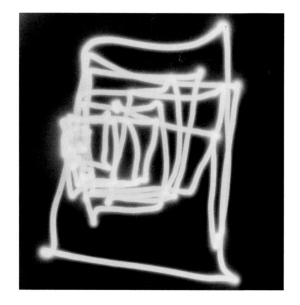

The Moon Up Close

The moon is perceived by the human eye as appearing closer than how the camera records it, especially when it is near the horizon. For this reason, a telephoto lens is the best option for those who wish to capture a portrait. Images of the moon made with a normal lens will likely appear underwhelming unless other elements are included in the scene. A lens converter can be useful to add magnification for a closer shot, but adding a converter will result in a loss of speed, approximately 2 stops every time the magnification is doubled. When shooting the moon, keep in mind that for each 100mm increase in focal length, the moon's diameter will increase by 1mm in a 35mm frame.

Phases and Seasons of the Moon

The moon circles the earth in approximately 28 days. Its phases are caused by the relative positions of the earth, the moon, and the sun. It appears to us as full when the earth is between the sun and the moon. When the moon is in the middle, it appears dark, or new, because the light of the sun is hitting the side of the moon not visible on earth.

There are many tools available on the Web for gathering data about the moon (and the sun) for any given location and at any date. One free service offered by the U.S. Naval Observatory, http://aa.usno.navy.mil/data/docs/RS_OneDay.html, is divided into two parts, one for U.S. locations and the other for locations worldwide.

The Moon on High

The rotation of the earth makes the moon appear to move through the sky very quickly. It moves its own diameter within two minutes and will therefore record as a sausage-shaped blur in a long-exposure photograph. The bright illumination of a high, full moon will blow out all details of its face at shutter speeds longer than 1/125 of a second. A nocturnal landscape generally requires a much longer exposure. This makes it challenging to properly expose both elements in one scene.

The moon was the medium and a handheld 2 1/4 camera was used as a drawing implement in this abstract image. The light of the moon is so strong that it registers on film very quickly. In order to create a clean line rather than blurred edges, the gesture of the drawing had to be relatively fast and steady. When the direction of the line changed, the slight pause registered the circular, blurred form of the moon.

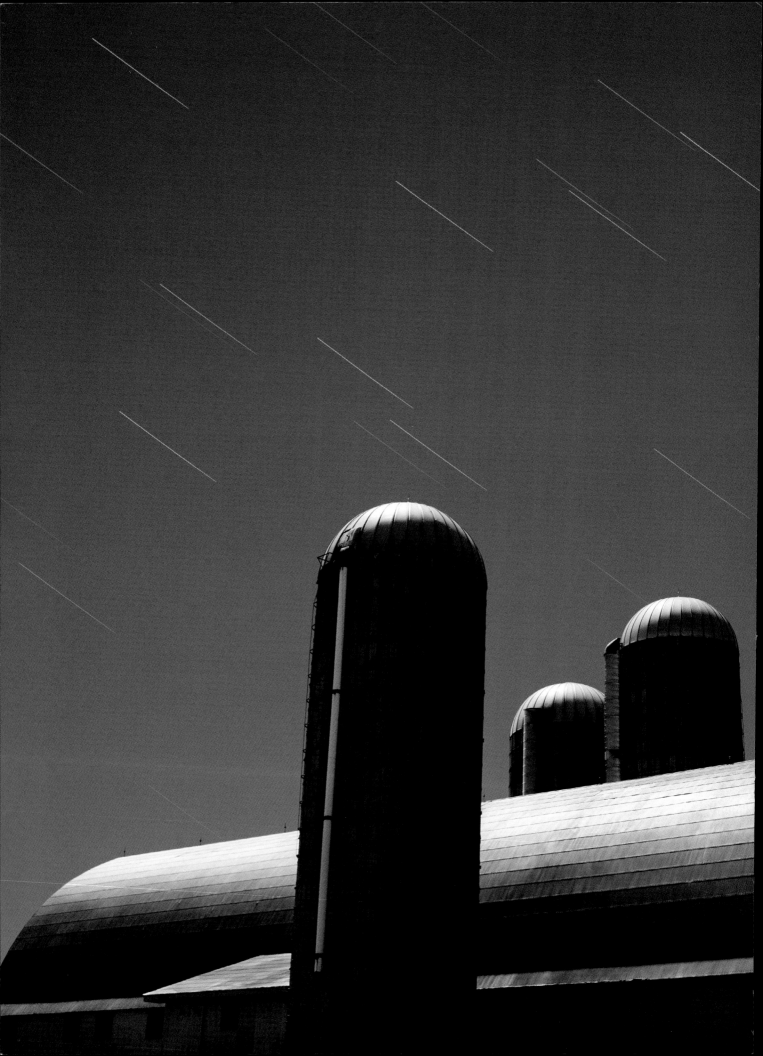

© **CHIP FORELLI**

Camera Hasselblad
Lens 60mm
Aperture f/16
Exposure 24 minutes
Film Kodak T-Max 100

Moon Glow and Moon Shadows

The full moon casts a powerful light that is further amplified by light colors or reflective surfaces such as water, metal, or snow. Full-moon images made on a clear night under these conditions can easily overexpose and will appear as if they were taken in daylight. Shadows cast by the moon can add intrigue to a photograph, however these shadows track the same movement as the moon does. As the exposure time of a moonlit image is increased, moon shadows will soften and become increasingly indistinct.

The "Sunny 11" Rule

Since the moonlight that shines earthward is sunlight reflected off the moon's gray surface, the standard "Sunny 16" rule for daytime exposures can be applied in full-moon situations as the "Sunny 11" rule. Applying this rule assumes the moon is high in the sky with very clear air. Under those conditions the details of its face can be recorded at 1/ISO at f/11. Yet, many factors can conspire to reduce the moon's brightness. Atmospheric issues such as air pollution, haze, or humidity, as well as conditions where the moon is less than full or close to the horizon, will dictate longer exposures, but under all circumstances a fast shutter speed is required.

A rural barn with a metallic roof turns into a giant reflector in the light of the full moon. The moonlight we see is sunlight that strikes the moon's surface and is reflected back to earth. Its intensity, weather notwithstanding, depends on the relative positions of the sun, the earth, and the moon as they cycle through the year. Since this image was made during a full moon that occurred a few nights after an almost total lunar eclipse, the angle of the sun's rays striking the moon was direct and resulted in very bright moonlight.

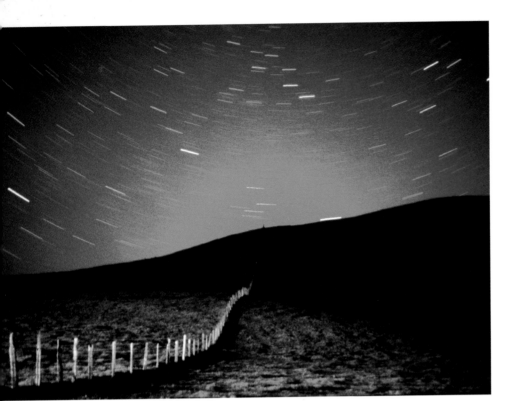

© STEVE HARPER

Camera Leicaflex
Lens 50mm
Aperture f/8
Exposure 15 minutes
Film Kodak 160T

Starry Nights

Besides the prerequisite of a clear night, the most important factor for obtaining clear, crisp exposures of the stars is a vantage point that limits or eliminates added illumination or ambient light. Although stars can be seen and captured in urban or suburban areas, a road trip to an isolated setting or, at the very least, a vantage point such as a skyscraper rooftop, far above the glare of city lights, will yield clearer pictures when the stars are the primary subjects. The stars are best photographed when there is no moon because a moonlit night will lower the contrast between the stars and the sky.

Stars record as linear elements in nighttime, long-exposure photographs because of the rotation of the earth rather than the movement of the stars themselves. The degree of this movement is variable and is based on several factors. When working with telephoto lenses, stars can appear to move almost instantaneously and star trails will record in an image with exposure times of as little as 5 to 10 seconds. With normal lenses, 20 to 30 seconds can be considered as a general threshold for when star trails might begin to be perceived in an image rather than stars appearing as fixed points of light.

Stars can be recorded in different colors, from the classic yellow and white, to blue and even red. These colors are related to the age, temperature, and elemental composition on the stars' surfaces and can best be captured by the camera when the weather is clear, there is no ambient light in the scene, and a fast lens/wide aperture combination is used.

Multicolored star trails fill the sky with streaks of light above the rolling hills of Marin County, California. The upward curve of the stars indicates that the camera was pointing to the north. All stars revolve around Polaris, located high above the edge of this image. The longer the exposure time, the more significant the stars become as a design element in an image.

Aim the camera at the North Star (Polaris) to capture a long exposure of star trails forming concentric circles with Polaris at the center. Use a compass to point out the northern sky. To locate Polaris, look for the Big Dipper first. Identify the two pointer stars that form the Big Dipper's cup and follow these in a straight line to a moderately bright star a short distance away. That is Polaris. It can also be identified as the last star in the Little Dipper's tail.

POSITION ON STARS' APPEARANCE IN PHOTOGRAPHS

The movement of star trails recorded in a long-exposure photograph is dependent on several factors:

One's position in relation to the equator.

• At the equator, star trails will trace a vertical path in a long-exposure photograph.
• The farther north one travels, the more horizontal the star trails will be.

The direction the camera is pointed: north, south, east, or west.

• Stars curve either left or right depending on whether the camera is pointed east or west.
• When the camera is pointed south, star trails form straight lines.
• When the camera is pointed north and the North Star is included in the frame, the stars form concentric circles around this point.

Capturing Stars and Star Trails

Camera ISO settings, choice of lens/aperture, and framing decisions are the primary factors to influence how a starry night will be portrayed in a photograph.

Images featuring long star trails are generally made with slow-speed, fine-grained film or low to moderate ISO settings. Exposures times can range from a number of minutes to an hour or more. Since film suffers from reciprocity failure, exposure times at the long end of the scale are common with film captures. Reciprocity is not an issue with digital cameras, so these exposures tend to be of shorter duration, especially when image noise is a limiting factor.

A major hurdle when working with long exposure times is battery drain. Mechanical film-based cameras are often preferred for long-exposure photographs because batteries are not required in order for the shutter to function. Long exposures with a digital camera can often eat up a charge within a few frames. To conserve power when shooting, keep the camera's LCD screen turned off. When working at night with cameras and other equipment that has electronics and requires batteries to function, always make sure to carry plenty of backups.

Lens selection influences the amount of time needed for the stars to track across an image in streaks of light. The wider the lens, the greater the section of sky covered and, therefore, the smaller the area that each individual star takes up in the overall scene. This means that the stars will show less movement in an image made with a wide-angle lens than in an image that shows a portion of the same scene photographed with a longer lens over a comparable length of time.

Faster lenses and wider aperture settings increase the amount of light that enters the camera. Wider *f*-stop settings (*f*/5.6 to *f*/1 depending on the lens, when shooting

> Stars that are closest to Polaris will exhibit shorter star trails relative to the stars that make concentric circles farther away from this central point. When an image showing the stars as fixed points is desired, take advantage of this phenomenon by composing the scene with Polaris at the edge of the frame.

 © JILL WATERMAN

Camera	Nikon FE
Lens	50mm
Aperture	f/4
Exposure	about 30 minutes
Film	Fujichrome RDP Provia 100

 © BARBARA YOSHIDA

Camera	Wista Field Camera
Lens	Nikkor-W 150 mm
Aperture	f/5.6
Exposure	10 minutes
Film	Kodak Tri-X

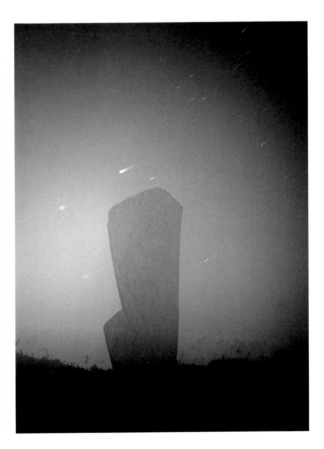

LEFT: The absence of light pollution and limited ambient lighting allow the detailed recording of bright, multicolored star trails against a dark sky. The vertical star trails are caused by the proximity to the equator. The weather was clear when this shot began, but a sudden front moved through toward the end of the exposure. Yet, the resulting image appears as if made under clear conditions. Tiny breaks in the star trails at the top of the image are the only evidence of the weather issues that ended the shot. **RIGHT:** Humidity in the air can cause the camera lens to fog during long exposures in the field. In these circumstances, linear details like star trails can take on the appearance of a comet with a tail that loses sharpness at one end due to the reflectance of the moisture on the lens.

with 35mm cameras) will enable fainter stars to be recorded in the scene and result in pictures that have a lush star-field effect. When composing a scene that combines the stars with foreground elements, depth of field should be carefully considered while setting the f-stop and focusing the lens.

Interrupting the Stars

When the weather is less than crystal clear, the stars will mark the sky with intermittent trails as they make their appearance from behind cloud cover or mist. If the humidity level is high, they may appear as soft and blurry even if the lens is focused to record them as tack sharp. If the dew point rises during a long exposure, an image with star trails that taper from sharpness to what resembles a blurry tail may be the result.

Star Trails and Jet Trails

The encroaching signs of civilization are perhaps nowhere more disruptive than in the bold trails made by airplane lights that crisscross overhead in the night sky in even the most rural of settings. While rerouting flight lanes is hardly an option, studying the sky to identify flight patterns before selecting a vantage point for photography can be a practical way to keep these elements to a minimum. If an airplane approaches the scene in the midst of an exposure, covering the lens with a black card while it passes through the image area will prevent the light trail from registering in the photograph. Depending on how long the lens is covered, a short interruption in the star trails may also be visible in the image.

Shooting Stars

"Shooting stars" are the common name for meteors. These heavenly bodies are basically orbiting grit and debris that ignite as they collide with air molecules at the edge of the Earth's atmosphere. The direction of the Earth's orbit causes meteor sightings to be most prevalent from after midnight until before dawn. Certain times of the year, the month of August in particular, provide heightened opportunities for photographing meteor showers at their peak.

Meteor activity is best photographed using the shortest exposure time possible to differentiate the motion of the "shooting star" from real stars that appear in the sky as fixed. Since the illumination generated by meteors often tends to be faint, and their appearance in the sky is of brief duration, it is particularly useful to combine a high ISO with a fast lens at the widest possible f-stop to capture these fleeting moments.

Higher ISO settings allow shorter exposure times but this comes at a cost of increased film grain or digital image noise. Use of noise-reduction software in post-production can help eliminate high ISO noise in the digital realm. For film photographers, color transparency film can be push-processed at higher ISO settings to increase film speed. A high-speed color film that handles push-processing well, Fujichrome Provia 400F can be rated at ISO 1000 and pushed approximately 1 1/2 stops in development.

In remote locations without pollution from ambient lights, using wider apertures during long exposures will result in star trails that are brighter, are more abundant, and have greater variations in color.

The Aurora Borealis

Also known as the northern lights, the aurora borealis (or aurora australis in the Southern Hemisphere) is visible in the night sky as a bright glow or cloud. Auroras occur in the earth's upper atmosphere and are caused when high-energy particles from the sun collide with atmospheric atoms and ions. The atmosphere consists mainly of nitrogen and oxygen, which emit characteristic colors when hit. Auroras are most often seen at high latitudes and, especially, in polar regions, where their intensity and movement are clearly visible.

Types of Auroras

Auroras come in all shapes, sizes, and levels of motion. They can simmer in one place or explode and dance across the sky. Auroras are most commonly observed with a green cast. Because of this inherent color, the most accurate color will result from using daylight film or color-balance settings (or shooting in raw file format). Rarely, auroras can also be observed in shades of red. This phenomenon is caused by the electrons from the sun striking oxygen at very high levels of the atmosphere. The more common green auroras occur at much lower atmospheric levels. In the Northern Hemisphere auroras are most often observed along an east-to-west axis because they form in a band encircling the magnetic North Pole.

Tracking Auroras outside of Arctic Climes

During occurrences of severe sunspot activity and strong magnetic storms, auroras can occasionally be witnessed in more temperate latitudes, such as U.S. locations as far south as the mid-Atlantic states. At these latitudes the phenomena can be faint and hard to perceive by the naked eye. In such cases a digital camera can help to identify areas of subtle atmospheric activity.

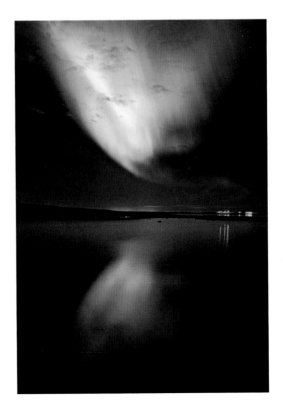

 © RAGNAR TH. SIGURDSSON/ARCTIC-IMAGES

Camera	Canon EOS-1Ds Mark II
Lens	24mm
ISO	400
Aperture	f/3.5
Exposure	1/15 second

While most auroras generate a green light, Sigurdsson captured this rare occurrence of an extremely bright aurora with red highlights outside the home of Iceland's president. He framed the aurora to include its reflection in the water, as evidence that this once-in-a-lifetime sighting was indeed real.

As a photographer based in the Icelandic north, Ragnar Th. Sigurdsson is an expert at photographing the aurora. His preferred situation for photographing the northern lights is to seek out a snow-covered landscape with a half moon to illuminate the scene. He finds that the reflection in the snow from a full moon is too bright, but the reflection in snow from a half moon is just the right amount of light to balance the scene.

Sigurdsson strives for both factual reference and strong concepts in his aurora images. He often composes the scene to include a reflection of the aurora in water as added proof of its existence. Because the northern lights are a strong source of energy, he sometimes places the phenomena in relation to other power sources, such as electric cables, geothermal steam, or car headlights.

Since the aurora is generally a moving target, a fast shutter speed is required to record it to best effect. The method generally recommended is to use the highest possible ISO setting capable of delivering acceptable results. An ideal setting of ISO 3000 will yield a lot of grain and poor image quality for general purposes, however a method called gas hypersensitizaton is commonly used by astrophotographers to achieve acceptable images from slow-speed, fine-grained films boosted to an ultra-high ISO rating. This method involves the treatment of film in a mix of hydrogen and nitrogen gases to increase film speed and reduce reciprocity failure. Digital technology has greatly supplanted the need for this method among the general public but film hypering is still employed by specialists in photographing the distant cosmos. ■

DIGITAL CAPTURE METHOD FOR IDENTIFYING AREAS OF FAINT AURORAL ACTIVITY

- Monitor general space activity through e-mail alerts from Web sites like www.spaceweather.com.
- When activity is predicted for your area, find an observation site that will allow maximum visibility and a minimum of disturbance from light pollution or other distracting elements.
- Use a compass to find a location with clear sky facing north.
- Set the digital camera's ISO levels to as high a reading as possible and open the aperture to its widest setting.
- With the camera on a tripod, point the camera toward areas in the northern sky and, depending on general lighting conditions, begin making exposures approximately two seconds in length.
- Consult the LCD display to check results and adjust exposure time and ISO settings as needed to capture an image.
- Pan the sky and make images in different areas. Look for areas that show green or reddish hues.
- Once you find interesting activity, try making longer exposures at a lower ISO setting for best results.

To tame the movement of an active aurora, use a fast lens and a high ISO setting to limit exposure time. An exposure time of 10 to 15 seconds at ISO 400 should freeze the aurora and avoid the appearance of long star trails.

 © JIM REED

LEFT
Camera	Nikon D100
Lens	Nikkor 14mm; 1:2.8
ISO	800
Aperture	f/2.8
Exposure	30 seconds; activated with self-timer

 © JILL WATERMAN

RIGHT
Camera	Nikon F3HP
Lens	28mm; 1:2.8
Aperture	about f/5.6
Exposure	about 1 minute
Film	Fujichrome Velvia 100

LEFT: Reed acted on a tip from the Space Weather Web site to scout the occurrence of a severe geomagnetic storm predicted to generate aurora activity in his local area. Although only faintly visible to the human eye, the effects of the aurora are clearly visible in a photograph due to setting the camera at a high ISO and extending the exposure time to a few seconds. On this occasion the aurora simply hung in the air and allowed Reed to thoroughly work the scene. After photographing the orange glow of the phenomena reflected in the lake, he set the camera's self-timer and posed with his chase partner and a flashlight pointed skyward for a silhouetted portrait of the pair observing the action overhead. **RIGHT:** A high ISO rating and a fast shutter speed are strongly recommended for shooting the aurora, but 100-speed slide film was the only film available when the phenomena appeared during a visit to Iceland. A full moon brightened this beachfront scene, but exposure was still tricky to estimate. Past experience dictated at least a minute to record the scene on film adequately, and this risked reducing the phenomena to a blur. After framing the shot with the aurora present, the photographer waited for it to dissipate. Once the phenomena had calmed, the exposure was started to record the background landscape. After a minute it reappeared in full force, and the exposure was stopped at that instant. This example demonstrates that established recommendations are only a starting point and that close observation and a bit of creative thinking are equally important to successful image-making at night.

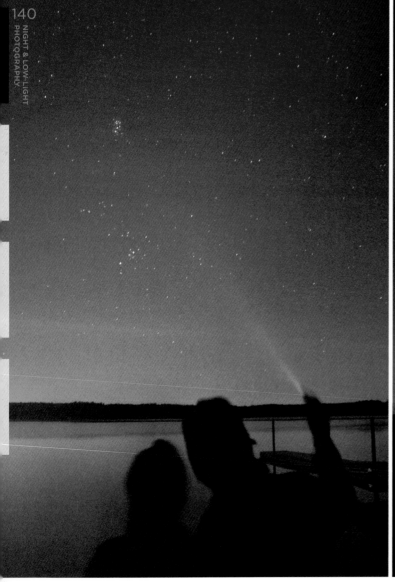

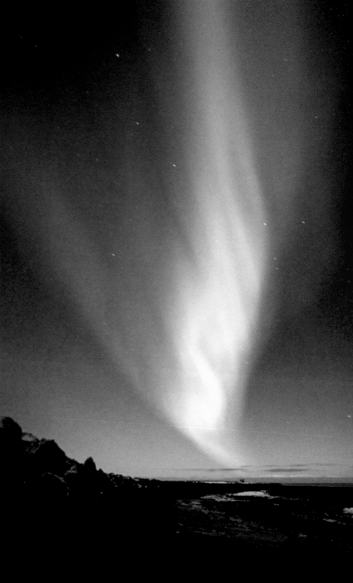

© RAGNAR TH.
SIGURDSSON/ARCTIC-IMAGES

Camera	Mamiya 6. 6x6
Lens	50mm
Aperture	f/5.6
Exposure	20 seconds
Film	Fujicolor 1600

Personal Vision

Number one is to learn all the rules, then master all the rules, and then, after that, you can break all the rules.

Ragnar Th. Sigurdsson

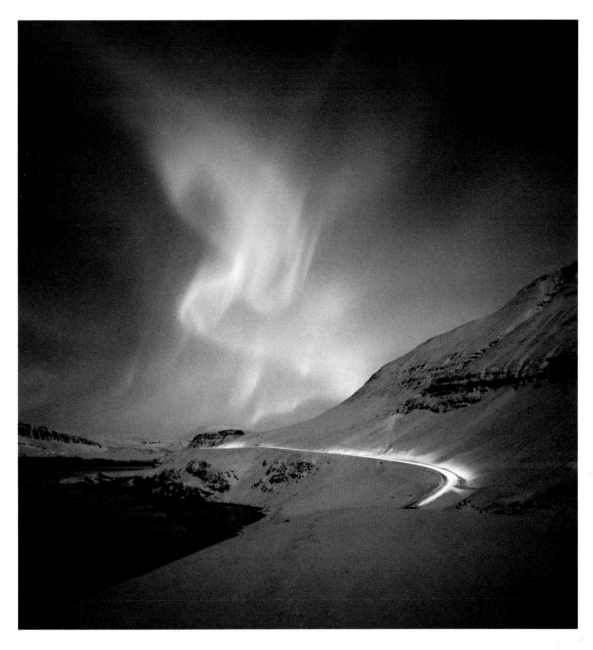

Two passing cars add to the energy of the aurora's display over a snowcapped fjord just north of Reykjavik. Before he began working digitally, Sigurdsson typically photographed the aurora using medium-format cameras and high-speed negative film. This combination optimized image sharpness in relation to film speed. He used negative film for the greatest amount of exposure latitude and preferred the grain structure of Fujifilm over Kodak for purposes of scanning and output.

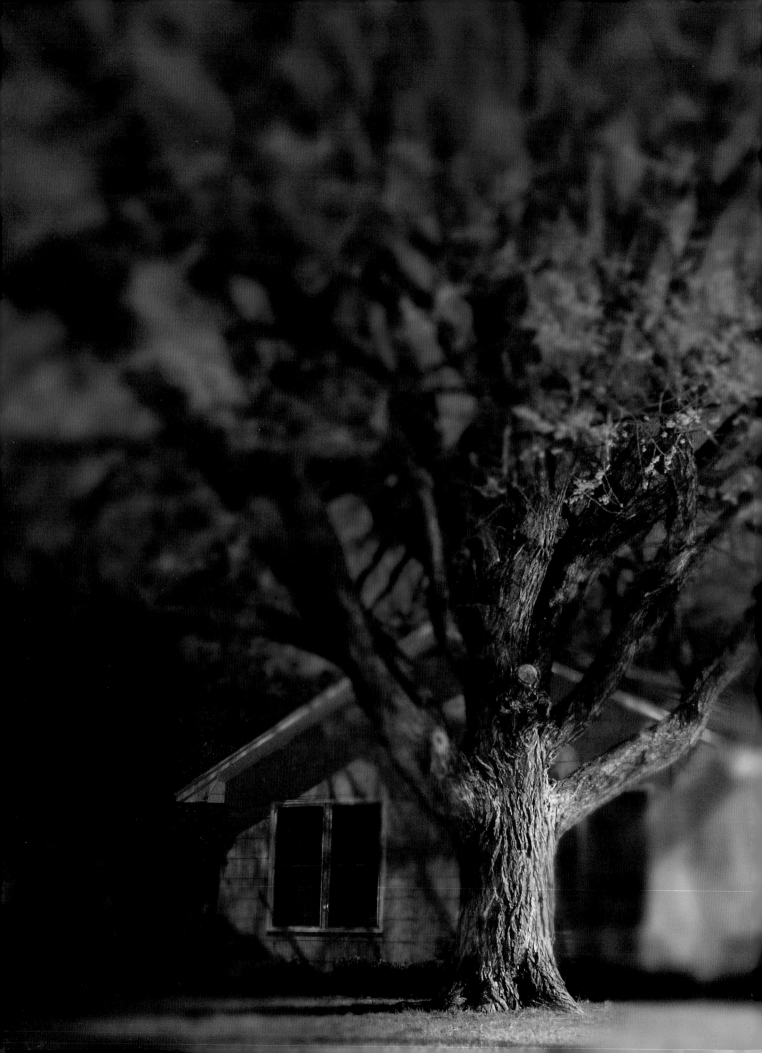

These three histograms illustrate an important concept in night photography.

1. Histogram showing a typical daytime photograph where the range of exposure values is more or less evenly distributed across the bar chart.

2. Histogram showing the original raw file of the Distant Water night landscape where the exposure values are shifted mainly to the left of center.

3. Histogram showing the final edited version of the Distant Water image, ready for output. Although the exposure values in the third histogram are still mainly left of center, postproduction work on the image resulted in extending the exposure to add detail at left (blacks) and right (whites).

Digital Exposures, Histograms, and Flashing Highlights

Digital Exposures

Digital cameras record and store images as bits. This is a very important aspect to making digital captures and understanding exposure at night. The information is not recorded in a linear fashion across the full span of exposure values as happens on film. There are far fewer bits allocated to recording shadow detail than highlight detail. A common phrase about optimum digital exposure is to "expose to the right," and thus to expose the image as "bright" as possible without blowing out the highlights. This runs counter to the common wisdom when working with film that is to "expose for the shadows and develop for the highlights."

Digital capture allows for the immediate feedback of viewing images on the camera's LCD preview screen, but that is not the best method for accurately judging a nighttime exposure. Although the image preview is a great tool for judging composition, the image displayed in preview mode is likely to appear as far brighter than the data contained in the actual image file. In low-light conditions this can be very misleading, and it can result in captures that appear sufficiently exposed in the field yet are actually significantly underexposed when downloaded.

Two valuable supplements for judging exposure in low-light conditions are the histogram and flashing highlight modes. These data are generally easily viewed with the touch of the camera controls. Both modes will appear overlaid on the image in the camera's LCD screen.

Histograms and Flashing Highlights

The *histogram* shows the overall "exposure" of an image as it is distributed from shadows to highlights. The proportion of pixels at each exposure value is displayed along a horizontal bar chart. An ideal histogram, and an ideal exposure, should show data in a smooth transition that fills the histogram all the way to the right edge without being

© **MARK JAREMKO**

| Camera | Canon EOS-1Ds Mark II | Lens | 24-70mm zoom at widest setting | ISO | 200 |
| Aperture | f/2.8 | Exposure | 8 seconds | | |

USING THE HISTOGRAM TO JUDGE NIGHTTIME EXPOSURES

Although the two histograms of this night landscape are quite similar, they work well to illustrate the adjustments Jaremko made in postproduction from his original raw capture to the final version ready for output. Both the original raw and edited final histograms for the Distant Water landscape have very little information in the top half of the bar chart. This is typical of a night photograph.

The key point in this comparison is that a histogram of a "night" image will usually not map to the ideal histogram of a daytime image. For anyone accustomed to reviewing histograms of daytime images, the night landscape histograms appear very underexposed. For this reason, the "Auto" exposure features in applications such as Photoshop do not handle night photographs well. Auto exposure features look at the histogram, make assumptions as to what the image should look like, and modify the histogram to match this ideal. This tends to greatly overexpose a typical night shot.

chopped off. If data is chopped off at the edge of the histogram, there are areas of the image that are blown out and cannot be recovered (similar to overexposed slide film). By checking the histogram after making an exposure, it is possible to make needed exposure adjustments by reducing or extending the spread of the data until it occupies an ideal position along the bar chart.

The *flashing-highlights* mode shows the areas of an image capture that are likely to be overexposed. This displays as a blinking white light on top of highlight areas of an image preview. When consulting flashing highlights, the main areas of concern are limited to parts of an image that need to have detail. If the only flashing areas are streetlights or the brightest highlights of a sky, then the exposure is fine. It is not usually expected to have detail in these areas whether using digital capture or film. But if there are flashing areas in a capture where detail is desired and shadow areas are underexposed, then it is time to consider making multiple captures to address this issue in postproduction with Merge to HDR.

Low-light conditions make it advisable to capture as much brightness in an image as possible because most of the data being recorded is in the shadows or the lower half of the histogram, the part with the least number of bits allocated for storage of details. By maximizing the image exposure, more data is allocated to the recording of shadow details. When the image capture is adjusted in postproduction, more of the shadow data is retained, thus the final image holds much more shadow detail than an image that appears to be "correctly" exposed when viewed on the preview screen. An ideal nighttime image from a digital camera might initially appear overexposed, assuming highlight detail is not blown out. One of the primary benefits of digital night photography is the ease at which slightly overexposed images can be finessed in Photoshop after the fact. It is far more effective to make an image darker in Photoshop than to make it lighter, and this produces the best results.

In this distant view of San Francisco from Marin County's Fort Baker, the clouds were moving very fast with a rolling fog coming off the ocean. The atmosphere in flux required about thirty exposures at different camera settings in order for Jaremko to nail the shot. The fast- moving clouds limited options for exposure time. There was not enough light for exposures of 2 seconds or less even at ISO 400. Given the circumstances, Jaremko's best alternative was to open the aperture to its widest f-stop and set the ISO to the highest level he could tolerate without adding excessive noise. His selection of ISO 200 resulted in an 8-second exposure time. Although shooting at an ISO of 100 would have been greatly preferred, doubling the exposure time to 16 seconds would have reduced definition in the clouds. Jaremko added data to shadow areas and stretched the highlights in postproduction to further enhance the final result.

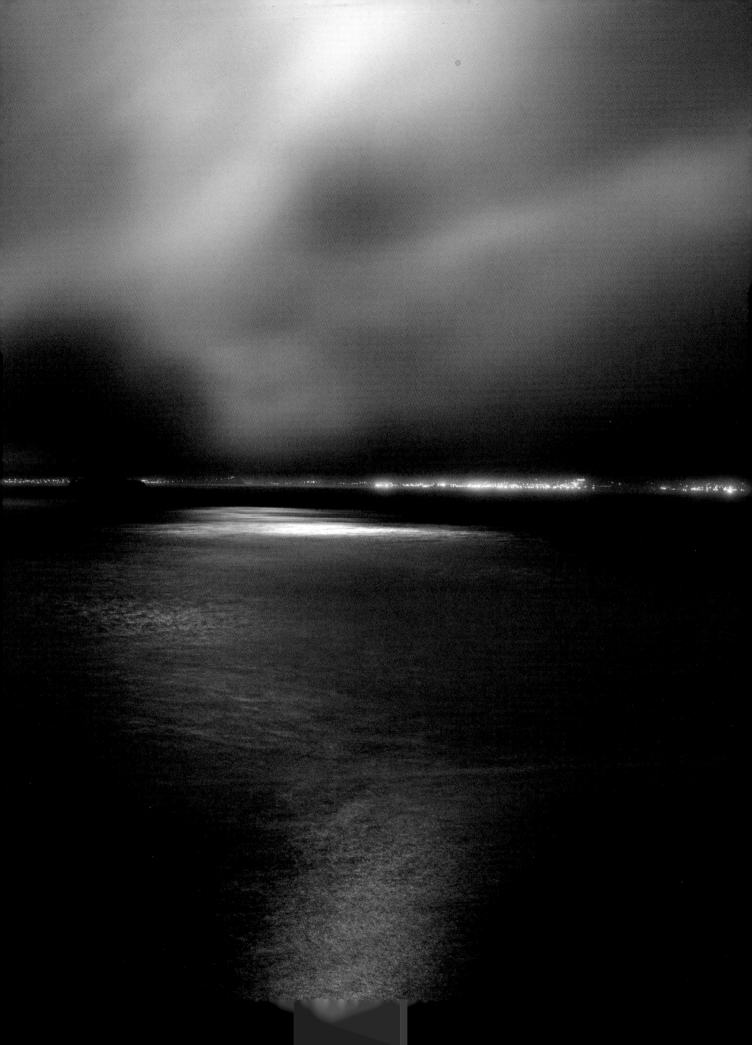

Digital Black-and-White Conversions

One troubling issue when shooting at night and in low-light situations are color-casts generated by artificial lighting from varied sources. A classic option for eliminating this distracting element is to convert color captures to black-and-white. There are many different methods for making black-and-white conversions. Multiple possibilities are available through Adobe Photoshop alone, and specialized black-and-white plug-in applications offer other routes. The latest image-management programs such as Adobe Lightroom and Apple Aperture also offer excellent tools for converting color images to black and white. Adobe's Camera Raw has a checkbox to convert to black and white directly from raw files. Conversion methods range from extremely simple procedures with minimal tonality controls to extremely complex operations where individual tones can be finessed with a high level of accuracy. The two methods featured here offer a basic introduction to this highly specialized subject.

Simple Black-and-White Conversions Using Channel Mixer

A simple method for converting images using Photoshop versions prior to CS3 employs the Channel Mixer tool. This is a very flexible way to blend varied amounts of individual color channels of an image.

- Open the image in Photoshop, go to the menu selections at the top and select Image > Adjustments > Channel Mixer.
- A dialog box will appear with sliders for Red, Green, and Blue color channels.
- Check the Monochrome box in the bottom left-hand corner. The image will turn to black and white and the Output Channel pull-down menu will change to Gray.
- Make a baseline conversion by adjusting the color sliders to desired settings. For the image pictured here, Frazer used RGB = 40, 30, 30. Try different combinations to arrive at the mix best suited to the image. Some practitioners feel the combination of three figures needs to equal 100 percent. While this is important in order to maintain the same overall image brightness, final percentages can vary widely to suit individual tastes.

- Click OK and go back to the menu selections at the top.
- Image contrast and tonality can be further modified by a number of other tools contained under the Image menu.
- To use the Levels tool, select Image > Adjustments > Levels. This will allow for adjustments to individual color channels, via the pull-down menu, or all channels at once.
- When image contrast and tone are adjusted to preference, rename and save this file and the Black-and-White conversion is complete.

Photoshop CS3's New Black-and-White Command Function

Photoshop affords making black-and-white conversions in a variety of different ways. A new command for black-and-white conversion introduced with Photoshop CS3 allows more flexibility and greater control than other popular conversion tools, such as methods that employ the channel mixer or gradient map, that were standard fare for converting images in earlier versions of Photoshop.

© **ANDY FRAZER**

OPPOSITE

Camera	Canon D60	Lens	Canon 17–40mm L 1:4 zoom	ISO	200	Aperture	f/8
Exposure	4 minutes	Lighting	Full moon and painting with flashlight from multiple angles				

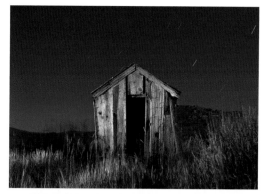

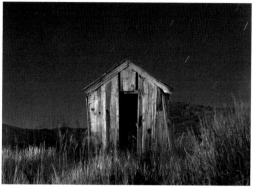

- Open the image in Photoshop, go to the menu selections at the top and select Image > Adjustments > Black and White. The image automatically changes to black and white as soon as this selection is made.
- A dialog box will appear with sliders for six different color options: Red, Yellow, Green, Cyan, Blue, and Magenta.
- Adjust each slider to change the relative brightness of each respective area of color from the original image. This adjustment will be performed on the version of the image displayed in black and white on the screen.
- Adjusting multiple sliders will allow the optimization of black-and-white tones to very exacting preferences.
- Once the sliders are adjusted to produce an image with an optimal tonality range, rename and save the file, and the customized black-and-white conversion is complete.

Additional Useful Command Options
- A second command option adjusts brightness levels to a specific image area by moving the cursor directly over the section of the image requiring adjustment. This is particularly helpful in situations when it is unclear which slider will be most effective for making a tonal adjustment. The cursor command will provide a localized adjustment to isolated color areas, yet if the same color appears in other parts of the image, it will cause an identical tonality shift to those areas as well.
- A preset pull-down menu allows for saving a specific type of conversion for reuse with other images.
- A checkbox for tint allows addition and adjustment toning to the black-and-white image through the use of two sliders: Hue and Saturation.

Beau Comeaux and Photoshop Tips

Beau Comeaux has been photographing extensively at night since 1997. Working initially with a film camera, he began using a prosumer digital in 2003 to check exposures and previsualize what he wanted to get out of a shot. He quickly realized that the lack of reciprocity failure of digital allowed him to be much more prolific. Over the past several years, he has honed his digital skills and his artistic vision to develop a complex exploration of the nighttime environment enhanced by extensive postproduction work.

Rich textures compete with a full color palette in the color version of this image showing a wooden shed in a field of tall grass. Frazer opted to bring the textures in the image to the forefront by converting the image to black and white using the Channel Mixer tool in Photoshop CS. The Channel Mixer method allows him to adjust image contrast and tonality using multiple tools. Not one to follow a regimented workflow, he often refines the conversion by adjusting Levels or Curves after making a baseline Channel Mixer adjustment.

On a typical night Comeaux sets out around 10 pm after the last cars have pulled into the driveways of the suburban neighborhoods he photographs. Shooting in raw mode with an auto white balance, he will capture up to four gigs of files per night. Back at the computer, he downloads files from which to review and select the next scene for his Photoshop transformations. He regularly archives images to one of several 300- to 500-gigabyte backup drives as a protection against losing valuable work.

Comeaux spends six hours (in one sitting) to fifty hours or more (over the span of a month) on an image. He works three or four pieces simultaneously with one generally pegged as the star. Each piece requires a distinct approach, and his digital arsenal has gotten more complex over time and involves increasing amounts of pixel gymnastics. These are a few of his favorite tricks:

Reducing Noise with the Despeckle Filter

The Despeckle filter is useful for reducing the pixel-based noise that can be prevalent in nighttime captures. A very mild filter with no percentage settings, this can be used multiple times on individual color channels for a cumulative effect. It can be found in the Filters menu of Photoshop inside the Noise submenu.

Merge to HDR (High Dynamic Range)

The span of brightness levels in an image from dark to light is generally referred to as dynamic range. Since night and low-light situations have an inherent high contrast, with dynamic range that goes off the charts, it has always been difficult for photographers to accurately capture full exposure details in one single shot. Merge to HDR makes it possible to take a series of widely bracketed captures spanning a full exposure range (typically 10 stops of captured range) and automatically combine them into one image that benefits from the tonal detail of the entire series. The merged image generated by the software is typically rather flat and will greatly benefit from a curves adjustment to finesse the

tonal balance before the file is saved. There are four possible methods for creating an HDR file; but only one, the Local Adaptation method, will allow for making this curves adjustment to the file. Use of the Local Adaptation HDR method allows the greatest amount of flexibility with the image because, unlike the other methods, it addresses tonal changes on a per-pixel basis.

Merge to HDR can be a very useful and powerful tool to explore at night and in low-light situations, but a certain degree of finesse is involved to achieve results that appear realistic and seamless. This technique is not appropriate for scenes that have limited dynamic range initially. Due to the extreme contrast range compressed into one file, images produced using the Merge to HDR technique can sometimes have a very artificial-looking appearance if the technique is not adeptly tweaked.

Image Stitching with Perspective Shifts

When he finds a situation that he really likes, Comeaux works with a segment shooting approach to make a dozen or more captures from different vantage points. In postproduction, he works with

Shooting in raw format allows much more flexibility in adjusting exposures and color balance after the fact. It enables one to concentrate on shooting the image rather than getting caught up in things like white balance. It also allows for capturing scenes at a bit depth of 12- to 14-bits, instead of the standard 8-bits, to result in a more robust file.

the Photo Merge feature in Photoshop to combine parts and create subtle effects of optical confusion for the viewer. He counteracts perspective shifts with software corrections so that alignments match up but visual effects go awry.

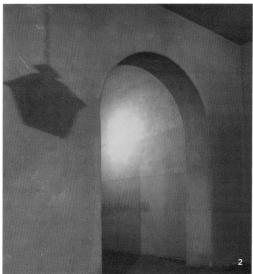

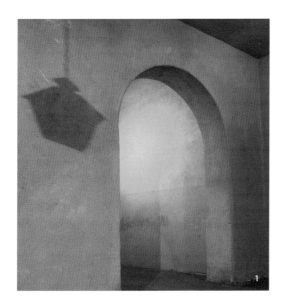

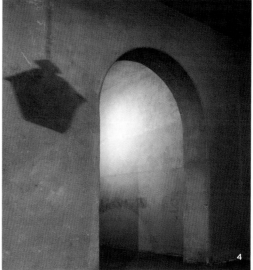

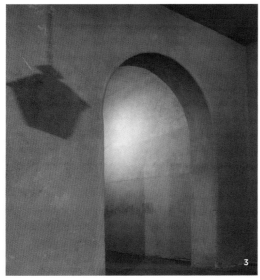

© **MARK JAREMKO**

Camera Canon EOS-1Ds Mark II
Lens 24-70mm (set at 27mm)
ISO 100
Aperture f/8
Exposure 4 seconds

Using the customized settings for black-and-white conversion in Photoshop CS3, Jaremko transformed an architectural detail of an arched hallway from a scene overrun by garish color-casts to a custom black-and-white conversion with full tonal range. The conversion options he considered in this process are outlined below.

1. In the original raw capture, a graphically appealing architectural detail turned into a color temperature challenge due to the monochromatic yellow color-cast from sodium-vapor lighting.

2. After the original image was adjusted using the white balance controls in Adobe Camera Raw to remove the yellow cast and make the background wall a neutral gray, residual color-casts turned one corner of the image magenta and the other corner cyan.

3. A black-and-white auto conversion in Photoshop CS2 offers no control and bland results. This is the worst way to convert to Black and White.

4. Customized black-and-white conversion allows for selection and modification of individual color ranges. This method effectively boosts the contrast or decreases the brightness in each color channel, and is similar to the tonal enhancements that occur when placing differently colored filters in front of black-and-white film.

Making a switch from RGB to LAB color space can be an especially helpful tool for tweaking colors since brightness and color information are separate in LAB color space. This makes it possible to adjust color areas of an image, in Channels A and B, without affecting the Lightness Channel, where image detail is held.

Image Blurring with Gaussian Blur and Lens Blur

Comeaux creates blur effects in his pieces at the end of his image workflow. If he's not careful, extensive manipulations to multiple image layers can lead to unexpected results or adverse effects like posterization. He has found flattening the image to be a crucial step before he begins working with blur tools. Comeaux recently discovered that converting files from 16-bits to 32-bits in Photoshop CS3 also helps to limit problems when he works with image blurring. Increasing the bit depth to 32-bits means less destruction to brightness levels in the image and a smoother transition from tone to tone while he pushes and pulls the pixels around the file. After the manipulations are complete, he converts the file back to 8-bits for optimal display and output. Comeaux uses the Lens Blur filter for simple effects but works with Gaussian Blur for more control and greater flexibility when working with image selections that are particularly complex. Gaussian Blur is also less calculation-intensive for the computer and allows him to work with larger file sizes than he could when using Lens Blur.

Comeaux recommends the following tips before working with image blurring:

- Flatten the file before blurring to guard against unexpected results from the interactions of multiple layers.
- Resave the file with a new working title and archive the previous state for future access.
- If working in CS3, convert the file from 16-bits to 32-bits to limit posterization.

Using Gaussian Blur to Reduce Color Noise

The Gaussian Blur filter can help reduce color noise in image captures made at high ISO settings or from cameras with less sophisticated sensors and chips. Gaussian blur affects only the color information in the image. It blurs distracting color pixels without adversely affecting the image detail.

Here's How to Do It:

- From the Photoshop toolbar select Filter > Gaussian Blur.
- Adjust the slider to a 4-pixel radius and click OK.
- Go to Edit > Fade Gaussian Blur.
- From the Mode pull-down menu select the option for Color.
- Save the image as a new version and notice how it exhibits much less color noise than the original.

© **BEAU COMEAUX**

Camera	Canon Digital Rebel XT
Lens	Canon 18–55mm
ISO	400
Aperture	f/8
Exposure	30 seconds

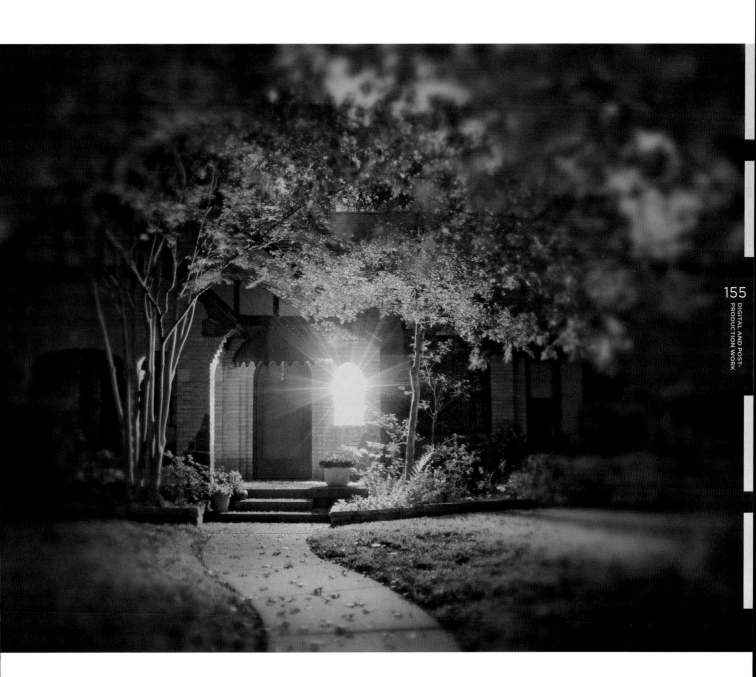

Comeaux shot a 6-stop bracket of this scene and planned to use Merge to HDR. After reviewing the captures, he found a single frame in the middle of the bracket that accurately captured the full contrast range and the desired star-light effect of the central votive light. An image captured with one purpose in mind can easily lead to other possibilities once the file is carefully examined in postproduction.

To transform this image from a dull scene with flat lighting, Comeaux made extensive adjustments to contrast and color. The original capture shows little distinction between bricks and mortar in the house façade. Comeaux removed color from certain brightness areas to make the mortar whiter and to add contrast to the bricks. He selectively applied Gaussian Blur at the end of his workflow after flattening the file and changing bit depth.

		OPPOSITE	
Camera	Canon Digital Rebel XT	**Camera**	Canon Digital Rebel XT
Lens	Canon 18-55mm	**Lens**	Canon 18-55mm
ISO	200	**ISO**	400
Aperture	f/4.5	**Aperture**	f/4.5
Exposure	30 seconds	**Exposure**	30 seconds

The disorienting perspective in this image was created from just two horizontal images shot with a wide-angle zoom lens. Comeaux likes to play with seamless perspective shifts in a compacted space to create a visual discord that strikes deep within the human optical system.

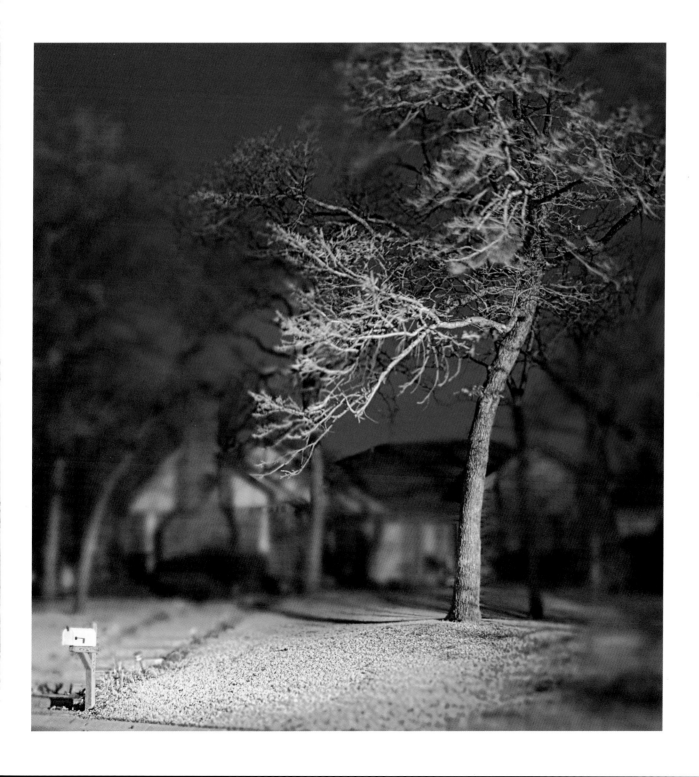

157

DIGITAL AND POST-
PRODUCTION WORK

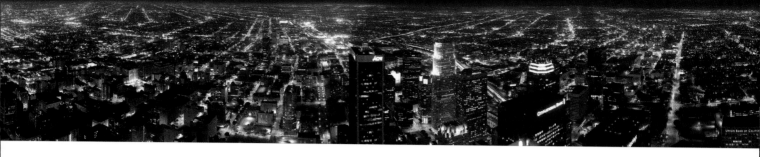

© **HELEN K. GARBER**

Camera	Hassleblad H1
	Digital with Leaf Aptus 22 Back
Lens	35mm
ISO	100
Aperture	f/11
Exposures	Undocumented
Additional	Composite of 16 frames
	and 4 additional files

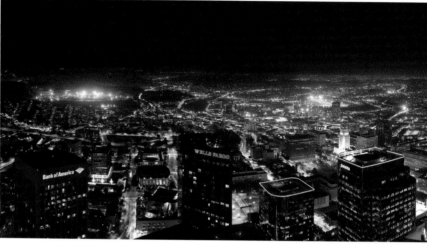

Helen K. Garber
and a Night View of Los Angeles

Helen K. Garber is best known for her classic series of film-based black-and-white photographs, *Urban Noir*, but a rare invitation to photograph atop the U.S. Bank Tower in downtown Los Angeles led her to create a digital panoramic of the entire L.A. skyline lit up at night in full color and with high-resolution digital capture.

During her first trip to the skyscraper's helipad, Garber shot with 35mm transparency film. The idea for a panoramic view did not occur to her until she discovered the breathtaking vista and the clear conditions on-site. Rather than using the usual method of shooting a panoramic from a fixed position, Garber shot from the perimeter of the helipad in order to include many key landmarks otherwise hidden from view. She photographed from 16 points around the building's edge and rotated through 20mm, 35mm, and 85mm lenses to produce plenty of raw material from which to construct a composite.

A few months after this shoot, Garber learned of an upcoming Architecture Biennale where the city of Los Angeles would be prominently featured. She sent an exhibition proposal of her nighttime work to the Biennale's curator, and this resulted in an invitation for her to present the panoramic skyline shot. Yet, as Garber began to put the pieces together, she noticed there was a key section of the landscape missing from the images needed to create the panorama. She tried frantically to assemble the panorama with the materials she had already shot until, fortuitously, she received a new opportunity to access the bank tower heliport for a reshoot.

Lights from the entire city of Los Angeles stretch endlessly across the horizon in a 360-degree panorama as seen from the U.S. Bank Tower. The panoramic skyline was stitched together from a sequence of sixteen medium-format digital captures and additional elements pulled from earlier coverage shot on film.

Camera	4x5 Speed Grapihc
Lens	135mm Graflex or 180mm Schneider
Aperture	*f*/5.6 and *f*/11
Exposure	About 4 minutes
Film	Fuji NPL 160 tungsten

9 Specialty Styles And Techniques At Night

Perhaps more than any other aspect of the medium, night photography opens the doors to the interpretation and the vision of the artist. There is no single method or easy answer for making pictures or achieving success. Technical skill is important, yet this alone does not make meaningful images. While this gives photographers a tremendous amount of creative freedom and favors an experimental and intuitive approach, it does not take away from the need for a thorough understanding and firm control of the methods and tools involved in the process. All of the photographers included in this book have developed individual techniques in order to achieve images that make a distinctive statement. The seven photographers featured here provide examples of ways to reach beyond the basics and combine a unique vision with a process-oriented approach.

An iron railing acts as a divider between two different light sources in this early-dawn shot. The roses at left are warmed by an incandescent porch light, while the right side of the frame is lit by the cool blue light of a pre-dawn sky.

❗☐ In rural areas with the possibility of recording celestial bodies, use a compass to identify the direction the camera lens is pointing and note the time and date at which the image is made. A planetarium software program can then be used to identify the specific phenomena that appear in the image.

Robert Vizzini

Process

Robert Vizzini uses an alternative process called *lith printing* for much of his work. With this technique, a developer intended for high-contrast lithographic film reacts with photographic paper differently than a normal developer would. The image is revealed slowly through a method called "infectious development." Development times vary widely from one print to the next and can extend for as long as twelve minutes. The paper is immersed in the developer, and it first appears to have no reaction until the image suddenly comes up. Each image must be inspected in the tray to monitor shadow detail, and the print must be "snatched" from the developer before the shadows reach their peak. The print is then placed in a stop bath, which darkens the tonality. Then, in the fixer, the color shifts warmer and the image appears to get lighter. Once the print is completed, a dry-down process must be factored into the final image appearance. The complexity and unpredictability of this process means that each step needs to be carefully considered for best results.

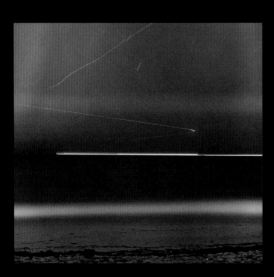

© ROBERT VIZZINI

Camera	Hasselblad 503CW
Lens	Zeiss 80mm f2.8 CF Planar T*
Aperture	f/5.6
Exposure	5 minutes
Film	Kodak T-Max 400

OPPOSITE

Camera	Hasselblad 503CW
Lens	Zeiss 100mm f3.5 CF Planar T*
Aperture	f/5.6
Exposure	20 minutes
Film	Kodak T-Max 400

Star trails, airplane lights, and illumination from a boat on the horizon etch the image with calligraphic precision and add to the abstract mystery of Vizzini's series of night seascapes. This series is also lith printed, however, Vizzini used a warm-toned Bergger paper that has a very heavy base and a rich-looking silver content. Every paper-and-lith combination results in very different effects to allow a wide range of expression between different series of work. To give the images in this series a distinctive color and feeling, Vizzini split-toned the prints in sepia and gold. The toning process alone requires two darkrooms and six or seven trays.

Abundant star trails are recorded through an open window in a darkened room because of the wide aperture setting. Vizzini works with alternative processes such as lith printing to give his prints a distinctive look. Because he did not have formal instruction in the process, his technique is very different from other practitioners. Instead of developing prints in a dilute solution, he uses the developer at full

LEFT: The reflective surfaces and lighting of numerous passing cars and trucks record as ghosts in this roadside image from the rural plains. Vizzini parked on the shoulder of the road and set up the shot at the front of the car as a partial shield from passing traffic. The camera and tripod were positioned at a low angle for solid grounding. Vehicle lights become increasingly blown out the farther they get from the camera because of the way distance gets compressed in three-dimensional space as translated to the flat plane of an image. The parallel angle of the star trails to the motion blur was an unexpected coincidence that was not discovered until after the negative was developed. **RIGHT:** A somber composition of barren tree limbs against the night sky is brought to life by the contrast of a full moon and bright window lights. Lith printing techniques develop the silver grains in photographic paper. The resulting texture can range from smooth to grainy depending on specific times for exposure and development. Vizzini's process favors a grainy texture called "pepper fog," prevalent in this print. Many other lith printers add an extra chemical to the developer to avoid the occurrence of this textured effect.

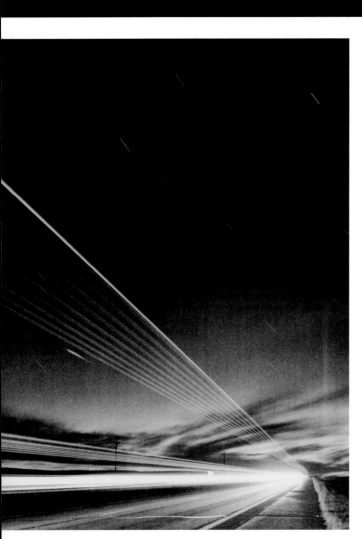

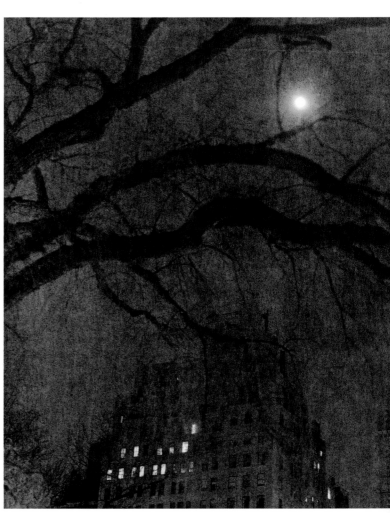

Barbara Yoshida

Process

Mountains, solitary rocks, and standing stones photographed by moonlight are Barbara Yoshida's specialty. Although she travels by air and car to reach her remote locations, once on-site her working methods resemble those of explorers from a bygone era. She works almost exclusively with a 4x5 Wista field camera, which is more portable and less costly than other 4x5 models.

In addition to the usual options for printing her images photographically or with digital output, Yoshida selects certain images to edition as *photogravure prints.* The process she uses is the same continuous-tone method that has been used for over a century and is distinct from the "photo-etching" process that uses a half-tone. To create a photogravure, the corrosive salt ferric chloride is used in varied solutions to etch copper plates. First, the photographic negative is transferred to a film positive that is enlarged to the same size as the final image, either through current digital methods or, more traditionally, in the darkroom. This film positive is exposed onto a sheet of light-sensitized gelatin-coated paper, which is adhered to a copper plate with a mirror-finish. The paper backing is peeled off, to leave the gelatin with the latent image on the surface of the copper. The gelatin coating is thicker in highlight areas, which protects the copper longest during the etching process. The plate is moved through a series of acid baths of differing strengths to etch the copper wherever it is not protected by the gelatin. The dark areas of the image are less protected than the highlights and are therefore etched deeper by the acid, so that these areas will hold more ink. If the plate is treated in each acid bath for the correct amount of time before it is moved to the next bath, all of the tones in the image will be captured. After etching is complete, the gelatin is removed and the plate is printed on a press. The etched copper is covered with ink, which is rubbed into the plate's textured surface with a stiff cloth. The copper surface is then carefully wiped by hand so that the ink only remains in the crevices etched by the acid. The plate is placed on an etching press with a sheet of dampened paper on top. As it passes through the press under very high pressure, the paper presses into the etched crevices and picks up the ink.

Personal Vision

Although I would normally have waited until the moon were "higher" in the sky, I knew how quickly the weather could change, so I took a couple of shots of Clements Mountain when the moonlight was still quite yellow and not that strong—the hazy cloud cover obscured the light, too, so I increased the exposure times to 12 minutes and 16 minutes instead of my usual 8-minute exposure time for full moonlight... After those two shots, the sky was mostly covered with thin clouds so I drove to Chief Mountain...

When I got back to Logan Pass, it was crystal clear and the full moon was "high" in the sky—the kind of night I dream of! At times the gusts of wind were so strong that the tripod moved—I tried to steady it with my arms, pressing down with as much strength as I had. Not surprising, since I was standing at the top of the Continental Divide. Later, when I looked at the film, I could see the zigzags in the star trails that showed when gusts of wind had jarred the camera.

–Journal entry, Barbara Yoshida

© **BARBARA YOSHIDA**

LEFT		RIGHT		OPPOSITE LEFT AND RIGHT	
Camera	Wista 4x5 Field Camera	Camera	Wista 4x5 Field Camera	Camera	Wista 4x5 Field Camera
Lens	Nikkor-W 150-mm	Lens	Nikkor-W 150-mm	Lens	Nikkor-W 150-mm
Aperture	f/5.6	Aperture	f/5.6	Aperture	f/5.6
Exposure	12 minutes	Exposure	8 minutes	Exposure	8 minutes
Film	Kodak Tri-X	Film	Kodak Tri-X	Film	Kodak Tri-X

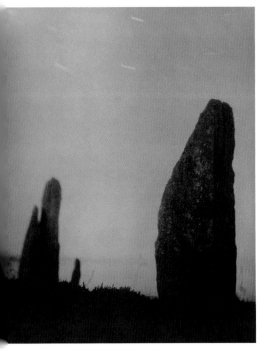

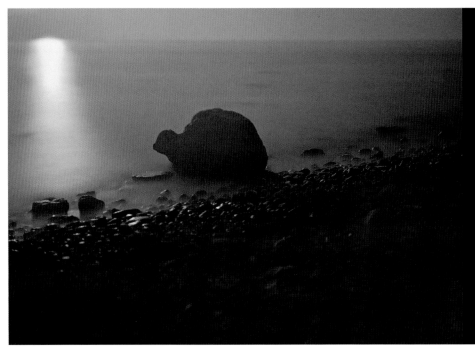

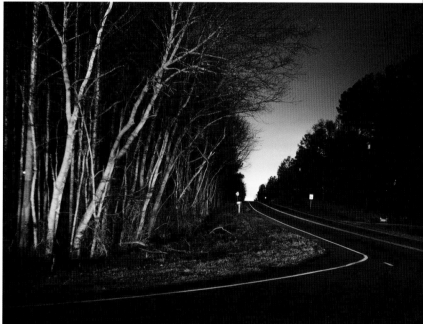

TOP LEFT

Camera	4x5 Speed Graphic
Lens	135mm Graflex or 180mm Schneider
Aperture	probably *f*/11
Exposure	between 4 and 8 minutes
Film	Fuji NPL 160 tungsten

TOP RIGHT

Camera	4x5 Graflex field camera
Lens	135mm Graflex or 180mm Schneider
Aperture	probably between *f*/11 and *f*/22
Exposure	about 8 minutes
Film	Fuji NPL 160 tungsten

BOTTOM

Camera	Unspecified 4x5
Lens	135mm Graflex or 180mm Schneider
Aperture	probably *f*/11
Exposure	40 minutes
Film	Kodak 160 NC daylight

TOP LEFT: A neighbor's exterior motion lamp set the scene for this colorful shot of a flowerbed with the stark contrast of a garage door out of focus in the back. Sharp had no way to prevent the motion light from coming on during the exposure, so she decided to make the lighting an element in the image. She walked back and forth in front of the lamp to keep the light illuminated during the entire exposure. She carefully balanced the colors in printing to bring out the alchemy that occurred between her favorite tungsten negative film, the atmosphere, and the lights. **TOP RIGHT:** The camera was positioned at ground level for a heroic perspective on the leggy growth of these summer blooms. For close-up shots like this one, Sharp hedges her bets with depth of field. She often stops down her lens to ensure the sharpest focus on her subject. A camping light placed on the ground to the left of the camera blasts the flowers with light. The fall-off of the light source allows foreground and background to fade to black. **ABOVE:** Ambient light pollution and an adjacent traffic signal sequentially flashing red, green, and yellow lights created a strong color-cast in the daylight film used for this rural highway landscape. This scene appears calm and empty, but a lot of effort went into blocking the lens to avoid lights from passing cars. In addition to factoring for reciprocity failure of the film during the long exposure, extra time was added to compensate for when Sharp covered the lens because of the nighttime traffic.

Personal Vision

When I'm shooting at night, the world, with all its excessive emotion, has to be asleep. I just need the place to myself. I want to encounter the world on its own terms, not our terms.

Normally when we shoot, we're making the variables. What I love about night shooting is it feels like the reverse. I'm a little camera, and I go out into the world and I'm always at *f*/11. My little aperture is going to be open for about 20 minutes, give or take, and so I don't change. But what I point at does.

–MJ Sharp

OPPOSITE TOP LEFT		OPPOSITE TOP RIGHT	
Camera	Holga	Camera	Hasselblad
Lens	Fixed 60mm	Lens	80mm
Aperture	f/8	Aperture	f/5.6
Exposure	25 minutes	Exposure	about 1 minute
Film	Agfa Optima 400	Film	Fuji NPL 160

OPPOSITE BOTTOM LEFT		OPPOSITE BOTTOM RIGHT	
Camera	Holga	Camera	Hasselblad
Lens	Fixed 60mm	Lens	80mm
Aperture	f/8	Aperture	f/5.6
Exposure	25 minutes	Exposure	25 minutes
Film	Kodak BW 400CN chromogenic	Film	Fuji NPL 160

Susanne Friedrich

Process

As an inexpensive option for making night photographs in medium format, Susanne Friedrich customized a Holga camera by the following steps:

• Remove the camera back. Using the square plastic insert will produce rectangular images with sharp edges. If square, vignetted pictures are desired, discard this insert.
• Detach the lens mechanism from the camera body by unscrewing two interior screws.
• Slide the shutter button out of its holder and carefully disassemble the shutter assembly by removing the screws on the back of the lensboard.
• Unsolder or clip the wires that activate the flash and disassemble the shutter cock.
• Glue the circular dial that opens the shutter so that it remains in the open position and will allow light to enter the camera.
• Reattach the lens element to the camera body and replace the screws.

The Holga is now ready to take night photographs of unlimited duration simply by using the lens cap at the beginning and the end of the exposure.

Holgas are subject to light leaks, so to avoid light from fogging areas of the film, Friedrich covers all camera edges with gaffers or electrical tape. To prevent light reflections inside the camera, she spray-paints the interior with matte black paint.

In working with the Holga, Friedrich estimates her exposure times based on past experience. She uses the following guidelines in different environments:

• 25 to 30 minutes under full moon conditions with no other light sources.
• 10 to 15 minutes under urban situations.

Additional information about customizing Holga cameras is available from the following Web sites:

• Argonauta Productions: <www.argonauta.com>
• Holgamods: <www.holgamods.com> (customized cameras with cable release or bulb settings can be ordered from this Web site)

Personal Vision

Obviously the Holga lens isn't very fast. All the layers of plastic really absorb a lot of light, so shooting with this lens requires a lot more exposure than with a Hasselblad.

–Susanne Friedrich

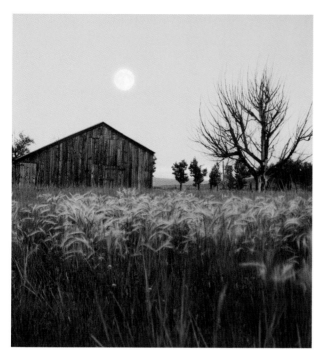

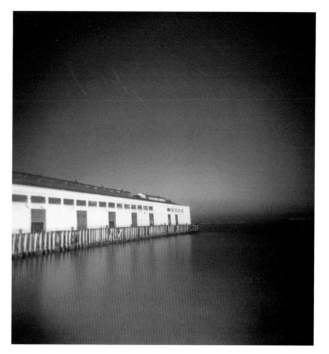

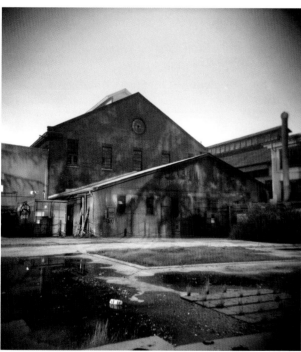

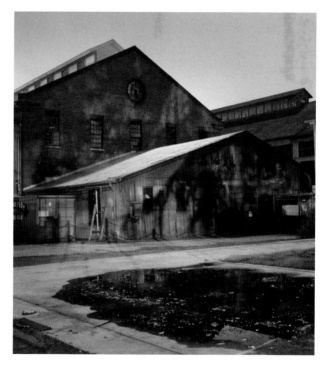

TOP LEFT: A twilight shot of the rising moon was enhanced with digital darkroom work. The one-minute exposure needed for the landscape resulted in the moon recording as overexposed and blurry. Friedrich scanned the negative and enhanced contrast in the midtones. She adjusted the color of the sky and shifted the balance from orange to pink. She could have left the moon a blurry white blob but decided to refine it, adding the moon-faced texture to help make the image come alive. **TOP RIGHT:** The cool blue of a moonlit sky is balanced against the yellow cast of streetlights reflected in the water during a long exposure time. In the midst of this shot Friedrich covered her camera lens to avoid recording the lights from a passing ship. This interruption to the exposure is evidenced by a break in the star trails. If the lens is covered for an extended period during an exposure, this time must be factored back into the end of the shot. **BOTTOM LEFT:** Estimating exposures with the Holga is a very intuitive process. Friedrich's full moon exposures average 30 minutes. With low light and a plastic lens five or ten minutes either way does not seem to make a big difference. Her favorite film to use with the Holga at night is this black-and-white negative film made for color processing. The medium-format negative delivers fine grain plus nice shadow detail and a good range of exposure tolerance. **BOTTOM RIGHT:** After mastering the Holga when shooting at night, Friedrich bought a Hasselblad to have more control over the image quality. Since film exposure is such a slow process, it helps to have two cameras running at once, effectively doubling the image production. After scanning the negatives, Friedrich sometimes enhances her images in Photoshop. Here, she adjusted contrast levels to emphasize the play of shadows cast on the warehouse from nearby street lights and from painting the scene with gelled flashlights.

When handholding a 35mm camera for a long exposure without a tripod or other means of support, pull wrists together and elbows in toward the body. For vertical pictures, use the bottom hand as a brace against the chest. To further steady the camera when shooting, take a deep breath and release it when clicking the shutter. Put one foot in front of the other for balance and think of your feet as rooted to the ground.

Personal Vision

There's a color palette in my head, and a lot of my photographs are adjusted to that. It's a feeling. It's like adjusting the color on the TV set until it looks good.

–Marc Yankus

Marc Yankus

Process

In Marc Yankus's nighttime views of New York, the ease of in-camera metering and automatic camera settings used during image capture are combined with extensive digital layering and exacting postproduction work. To obtain more accurate, saturated colors and for added flexibility in printing, Yankus uses a RIP made by a company called Imageprint. A RIP (Raster Image Processor) is a specialty software program installed in the computer to replace the printer driver and handle the printing process. This is a professional application and therefore a serious level purchase, but it can improve quality in certain images by allowing the printer to spray ink in a more specialized manner. Prints show better shadow detail and smoother transitions of image tones and gradients. Blacks have less of a tendency to posterize, band, or block up, which can be an important advantage with photographs shot at night and in low light.

Use of a RIP can be especially beneficial in printing black-and-white images with custom black inksets, since the software can use multiple shades of black ink to create a black-and-white print. The software also includes a library of custom profiles for most combinations of papers and inks. Instead of needing to create a custom profile for printing accuracy, Yankus can find a profile for the Hahnemuhle matte paper he uses to edition his work within the options provided by the RIP. Yankus prints his images at two sizes, 11x17 and 17x22, in editions of fifteen copies each. When he needs to make a number of prints at one time, he uses the RIP to spool multiple images to the printer automatically. This frees up his time from overseeing the printing process and adds to the convenience.

© **MARC YANKUS**

Camera	Nikon N90s
Lens	50mm
Aperture	Auto setting
Exposure	Undocumented
Film	Fujichrome Sensia 400

A twilight bike ride was an ideal opportunity for a handheld grab shot of city lights on Manhattan's West Side. Yankus purposely defocused his camera when shooting and let the automatic camera settings do the rest. This composition is cropped from a 35mm horizontal to eliminate distracting elements at the side. After scanning the slide to bring it into a digital workflow, he layered a texture on top and adjusted the hue from red to a more orange tone to suit his color palette.

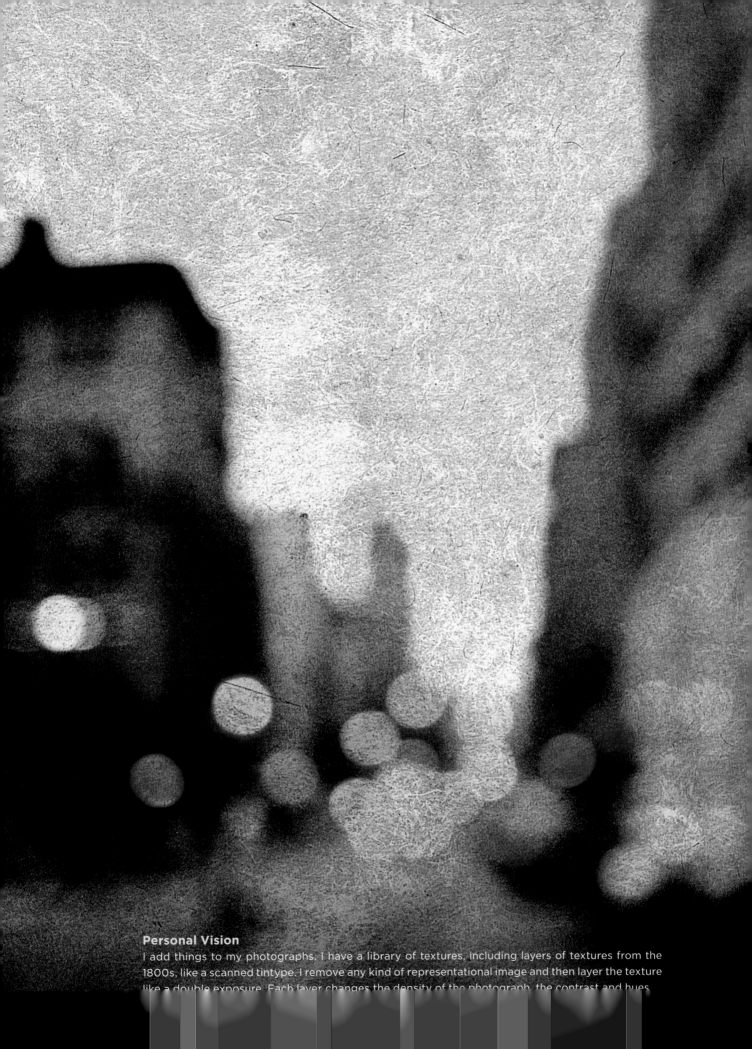

Personal Vision

I add things to my photographs. I have a library of textures, including layers of textures from the 1800s, like a scanned tintype. I remove any kind of representational image and then layer the texture like a double exposure. Each layer changes the density of the photograph, the contrast and hues,

© **MARC YANKUS**

LEFT		TOP RIGHT		BOTTOM RIGHT	
Camera	Nikon N90s	Camera	Nikon N90s	Camera	Nikon N90s
Lens	50mm	Lens	50mm	Lens	50mm
Aperture	Auto setting	Aperture	Auto setting	Aperture	Auto setting
Exposure	Undocumented	Exposure	Undocumented	Exposure	Undocumented
Film	Fujichrome Sensia 400	Film	Fujichrome Sensia 400	Film	Fujichrome Sensia 400

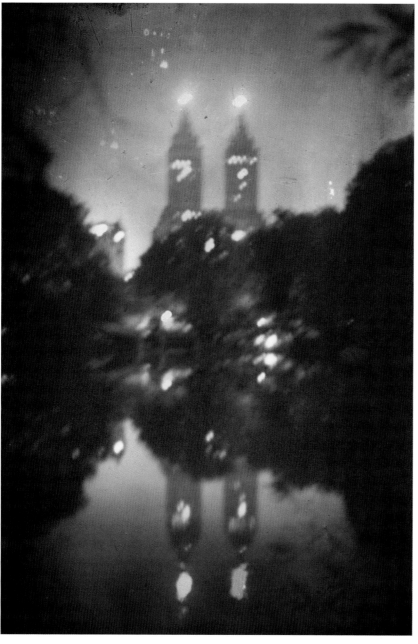

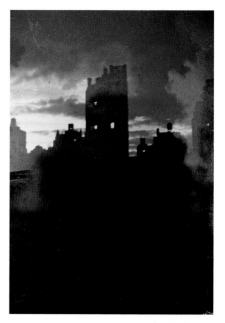

LEFT: The reflections of a landmark building in water were the inspiration for this nocturnal view in an ethereal setting. The atmosphere of a misty night was further enhanced in postproduction by adding multiple layers of texture in Photoshop. Using a tripod in urban settings draws unnecessary attention and can be problematic, so Yankus hand-holds the camera for his night shots. This gives them a blurred, impressionistic look that suits his pictorialist style. He uses the in-camera meter to automatically set the aperture and exposure time. Because he shoots at a high ISO, his exposures are never more than a minute in length. **TOP RIGHT:** A nighttime urban landscape viewed from his window provides Yankus with a constantly evolving theme that he photographs when most of the world is asleep. He rests the lens against the window to steady the camera during a long exposure. This helps to eliminate reflections in the glass as well. In this piece, a texture layered on top of the image in Photoshop mixes with the sky at the sides of the image to intensify the effect of the clouds. Yankus tries out many different textures with an image before selecting the one that works best. **BOTTOM RIGHT:** In another view from his window at dawn, Yankus pictures the same building with a soft-focus silhouette. When photographing at night, an identical view is likely to look dramatically different from one night to the next. This makes it important to act on an interesting picture opportunity without delay, whenever one presents itself.

Daryl-Ann Saunders

Process

The atmosphere of subway platforms at night becomes a stage set for images that benefit from the low-light capability of high-speed film in the creation of a futuristic aesthetic. After a shoot, Daryl-Ann Saunders tries to have her film developed as soon as possible, to check results from a location in progress as well as to avoid traveling through airport security with exposed film. For uniformity in processing and presentation, she uses the automated system of a semi-pro photography chain found in most of the cities she visits. She orders two sets of 4x6 prints and works with these by viewing both sides of the image over a lightbox to transform an initial assembly of components into picture ideas. She sometimes also uses an extra CD with images saved as low-resolution files in her decision-making process.

Once Saunders identifies the negatives she wants to work with, she scans them at maximum resolution on a 4000 dpi film scanner to yield 80-megabyte RGB files. Several scans of an image may be needed to get one file that captures the best range of contrast from shadows and highlights. Next, she creates "assemblages" by bringing together the photos on the computer and works with multiple variations to identify the one best suited to her creative and printing intent. Once she hones in on a final version, she cleans the files and creates multiple Photoshop layers for exposure, contrast, and retouching. Because these layers can expand the size of a file to 1 gigabyte or more, this part of the process can easily take one week of 8-hour sessions. In the end, the finished file is flattened and burned to CD for output.

Saunders prints her work at a professional lab and consults with the printer during all steps of printing, from an initial test through several proofs to the final output. Her current paper choice is Fujifilm's Fujiflex Crystal Archive, which complements the metallic look of her subject matter. Super glossy and saturated, it is an archival photographic paper that can also be used for digital output. Saunders's digital C-prints are prepared in limited editions at several sizes. The largest sizes (up to 7 feet wide) are mounted on Plexiglas to ensure flatness before they are framed. All are fronted with Plexiglas rather than glass to keep the final frame weight to a minimum.

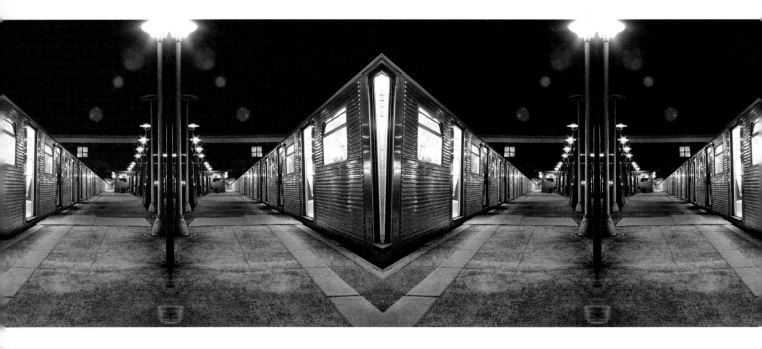

© **DARYL-ANN SAUNDERS**

OPPOSITE TOP

Camera	Olympus IS-3 SLR
Lens	Integrated 35–180mm 1:5.6 zoom
Aperture	f/22
Exposure	between 4 seconds and 10 minutes
Film	Fujicolor NPZ 800

OPPOSITE CENTER

Camera	Olympus IS-3 SLR
Lens	Integrated 35–180mm 1:5.6 zoom
Aperture	f/22
Exposure	between 4 seconds and 10 minutes
Film	Fujicolor NPZ 800

OPPOSITE BOTTOM

Camera	Olympus IS-3 SLR
Lens	Integrated 35–180mm 1:5.6 zoom
Aperture	f/22
Exposure	between 4 seconds and 10 minutes
Film	Fujicolor NPZ 800

RIGHT

Camera	Olympus IS-3 SLR
Lens	Integrated 35–180mm 1:5.6 zoom
Aperture	f/22
Exposure	between 4 seconds and 10 minutes
Film	Fujicolor NPZ 800

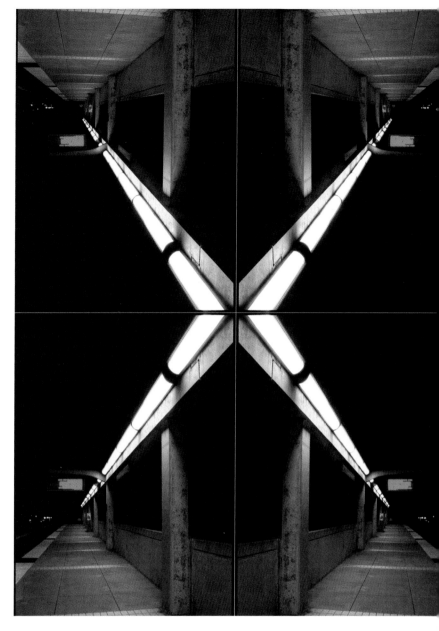

Personal Vision
A host of technical issues can arise with this work, and sometimes you have to rethink and change your expectations once you get on-site. Stand there and see if there is something better to derive from the subject.
–Daryl-Ann Saunders

OPPOSITE TOP: Saunders plays the role of architect by reconstructing the transit system from the nighttime images she makes on the subway platform. Here, one vertical image is stretched across four frames by scanning the negatives, flopping the files, and combining them edge-to-edge to result in an image that becomes panoramic in appearance. **OPPOSITE CENTER:** In this four-section composite, massive structures are abstracted to become space-age surfaces through Saunders's clever use of the edges of the frame and the recombining of identical parts. Her final pieces can measure up to 7 feet wide and are printed on Fujiflex Crystal Archive's metallic paper to lend to her images a sense of the materials used in the trains themselves. **OPPOSITE BOTTOM:** On a weeklong shooting trip to the San Francisco Bay area, Saunders spent entire days riding the length of the transit system to scout shooting locations. At some stations, the best lighting conditions are in the short window of twilight, when the fading daylight coexists with artificial lights. In an added twist on transit, this view combines different frames shot from the same vantage point to show sequential moments in one image.

TOP: The florescent lighting and LED readout of a deserted platform is transformed into a bold graphic design element in Saunders's latest work. In order to achieve maximum sharpness with her 35mm format, she keeps the camera aperture set at f/22. Because lighting conditions on the platform are subject to rapid change as a train enters the station she brackets the shutter speed and works on the fly with light levels in flux.

Another hand was at work in this image created during one of Harper's night-photography class trips. After much practice, student Kiyoshi Sekizuka became quite adept at a technique Harper taught for drawing with light using a filtered penlight. Harper asked him to collaborate in this long exposure by passing through the scene and drawing numbers 1 through 7. In this drawing, Sekizuka drew the "6" upside down, creating a "9" instead. When drawing with light in front of the camera, remember to draw letters or numbers backward because of the reversed vantage point of the lens.

© STEVE HARPER

Camera Mamiya RB 6×7 ProS
Lens 90mm
Aperture: f/16
Exposure 4 1/2 hours
Film Kodak 160 Tungsten

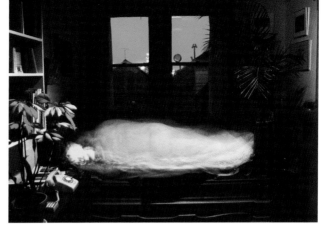

Extensive planning was needed to successfully record this image of the photographer asleep. Harper knew the intensity of lighting inside his room had to match the light coming through the window. He replaced the ceiling fixture with a 5-watt bulb surrounded by a four-inch collar. The light was further diffused with five layers of Kleenex tissue. The collar directed the light straight down instead of spreading it around the room evenly. The pink bedspread was chosen for its color which would register as bright on the film over the long exposure time.

Night Photography, Digital Technology, the Internet—and a Few Links

Before the Internet, the primary resources for photographic tips and inspiration were materials published in books or taught in classes and workshops. Complex exposure guidelines, plus issues such as reciprocity failure and color shifts under artificial light, made film-based night photography a bit of a black art. Comprehensive information and situation-oriented feedback was hard to get. Digital technology has simplified the learning curve for shooting in low light by allowing photographers to get immediate feedback on their work. These advances, coupled with the rise of the Internet, have had a great influence on both the popularity of night photography and the information available to those seeking information about this subject. In addition to insights from the photographers featured on these pages, the following shortlist includes some basic resources that were helpful to the research and writing of this book.

The Nocturnes: www.thenocturnes.com

Launched by Tim Baskerville in 1991, the Nocturnes Web site provides an international community for night photographers and is a leading source of information, education, images, and inspiration related to this specialty.

Cambridge in Colour: www.cambridgeincolour.com

The Web site of scientist and night-photography enthusiast Sean McHugh features extensive photography tutorials and technical information, much of which is geared to digital photography in low light and at night.

Lunar Light Photography: http://home.earthlink.net/~kitathome/LunarLight

The Web site of night photographer and engineer Kit Courter includes detailed technical information about digital night photography, moonlight-brightness and landscape techniques, atmospheric effects, reciprocity failure data, and other night-photography topics.

! After a group shoot, review images with other attendees for insights about different parts of a location or camera angles that vary between photographers. This knowledge about how the location records in photographs can be put to use on the next trip.

The Luminous Landscape: www.luminous-landscape.com

Although not specializing in night or low-light photography, this Web site by Canadian photographer Michael Reichmann features an encyclopedic amount of technical information and data, much of which is relevant to low-light and nighttime shooting.

Photo.Net: http://photo.net

This is another general-photography Web site, not specialized in night or low-light photography, but with technical information, reviews, and forums that may be helpful for a better understanding of low-light and nighttime shooting. Started as Philip Greenspun's home page at Massachusetts Institute of Technology, this site is now a community of more than 100,000 photographers with a goal of providing constructive criticism and helpful assistance to others.

Night of the Living Photographers: Free download available at http://studentfilms.com

A 23-minute documentary film by Andy Frazer that features interviews with five notable night photographers, three of whom are contributors to this book. A link to the download can also be found on Frazer's night-photography blog at: http://gorillasites.blogspot.com.

Photo Sharing and Blogs

The most dynamic aspect of the current online photography community can be found on photo-sharing Web sites and photography blogs. These resources have been a boon to specialty subjects such as night photography and have greatly enabled contacts between like-minded photographers, both online and in person. Although many of these sites are not specific to night photography, the larger communities have specialized photo streams where night photographers congregate and connect. Photo-sharing sites like Flickr (www.Flickr.com) provide a connection with a peer group who react to posted photographs and make it easy to get feedback and encouragement. New photographs and commentary about images are uploaded to these sites on a daily basis.

Cost is another advantage to photo-sharing sites and blogs. These services are often cost-free, and since they offer automatic design templates and easy uploading, many people are foregoing personal Web sites in favor of a site that is easy to maintain. Photographers with existing Web sites often use a blog or a photo-sharing image stream as an efficient way to augment their main site and to keep the content fresh. Search engines automatically rank blogs higher than static sites so this offers a big advantage to photographers who want to get their work noticed.

Resources and Links

The ever-evolving nature of the Internet makes it impossible to publish herein an accurate and thorough listing of Web sites, blogs, further resources, and links that may be of interest to night photographers. The perfect home for this information is the Web, where inactive links can be removed and referrals can be updated in a timely fashion.

For those seeking additional resources about night photography, or those who wish to recommend a resource or link for review and possible addition to the online resource list, please visit www.nightphotographybook.com. And do let us know what you think of this book!

© TROY PAIVA

Camera	Canon EOS 20D
Lens	12–24mm, 1:4 zoom at widest setting
ISO	100
Aperture	f/5.6
Exposure	about 2 minutes

Personal Vision

There's a big element of performance involved in shooting at night in a group. If you stand back—if you're not actively involved in it—it's like a dance. People are moving around with flashlights, and the movements have to be smooth and flow to get the photographic effect. It always looks like some kind of scene like a studio or a stage set, and it has this whole charged atmosphere of the night.

–Tim Baskerville

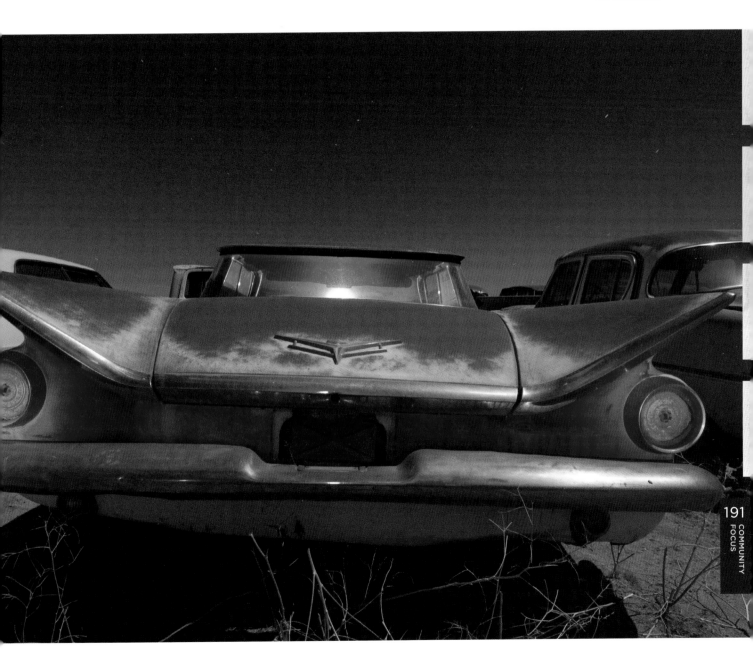

Troy Paiva always works with a tripod and generally tries several different lighting schemes in an image made with identical framing. His light-painting technique is an exacting process, and effects can vary greatly from one frame to the next. For an end result with seamless lighting, he will sometimes blend two or more frames in postproduction. In this image, a junkyard car is brought to life with a red-gelled flashlight aimed at the car taillights and a pop of purple- and green-gelled strobe through the car's front windshield.

■ Acknowledgments

There are many people whose efforts and support have been integral to this project. Simple acknowledgement is barely sufficient to repay their expertise and insights. All of the contributors have gone well above the call in offering their time and experience during interviews and in response to my many inquiries and requests for materials. In addition to teaching me much I did not know about a photographic specialty I've long been passionate about, I have learned the true value of community from the generous advice, encouragement, and the willingness of all my fellow night photographers to share their many tips and secrets. I am particularly indebted to the following people for their help and support: Bill Kouwenhoven for his multiple readings of this entire text, his thorough edits, and his advice; Mark Jaremko for his eloquent explanations of all things digital and his extensive feedback on this part of the text; Beau Comeaux, Lance Keimig, Tom Paiva, Ragnar Sigurdsson, Karen Thorsteinsson, and Christian Waeber, as well as the other featured photographers for their assistance with technical edits, fact checks and feedback.

Sincere thanks go out to Victoria Craven at Watson-Guptill and Lauren Wendle at PDN for the initial opportunity to pursue this project. My editor Abigail Wilentz has been a pleasure to work with and was a wonderfully calming influence. Alisa Palazzo, Timothy Hsu, Brian Phair, Alyn Evans, and everyone else at Watson Guptill have been extremely patient as this project has reached completion. My appreciation to Thom O'Connor at the Tabletop Studio for his organization and technical assistance making CMYK conversions of all the image files.

Michael Kenna has been incredibly generous with his time and praise in writing the book's foreword; Barbara Yoshida lent her typing talent to help transcribe endless hours of interview tapes; Julia Smith came to my aid with her general photographic expertise, wisdom under pressure, and awesome dustbusting talents; Drew Epstein offered sound legal advice; Jayne Rockmill and Shannon Wilkinson provided helpful insights into the world of publishing. And lastly, I'd like to acknowledge the support of the friends who have not seen me during the long months I've been working on this project, as well as the longstanding encouragement of my parents—my father, who would have so enjoyed to leaf through these pages, and my mother, who will be thrilled to show the finished product to her friends. For all my nonphotographer friends and relations, I hope this book finally helps to explain my crazy obsession with setting out alone with a camera, into the night.

—**Jill Waterman**

Glossary

Amplifier Glow (also known as Sensor Glow)– A type of digital image noise caused by the heating of the camera sensor that creates a thermal noise pattern, which usually manifests in an image as a gradient hue shift.

Analog– A method of photography that refers to the use of a film camera rather than digital capture.

Aperture– Opening in a camera lens through which light is admitted. Also referred to as *f*-stop, the aperture, together with the camera shutter, is one of two ways to control the light that enters the camera. The larger the number of the aperture setting, the smaller the lens opening.

Artifact– A flaw in a digital image that can be caused by the camera's optical system, dust, or noise issues with the camera's sensor or image processing algorithms in the camera.

Aspect Ratio– The shape of an image where the width is measured in relation to the height. A typical 35mm-film exposure has an aspect ratio of 3:2.

Astronomical Twilight– The time of darkness when the center of the sun is more than 12 degrees but less than 18 degrees below the horizon and astronomers can easily observe stars and other point sources in the darkened sky.

Auto Focus– An electronic feature of advanced camera systems that allows for automatically setting and maintaining the focus of a lens on a specified object. Auto focus may be less effective to use in dark or low-contrast shooting conditions because sufficient light is required in order for the auto-focus system to lock on an object.

Banding (also known as Posterization)– A type of digital artifact that manifests in an image as a series of discrete steps or bands of color or tonality rather than a continuous gradient.

Bit– A binary digit, or basic unit of digital measurement, which has a value of either 0 or 1.

Bit Depth (also known as Color Depth)– The number of bits used to represent the color of a single pixel. The available bit depth depends on the file type. A JPEG file stores 8 bits of color information, whereas a raw file stores 12 to 14 bits of color information. Images with higher bit depth provide a greater range of distinct colors.

Black-and-White Conversion– A method for digitally converting a color image to black and white using any of a variety of techniques in Photoshop or other imaging software.

Bracketing– A technique for ensuring a well-exposed image by capturing identical images at a range of exposure values on both sides of settings that are metered or estimated to produce desired results. This technique is especially useful in low-light and nighttime environments.

Bulb– A camera setting that enables the photographer to manually open and close the shutter and to make photographs of long duration that exceed settings available on the camera's shutter-speed dial.

Cable Release– A mechanical or electronic device that is screwed into the shutter-release button and enables exposures of long duration when the camera is set to bulb and, typically, stabilized on a tripod.

CCD (Charge Coupled Device)– The standard sensor technology at the heart of a digital camera. It converts light into an electric charge that leaves the sensor as an analog signal and is then digitized and stored as bits. This type of sensor typically has a very high capacity for light capture and image quality. Other sensors include those using CMOS technology (*see* CMOS, below).

Channels– Components of a digital image as separated into distinct color segments, typically the primary colors of red, green, and blue (RGB).

Civil Twilight– The time period in morning and evening when the sun is below the horizon but it is light enough to work outside without the aid of artificial lighting. Before sunrise, civil twilight begins when the sun is 6 degrees below the horizon; in the evening it lasts after sunset until the center of the sun is 6 degrees below the horizon.

Clipped Highlights– Highlight areas in an image that are cut off, resulting in information that is lost or unusable. Clipped highlights are recorded at the maximum value the sensor can record and register as pure white.

CMOS (Complementary Metal–Oxide Semiconductor) – A CMOS image sensor, also known as an active-pixel sensor, offers an alternative technology for capturing digital images that has become increasingly prevalent in some digital cameras. With CMOS sensors, light is converted from an electric charge to digital data within the sensor itself.

Color-Cast– Hues or color shift that occurs when film type or color temperature setting does not match the light recorded through the camera's lens. Color-casts often result from photographing under artificial lighting conditions. Undesirable effects may be controlled with filtration over the lens, by adjusting the white balance in a digital camera or by making adjustments in post-production.

Color Space– The different options that exist within an imaging software program to represent the range of colors that can be reproduced in an image. Some common types of color spaces include RGB, CMYK, and LAB color.

Color Temperature– All light sources have a specific color temperature measured in degrees Kelvin (K). Lower-color temperatures correlate to warmer colors and high-color temperatures correlate to cooler colors. The color temperature of bright sunlight falls toward the middle of the Kelvin scale at approximately 5,500 K.

Compendium Bellows– An extendable lens hood that attaches to the front of the camera to shield the lens from unwanted light that could create flare in an image.

Composite– A photograph created by the layering of image components, either through in-camera multiple exposures or by digital methods in postproduction. It allows for the seamless joining of photographic elements to create a multitude of effects.

Continuous Tone– An image that has smooth, unbroken transitions between gradations of color or shades of grays.

Cross Lighting– A lighting technique generally used for balancing contrast, whereby two lights are directed toward the subject from opposite sides. When lights of the same intensity are placed equidistant and at 90-degree angles from the camera to subject axis, this technique can be very effective in minimizing shadows in a scene.

Dark Current Noise (also known as fixed sensor noise)– An artifact of long exposures in low-light situations, this type of digital image noise is caused by the sensor heating up and producing anomalies in the digital file, usually manifested in an image as white specs or randomly colored pixels.

Dark Frame Noise Reduction or Dark Frame Subtraction (also known as Black Field Subtraction)– Method used to remove dark current noise caused by long exposures at night using digital cameras. Following an exposure of more than several minutes, a second exposure of equal duration is made while leaving the lens covered. The two digital files are combined in Photoshop and anomalies in the first exposure are subtracted by the totally black image that will have received the same amount of noise.

Depth of Field– The area in a scene that appears to be acceptably sharp in front of and behind the point on which the lens is focused. The smaller the aperture—corresponding to larger *f*-stops— the greater the depth of field. A larger aperture—corresponding to a smaller *f*-stop—will have shallow depth of field.

Dew Point– The temperature at which the air becomes saturated with moisture. In night photography, fogging of a camera lens may occur when the air temperature reaches the dew point.

Dialog Box– In a computer program, a dialog box enables the user to affect a set of choices by selecting options to be turned on or off or via a pull down menu with multiple choices.

D-Max– A measurement of the maximum measurable density across the dynamic range of an image. Its opposite, D-Min, is the minimum value whereby useful image information may be recorded on film or by sensor.

DSLR (Digital Single Lens Reflex)– A DSLR camera uses an automatic mirror system between the lens and the sensor to project the image through the viewfinder, allowing the photographer to frame a scene that largely replicates the composition of the final image. Most DSLR cameras use interchangeable lenses, while other types of digital cameras do not.

Dynamic Range– Ratio between the maximum and minimum levels of light that can be recorded in an image. Dynamic range is generally device dependant and can be described by the span from deepest shadows to brightest highlights.

Exposure Value (EV)– Measurement of the amount of light admitted by the combination of aperture and shutter-speed settings. It also represents the amount of exposure required by the film or sensor to accurately render an image, relative to the subject's luminosity.

Fill Flash– Light added from a flash or strobe to fill in shadow areas in an image.

Flashing Highlights– Essentially a warning of potential overexposure, flashing highlights appear in the camera's histogram display (*see* Histogram, below) when the lightest areas in an image begin to block up. As a rule of thumb, while some amount of flashing highlights may be desirable, too much can make it difficult to recover image detail in postproduction.

Fresnel Screen– An accessory for large-format cameras that covers or replaces the normal ground glass focusing screen with a screen or lens that appears "to even out" the light and make the image seem brighter. As such, it may be helpful in low-light conditions, especially when used with wide-angle lenses or "slow" lenses with small maximum apertures.

Ghosting– An imaging effect resulting from subjects in motion or reflections from bright lights that partially

register in a long-exposure photograph.

High Dynamic Range (HDR)– An imaging technique that allows for the recording of a far greater dynamic range of exposure values and tonal detail than could be captured in a single image. (*see* Merge to HDR, below).

Histogram– A visual representation of the overall "exposure" of a digital image as distributed from shadows to highlights. The proportion of pixels at each exposure value is displayed along a horizontal bar chart. An ideal histogram, and an ideal exposure, should show data in a smooth transition that fills the histogram all the way from the left edge to the right edge without being chopped off.

Hot Pixel (also known as a stuck pixel)– A type of dark current or fixed sensor image noise that manifests as a bright-colored dot in an image. Hot pixels can appear anywhere in an image yet they are most noticeable in dark areas of an image file.

Hot Shoe– Mounting bracket that allows a flash unit to be attached to the camera and provides an electrical connection between the camera and flash.

Hyperfocal Distance– A depth of field calculation that provides the closest distance at which a lens can be focused while keeping objects at infinity acceptably sharp. This distance is calculated using the combined factors of lens aperture and focal length. Several online resources and charts for calculating hyperfocal distances can be found through a simple Internet search.

Image Noise– Flawed data that manifest as artifacts in digital files. Digital image noise can be caused by a number of factors, including the sensor heating during long exposures. Noise may be removed or controlled through in-camera noise reduction or a variety of noise-reduction software programs.

Image Preview– A rendition of the image as viewed on a digital camera LCD display, both before and after image capture. In low light and nighttime conditions, review of an image on the LCD screen, together with the histogram and flashing highlights, are invaluable tools for judging the accuracy of an exposure and fine-tuning adjustments.

Image Stabilization– An advanced feature found in some digital cameras or lenses to enhance image sharpness and minimize camera shake. This is particularly useful when shooting at slow shutter speeds or with long focal length lenses.

Inverter– A portable power source that converts DC power stored in its battery or produced by a generator to 110-volt AC electricity to power lighting or other accessories.

ISO– A reference system for film speed and sensor sensitivity accepted by the International Standards Organization. The higher the ISO number, the greater the sensitivity to light. This system parallels and replaces the ASA ratings adopted by the American Standards Association. It also replaces the rating system of the German Industry Norm (DIN) system. When shooting in low light, higher ISO settings allow for the use of faster shutter speeds and smaller *f*-stops, but this can cause increased graininess in an image or unwanted digital noise or artifacts, especially during longer exposures.

Kelvin Scale– Temperature scale used to measure the color temperature of various light sources, where daylight is typically 5,500 degrees and tungsten is 3,200 degrees Kelvin.

LAB Color– An elective color space in Photoshop that can be used to make adjustments to color balance. In this color space, brightness and color information are stored separately in three channels: the L channel controls luminosity or brightness, the A Channel controls the opposing colors of green to red and the B Channel controls the opposing colors of blue to yellow.

Large Format– A camera that produces a large-sized negative or image file, typically 4x5 inches or larger, enabling extremely fine quality enlargements. Adjustments to front and back camera planes, or standards, allow greater control of perspective and depth of field than is commonly possible with small or medium formats.

LCD (liquid crystal display) screen– A feature on the back of most digital cameras, which allows the user to preview images immediately after an exposure is made. In low-light conditions, images may appear brighter when viewed on the LCD screen than the exposure that is recorded in the actual image file.

Lens Flare– Stray light that enters the lens, typically from an oblique angle, and is reflected inside the camera or lens before recording on film or the sensor as unwanted highlights, fogging, or glare in an image.

Light Meter– Electronic instrument, either built into a camera or used as a stand-alone device, to calculate exposure by measuring the intensity of light in a scene or on a subject. Meter readings are based on a given film speed or sensor setting and indicate available options for setting the lens aperture and shutter speed. There are many types of light meters, the most common of which measure light falling on a subject (incident metering) or reflected from a scene light (reflected metering). Spot meters may include a lens that enables a focus on a narrow field approximately 1 to 5 degrees in diameter. Specialized meters can also calculate color temperature and the cumulative effects of flash in combination with available light.

Light Painting– A creative technique, typically directed by the photographer, which employs supplemental lighting to affect an image during photography of darkened subjects. Common tools used for light painting include strobes, spotlights, Mag-Lites, or flashlights, with or without colored gels.

Long Exposure– A photographic exposure made by keeping the camera shutter open for an extended time period, typically at night or in darkened conditions, in order to allow sufficient light to expose an image on film or a digital sensor. In cameras with automated shutter speeds, the dial is typically set to bulb and the camera is stabilized using a tripod and cable release.

Luminosity– The amount of energy radiated from an object in the form of light. The level of brightness given off by a subject or object.

Megapixel– The terminology used to indicate the resolution or pixel recording capability of a digital camera's sensor. One megapixel is equal to one million pixels.

Mercury Vapor– Artificial-light source typically found in urban street lighting, mercury vapor lamps appear cool blue to the human eye and can cause a cyan-green color-cast in images.

Merge to HDR– A feature available in Adobe Photoshop versions CS2 and later to enable several bracketed exposures of an identical scene to be merged in post-production, resulting in a digital file with a far greater dynamic range of exposure values and tonal detail than could be captured in a single image.

Mirror Lockup– A feature of some SLR cameras that allows the photographer to lock the mirror in an open position before the shutter is opened. This can reduce the chance of blurred images caused by the mirror's movement during exposure times in the range of 1/4 second to 10 seconds.

Nautical Twilight– The time period after sunset and before sunrise when the center of the sun is more than six degrees but less than 12 degrees below the horizon. Nautical twilight is relevant to mariners as the time when the horizon line can still be distinguished under good atmospheric conditions and major stars can be used to take readings with a sextant.

Neutral Density Filters– Lens filters in a gray spectrum that add time to an exposure while not altering color-cast. They are often used to force slower shutter speeds or longer exposure times, thereby changing the look of an image by enhancing motion or to increase the working aperture, thereby decreasing depth of field.

Newton Rings– A pattern of concentric, alternating light and dark rings caused by interference of the light waves reflected between two nearly parallel surfaces. This can often result from film being placed between two pieces of glass, under an enlarger or on a scanner.

Noise Reduction– The process of removing noise from a signal. In digital photography, noise-reduction software to control image-sensor noise is often built into a digital-camera system, found as a filter in programs like Photoshop, or purchased as stand-alone software. Excessive noise reduction can have an adverse effect on image sharpness and clarity.

Output– Refers to either a digital print or digital image file produced from a digital camera, computer, or printer.

Pixel– An abbreviation for Picture Element. A pixel is the smallest unit to make up a digital image.

Point and Shoot– A compact camera designed primarily for simple operation, typically with automatic exposure, auto-focus, and a built-in flash. Although these cameras are convenient and easy to use, their functionality and effectiveness may be limited in low light or at night.

Posterization (also known as Banding)– A photographic process or effect, often undesirable, where the continuous tone of an image is replaced by more abrupt shifts of color and tonality that typically appear as flat banded areas of color.

Postproduction– Imaging work done with digital means after an exposure is made and an image file is downloaded from the camera or scanned from film.

Previsualize– To conceptualize how a given scene will appear in a photograph prior to capture and to make decisions about framing, camera settings, and stylistic treatments required to achieve the desired result.

Profile– In digital photography, an image may be converted by imaging software to a variety of different color spaces or profiles. Different profiles render different appearances of the same image. In digital printing, an output profile is a computer file used to describe how the printer should interpret colors in order to achieve desired results in an image.

Program Mode– Automatic exposure mode that allows the camera to adjust settings for aperture and shutter speed with little input from the photographer. This feature often includes options for result-oriented settings such as "fireworks," "museum," or "nighttime" situations, among many other choices.

Prosumer– A level of photographic equipment that is above the amateur consumer but below the highest level of professional quality.

Quick Release– A coupling device between a camera and tripod that allows the photographer to mount and remove the camera quickly and often remains attached to the bottom of the camera for ease of use.

Random Noise– Unwanted noise of a non-specific nature that appears in an image.

Rangefinder– A type of camera that does not utilize through the lens focusing but instead uses a built-in optical device for focusing through the viewfinder. Focus is often achieved by the merging of two parts of a split view into a single image.

Raw– All of the native information recorded by a camera's sensor prior to creating the final image.

Raw File– An image file that contains unprocessed

pixel information straight from the camera's sensor, prior to manipulation or conversion into a specific image format. A raw file is generally considered to be the digital equivalent of a film negative.

Reciprocity Failure– Inability of film to respond in a standard mathematic progression under long-exposure times, typically more than several minutes in duration. This failure is specific to individual film types. To obtain a properly exposed image under these conditions, specific reciprocity charts must be consulted and exposure times adjusted accordingly.

Resolution– The sharpness or clarity of an image and the ability of a lens, film, or digital imaging device to capture fine detail. In digital photography, resolution refers to the number of pixels recorded in the image, broken down by height and width. The resolution of a digital image will change in relation to its size.

Rim Lighting– Type of backlighting used to illuminate the edges of a subject.

RIP (Raster Image Processor)– A specialty software program installed in the computer to replace the printer driver and handle the printing process for greater control of color and print quality.

Self-Timer– A timing device used to trigger the camera's shutter without the use of a cable release. Self-timers may have presets or be fully programmable, depending on the sophistication of the camera model.

Sensor– The electronic element in a digital camera that receives and translates light waves into digital data. CCD and CMOS (*see* CCD and CMOS, above) are the two most common sensor technologies used for digital imaging.

Sensor Glow– *See* Amplifier Glow

Shift Lens– A specialty lens, often used in architectural photography with 35mm formats, which allows the photographer to shift the lens up or down, and left or right, thereby preventing parallel lines from converging in the image.

Shutter Lag– The time delay between the moment when the shutter button is depressed and the when the shutter is actually released. Shutter lag is typically more of an issue with older model and low-end digital cameras.

Shutter Speed– The length of time during which the shutter is open, allowing light to fall on the sensor or film. Shutter speed, along with the lens aperture and the ISO sensitivity, is one of the primary factors to control the exposure of an image.

Single Lens Reflex (SLR)– Typically, a 35mm-format camera which uses a mirror to project the image through a pentaprism and viewfinder, allowing the photographer to frame a scene that largely replicates the composition of the final image.

Sodium Vapor– Often used in urban street lighting, these lamps appear warmly amber to the eye and can cause an orange color-cast in images.

Specular Highlight– Illumination generated from a bright light or highly reflective surface that produces overexposed highlights in a captured image.

Star Trails– Lines of light that are recorded in an image during very long exposures of stars in the nighttime sky because of the movement of the earth.

Strobe– Used synonymously with flash.

Tungsten– A type of artificial lighting most commonly seen in incandescent light bulbs. When photographed with daylight film or a daylight setting in a digital camera, these lights typically produce images with a warm, orange color-cast. This can be neutralized by using a tungsten-based film or white balance setting or through the use of filters.

Vignetting– A reduction of brightness at the edges of an image in comparison to the center. Vignetting can be caused by a number of factors including the use of very wide angle or low quality optics, an improper fit between the camera and lens, or accessories such as lens hoods or filters that can block light at the periphery of the frame.

White Balance– Controls on a digital camera or in post-processing software programs that are used to compensate for the different Kelvin temperatures and color-casts caused by various light sources.

Zone Focusing– A distance-based focusing method that allows the focus of a lens to be set by reading the depth of field scale related to a selected aperture rather than focusing through the viewfinder.

Zone System– A system developed by Ansel Adams to precisely determine correct exposure and development times in order to place gradations of light and dark image areas into ten discrete zones, where zone zero is the darkest and zone ten is the brightest.

INDEX